MASTER CLASS
IN WATERMEDIA

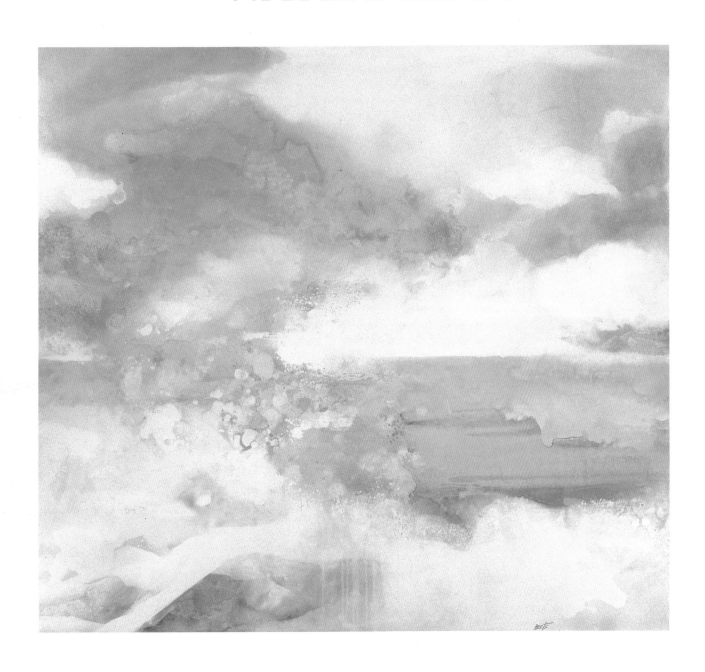

MASTER CLASS IN WATERMEDIA

Formerly **MASTER CLASS IN WATERCOLOR**

EDWARD BETTS, N.A., A.W.S.

Watson-Guptill Publications/New York

The epigraph on page 11 is from MUSEUM WITHOUT WALLS: THE VOICES OF SILENCE by André Malraux. Copyright © 1967 Martin Secker and Warburg. Used by permission of Doubleday, a division of Bantam Doubleday Dell Publishing Group, Inc.

The quotation accompanying the image on page 50 is from THE OUTERMOST HOUSE by Henry Beston. Copyright 1928, 1949, © 1956 by Henry Beston. Copyright © 1977 by Elizabeth C. Beston. Reprinted by permission of Henry Holt and Company, Inc.

*Half title: **Rising Clouds,*** 1988, acrylic on Masonite, 48 × 54". Private collection.

Title page: Detail of **Sunshore,** 1992, resist, watercolor, and acrylic on illustration board, 14 × 20". (See page 66 for the complete painting.)

Edited by Joy Aquilino
Designed by Areta Buk
Graphic production by Ellen Greene

Copyright © 1993 by Edward H. Betts

Published in 1993 by Watson-Guptill Publications, a division of BPI Communications, Inc., 1515 Broadway, New York, N.Y. 10036

The Library of Congress has catalogued the hardcover edition of this book as follows:

Betts, Edward H., 1920–
 Master class in watermedia: techniques in traditional and experimental painting / Edward Betts
 p. cm.
 Rev. ed. of: Master class in watercolor. 1975.
 Includes bibliographical references and index.
 ISBN 0-8230-3017-2
 1. Watercolor painting—Technique. I. Betts, Edward H., 1920–
Master class in watercolor. II. Title.
ND2420.B47 1993
751.4'2—dc20 93-3421
 CIP

 ISBN (paperback) 0-8230-3040-7

Manufactured in Hong Kong

First paperback printing, 2000

1 2 3 4 5 6 7 8 9 / 08 07 06 05 04 03 02 01 00

Edward Betts is a member of the National Academy of Design and the American Watercolor Society, and is a professor emeritus of art at the University of Illinois. He holds a B.A. degree in the history of art from Yale University and an M.F.A. in painting from the University of Illinois. Born in 1920 and brought up in New York City, he attended summer sessions at the Art Students League from 1935 to 1942, and as a full-time student there from 1946 to 1948, joining the University of Illinois School of Art and Design in 1949.

Betts has been represented in virtually every important national exhibition, including major surveys of contemporary American painting at the Metropolitan Museum of Art, the Whitney Museum of American Art, the Corcoran Gallery of Art, as well as other national exhibitions at the Art Institute of Chicago, the Brooklyn Museum, Denver Art Museum, San Francisco Art Museum, and the Pennsylvania Academy of Fine Arts. His paintings have been included in international exchange exhibitions in Japan, Brazil, England, Mexico, Australia, and Canada.

A three-time winner of the $2,000 First Altman Landscape Prize at the National Academy of Design, Betts has received more than seventy exhibition awards, among them seven awards at the American Watercolor Society, including two Silver Medals of Honor. His work is represented in sixty public and corporate collections, such as the Fogg Museum of Art, Virginia Museum of Fine Arts, Portland (Maine) Museum of Art, Upjohn Pharmaceutical Company, Continental Grain Company, Prudential Life Insurance Company, and Tupperware International.

In February 1983 *American Artist* magazine featured Betts as one of fourteen "living legends" in American watercolor. He is listed in *Who's Who in America* and *Who's Who in American Art.*

FOR EDIS

Acknowledgments

My thanks to:

Candace Raney, who saw the possibilities of giving a second life to my *Master Class in Watercolor*. She was not the first to suggest to me a revised edition of this book, but she was the one I listened to.

Joy Aquilino, who with taste and discrimination guided the manuscript through the process of combining my revisions with the original text. In addition, she had an unfailing eye in dealing with the visual material, and I can honestly say she was indeed a joy to work with.

Areta Buk, whose exciting and imaginative design handsomely reflects the spirit of the book itself; and Ellen Greene, who skillfully presided over the production phase. The nature of their individual contributions is such that they should never be taken for granted.

The publication of this book represents one of the personal satisfactions of a lifetime of painting and teaching. I could not have achieved it in its present form without the professionalism and enthusiastic support of all those listed here.

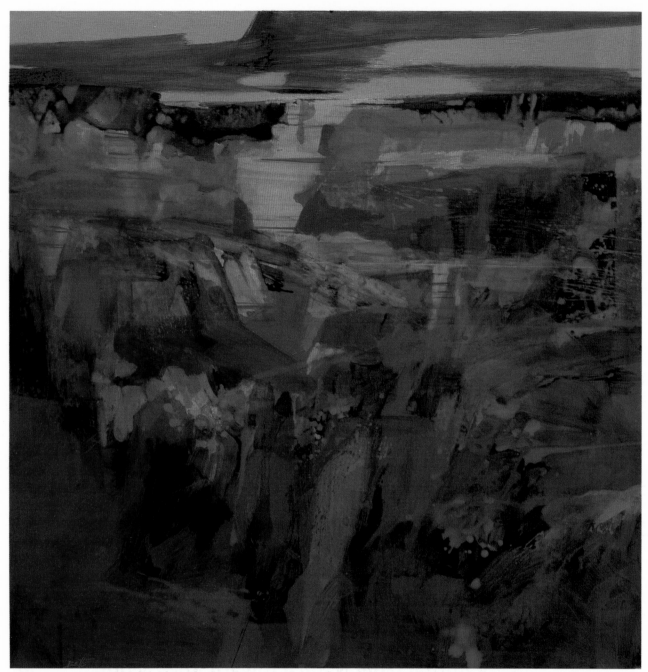

CANYON, 1987, ACRYLIC ON MASONITE, 48 × 48".

CONTENTS

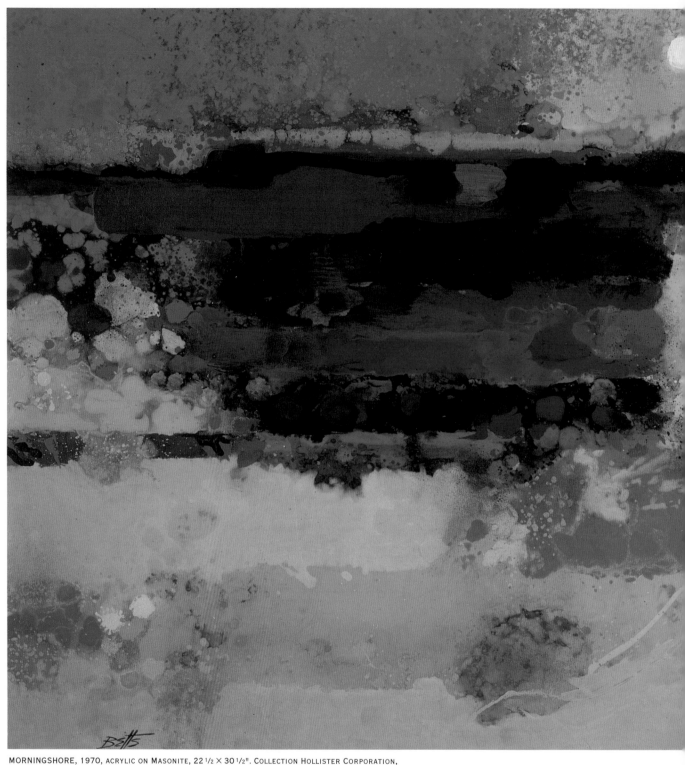

MORNINGSHORE, 1970, ACRYLIC ON MASONITE, 22 1/2 × 30 1/2". COLLECTION HOLLISTER CORPORATION, LIBERTYVILLE, ILLINOIS.

PREFACE

Under its original title, *Master Class in Watercolor,* this book was first published in 1975 and went through two additional printings in 1979 and 1981. It was intended primarily for artists who have considerable background in drawing, painting from nature, and knowledge of design. With all due modesty I must say it was enthusiastically received at that time, but since it featured only thirty-two color plates the publishers finally decided to let it go out of print.

With an impeccable sense of timing, Candace Raney, Senior Acquisitions Editor at Watson-Guptill Publications, approached me in the spring of 1992 concerning the possibility of my doing a revised edition. If she had called me a week earlier or later I would probably have declined, just as I had done with other editors a few years earlier. As it turned out, she caught me off guard and I agreed to take on the project.

So here it is in its fresh new form. The text remains very much the same, amplified in some ways, tightened up in others, but basically intact. The newest aspect is the increased number of color illustrations. Only a few from the original edition reappear here, and quite a number that were reproduced as black-and-white halftones are now shown in color. Many of the artworks reproduced were done especially for this new version; in some instances I even did paintings in styles that are uncharacteristic of the main body of my work in order to demonstrate specific points that could not otherwise be made. The change in title is in itself a welcome correction, since the emphasis all along had been more on the various watermedia than just on watercolor alone.

There are plenty of truly excellent books on traditional basic watercolor techniques, but from the personal responses I received from many professional and semiprofessional artists, as well as from a number of experienced amateurs, I could tell that this book had indeed fulfilled a genuine need by opening up avenues for change and expanding the range of pictorial possibilities for painters who had already reached a certain level of recognition and technical expertise, but who most wanted to know where they should go next in developing their art.

I have enjoyed this opportunity to improve on the early version of this book, and trust that my readers will derive from it even more pleasure and aesthetic stimulation than they did the first time around.

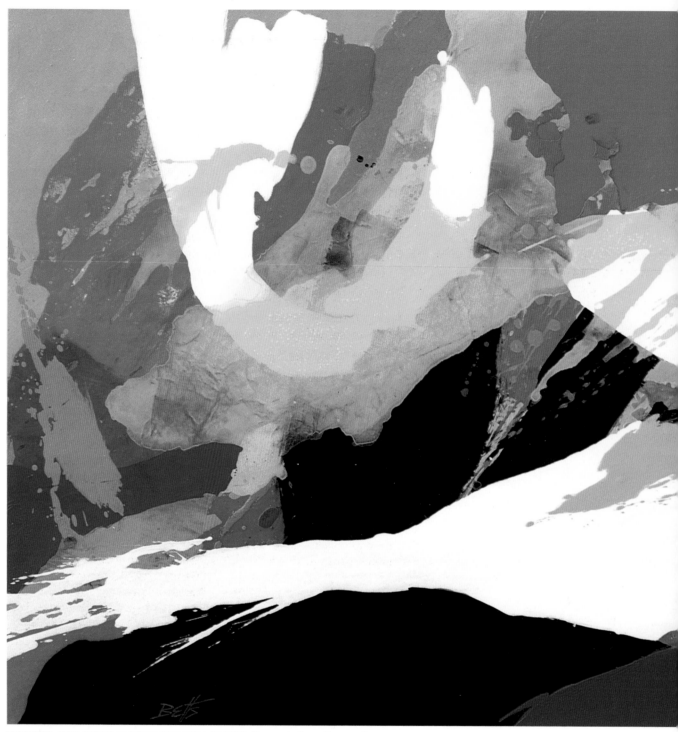

FLOODTIDE, 1980, ACRYLIC ON ILLUSTRATION BOARD, 22 × 30". COLLECTION BUSEY NATIONAL BANK,
URBANA, ILLINOIS.

INTRODUCTION

Just as a musician loves music and not nightingales, and a poet loves poetry and not sunsets, a painter is not primarily a person who responds to figures and landscapes. He is primarily one who loves pictures.

—André Malraux

This book came to be written as an indirect result of my serving on the juries for two major watercolor exhibitions. In both instances, the jury members rejected a great many paintings that were thoroughly competent—in fact, well above average. It might even be said that a very respectable exhibition could have been formed out of the work that had been rejected. What struck me at the time—and has lingered since in my mind—was that a jury of professional artists felt it was simply not enough for an artist to have a virtuoso technique or a dazzling control of the medium. There seemed to be an unspoken agreement on the part of those jury members that in paintings submitted to large national exhibitions technical competence is assumed, taken for granted. Given that skill, the big question then was: What has the artist done with that skill? What message is being communicated?

It was the feeling of the jury members, I think, that there is an obligation to go beyond craftsmanship, to push the medium beyond descriptive imitation toward the transformation of nature into solely pictorial terms, to form images that have urgency and communicative power and in which poetry or geometry is of more concern than an unimaginative list of visual facts.

In response to what happened on those juries, my own teaching in classes and workshops has stressed more than ever the need to acquire a strong foundation in all the disciplines of drawing and painting—and then to use these disciplines in a spirit of awareness, invention, improvisation, and discovery. This spirit is not an end in itself, of course, but a way for artists to synthesize the world around them with their private, inner worlds.

It is almost certain to become evident as you read further in this book, so I may as well confess right now that I am a split personality: I paint both representationally and abstractly and fully enjoy looking at paintings of both persuasions, responding to the special qualities of each. On my bookshelves Corot, Turner, Boudin, and Degas are next to Marin, Pollock, Frankenthaler, and de Kooning. I have no ax to grind for any particular style of art, whether it be traditional or modern. I look only for the one thing that transcends styles: quality.

I had an extremely academic, disciplined foundation in the study of art. I studied life drawing with Reginald Marsh, anatomy with George Bridgman, still life painting with Robert Brackman, portraiture with Wayman Adams, and figure painting with Robert Philipp, Jerry Farnsworth, and John Carroll. In those years I was thoroughly committed to representational painting.

Later on, painter and printmaker Harry Sternberg opened my eyes to the possibilities of abstract art. Although the major part of my work for the past forty years has been inclined toward the abstract, I still continue to paint representationally, happily, and with a perfectly clear conscience. I paint representationally not so much as a secret vice, but as a form of recreation—some people play golf, I paint watercolors—and also as a means of periodically renewing my contact with nature.

My use of representational paintings primarily as source material may be related to the idea that the Latin root of the word "abstract" refers to a "taking from" something. When painting—whether a landscape, interior, still life, figure, or whatever—an artist observes nature, selecting, extracting, and manipulating certain elements to give a heightened sense of the subject in terms of design rather than description.

This composition may be formally structured or spontaneous and splashy, but the general procedure involved is usually a taking apart of the subject and then reorganizing it into a new form that more strongly emphasizes interrelationships of line, plane, shape, pattern, color, and texture. The subject matter acts not so much as the predominant idea but as the underlying framework of a pictorial arrangement—not a report, an inventory, or a document, but a work of art.

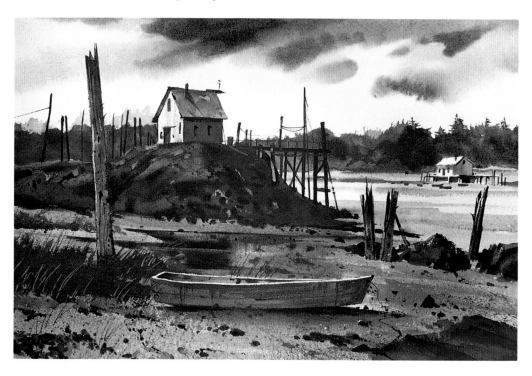

AFTER THE STORM, 1973, WATERCOLOR ON 300-LB. ARCHES ROUGH, 14 1/2 × 22". PRIVATE COLLECTION.

This is a typical example of my realist style in what I will always consider one of my favorite media. Because I was trained to paint representationally, and because I still respond deeply to the natural world around me, I continue to paint what I see and share my responses through the directness and sparkle of watercolor on paper. I am hopelessly addicted to painting pictures such as this, principally as a change of pace from my abstract painting.

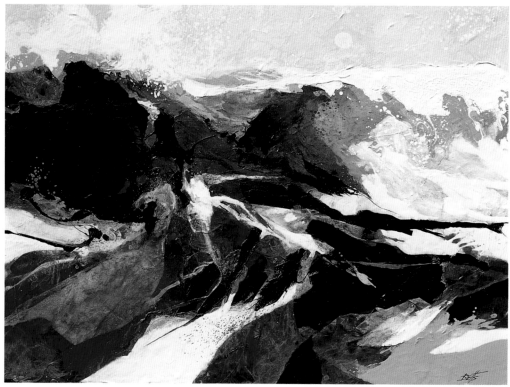

STORM SURF, 1970, MIXED MEDIA ON ILLUSTRATION BOARD, 19 × 27". PRIVATE COLLECTION.

This picture represents the other side of my "split personality." Rather than being descriptive of what the eye sees, it is an attempt to bring some kind of formal order out of the chaos of nature, to view things in terms of abstract design, and to reorganize rather than report. I have always found this far more exciting and challenging than representational painting, but both of these aspects of my art, as different as they seem, are mutually interdependent.

I am not at all in favor of the separation of, or the creation of an imaginary gulf between, figurative, descriptive art and abstract or nonobjective art. There is certainly plenty of room in this world for both styles to exist side by side, or even to exist within the same artist. It is not that realist painting is necessarily objectionable, but rather that in many cases it is done without taste or imagination. In the long run, however, artists should not be concerned with whether or not they are traditionalists or modernists or something in between; they should paint in whatever manner they find most natural and true to themselves. I suppose you might say it is a matter of painting the way you feel you *must* paint in spite of yourself, not the way you think you *ought* to paint.

This book is not an attempt to win readers over to the abstract viewpoint. What it comes down to is this: I am convinced that as artists we should be primarily involved with picture-building rather than with reproducing what we see in postcard views; that art, not anecdote, is our principal concern; and that a painting should take precedence over its subject matter. I often think of the painter Jack Tworkov, who said in answer to a question from an audience, "To ask for paintings which are understandable to all people everywhere, is to ask of the artist infinitely less than what he is capable of doing."

I think it is important for you as a painter to develop the finest technique possible in drawing and painting and then to use it toward some purpose other than a display of virtuosity, or trying to compete with the camera. I would like to think that if you paint abstractly, it is because you have already demonstrated that you can paint authoritatively in traditional modes; you have chosen to paint abstractly because you believe that it is your most natural means of creative expression, not because you hope it will be a means of disguising your deficiencies as a representational painter.

I urge you to think of tradition as a point of departure, to have love and respect for it but not to repeat it mindlessly. As the contemporary composer Hans Werner Henze has said, "When I study the score of, say, 'Figaro,' it is not to learn how to imitate Mozart. It is to find out what is in the music that is timeless."

I am directing this book, therefore, primarily at artists who have behind them a fundamental knowledge of representational drawing, composition, color, and painting techniques. I am not interested in the presentation of a 1-2-3 method for getting things done. Rather, by demonstration and example, I hope to open up other avenues and attitudes, other possibilities than those that have been so well discussed already in the many books on basic watercolor and acrylic techniques that are available.

The kind of painting I respect most cannot be taught in a "canned" fashion. The best painters have arrived at their art after long search, struggle, trial and error, and considerable thought and introspection—and, incidentally, after having painted hundreds of pictures. There is no one method that will guarantee success or acceptance in national shows; it just is not that simple. This, then, is a book principally for experienced watercolorists who wish to broaden their horizons and enrich their art, to get out of old habits and into fresh ways of seeing and painting.

Less experienced painters will also benefit from the ideas suggested in the following pages. But, in all fairness, I must remind them that experimental methods are most successfully used by artists whose skills are so much a part of them that they almost cease to be important any longer. In any event, creative techniques cannot be used as a cover-up for lack of knowledge or experience, nor can they serve as an evasion of the demands and disciplines of picture-making.

This book is merely a point of departure; what follows is the most challenging and exciting part—and the most difficult—and that is entirely up to you.

MEDITERRANEAN, 1988, ACRYLIC ON ILLUSTRATION BOARD, 15 × 20". COLLECTION CENTURY ASSOCIATION, NEW YORK CITY.
This picture began randomly, but gradually evolved into a composition where strict, formalized elements were combined with loosely handled color passages to achieve a balance of opposites. This represents an extreme degree of abstraction bordering on the totally nonobjective. The subject matter is sensed or felt, not rendered literally; there are no identifiable forms. The painting as a whole is more important to me than the facts.

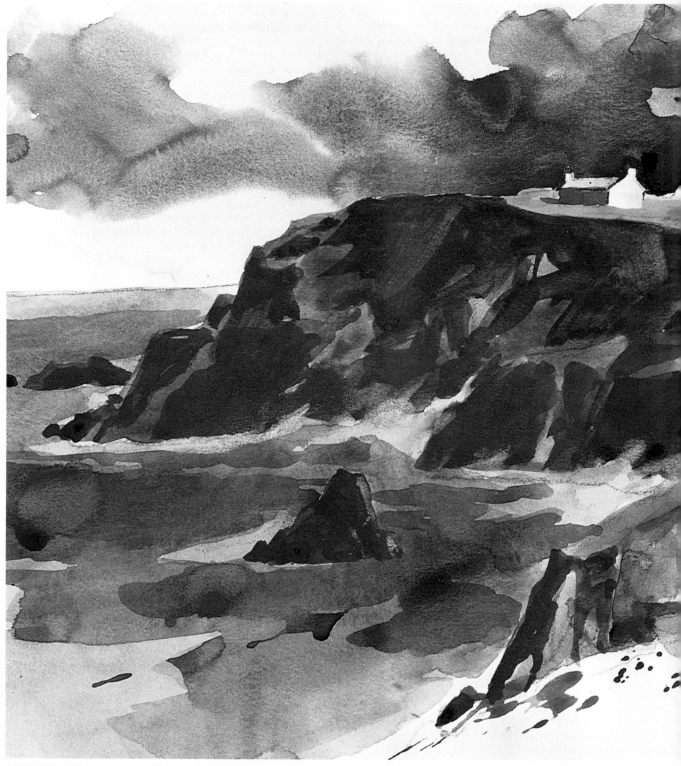

LAND'S END, 1984, WATERCOLOR ON 98-LB. PAPER, 11 × 14".

When time allows I may paint a watercolor sketch, since it is very similar to what the final watercolor might look like. This is a fifteen- or twenty-minute sketch painted on location at Land's End in Cornwall. Ignoring detail, my main goal was to capture the striking effect of the white buildings starkly spotlighted against the almost black sky, so other whites were suppressed in order to heighten that contrast.

SKETCHING ON LOCATION

Because nature is the prime source for most artists' creative impulses, the sketchbook is a basic piece of equipment. On-the-spot sketching is not just for beginners; it should be an activity that continues for a lifetime.

Drawing or painting from imagination is not sufficient. The only forms we can work with are those we have already observed, even unconsciously, and the majority of pictures based on purely imagined forms or situations lack conviction and authenticity. So it is important to sketch habitually and constantly, and to build a library of sketchbooks that can be referred to repeatedly through the years.

Let me first define what I mean by a *sketch* as opposed to a *drawing*. I think of a sketch as being a brief statement done from direct observation of the subject. It is relaxed and informal. Its main function is to convey essential information and to serve as an aid to memory later in the studio. The sketch is not as fully developed as a drawing and usually takes, at the most, not more than fifteen or twenty minutes to do. It may have written on it color notations and symbols that are meaningful only to the artist. The sketch is for the artist's private use, and this, of course, is what gives many sketches the quality that is so much admired by collectors: In sketches the artist draws for himself without the world looking over his shoulder, and therefore the sketch usually has far more spontaneity than a fully developed drawing.

In contrast to a sketch, a drawing is done as a work of art in its own right. It is more consciously executed and pushed further as to detail and formal structure. While some drawings are done in an hour or two, those that take weeks or even months are almost exclusively done in the studio.

WHY A SKETCHBOOK?

Convenience

There are quite a number of reasons for doing sketches from nature. Most obvious is the matter of convenience—the materials involved are few and easy to carry and set up. Painting outdoors in oils is a very complex undertaking, and even with watercolor there is the matter of the palette, board with paper stretched on it, paint tubes, brushes, jar, rags, and so on.

Simple sketch materials, on the other hand, can be carried in one hand and perhaps a pocket or two. Where there might be time for a sketch, there might not be time enough to do a painting—a storm coming up, the light changing, things in movement. A sketch can sometimes capture the moment where a painting could not.

Selecting Subject Matter

Aside from the matter of convenience, there are other reasons for sketching. One is that through sketching you can select subject matter. You can note whatever you respond to, and the sketch can indicate to you whether or not a particular subject has possibilities for working up as a painting. It is a means of sorting out and recording motifs that have appeal for one reason or another, so that at a later date the sketch can serve as a reminder of what the subject looked like, and perhaps even more important, of how it affected you and what mood or idea it might be used to express.

Information

A sketch can also be a way of storing information—the general arrangement of the subject, the distribution and placement of major forms, shapes, and masses, and the effect of lighting on those forms.

On another level, a sketch can record very specific things, such as texture or intricate detail that would be hard to remember. Informational or research drawings are descriptive in character, and while they may entail some degree of selection, simplification, and elimination, they are ordinarily rather literal and straightforward in their rendering of visual facts.

Composition

Another use for sketching is determining composition: finding a viewpoint toward the subject and arranging the subject to its maximum advantage within the rectangle of the sheet of paper. Sketches of this sort are the first step in seeing the subject as a possible painting; it is here that you determine whether it would look best in a horizontal or vertical format and also which elements should be suppressed or left out altogether. A series of sketches of a single motif can clarify which view is most appropriate in respect to the subject's readability, lighting, surface pattern, dramatic possibilities, or underlying abstract structure.

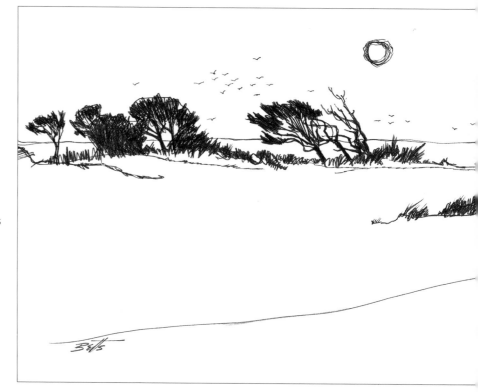

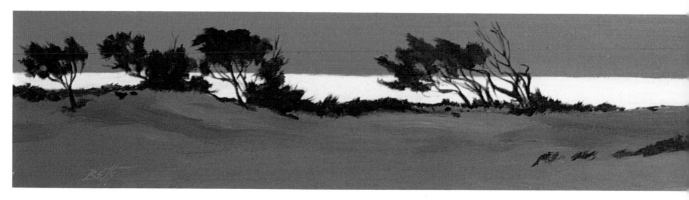

16

Vocabulary of Forms

Still another important reason for acquiring the sketching habit is that it adds to the artist's vocabulary of forms. A mental reservoir of shapes, forms, and textures is constantly being renewed and refreshed; the artist will most certainly draw on those resources, consciously or unconsciously, during the process of painting a picture. Thus, while many sketches may not apply to any particular painting, they are, in a sense, the broadest preparation for painting in general.

Reference

Finally, a sketchbook is used for later reference and as an aid to memory. Very often, in going through their sketchbooks for ideas, artists will bypass certain drawings that do not "speak" to them. Then, perhaps ten or twenty years later, they will suddenly see the possibilities in them revealed fully for the first time. Sketches mean different things to artists at different stages of their lives, depending on their current interests and outlook.

Written Notes

There are those times when even a quick sketch is impractical for any one of a number of reasons—subtlety of lighting, rapidly changing effects of light or color, and pressure of time. So occasionally I use written notes rather than a sketch to describe effects that I feel I cannot record in any other way.

For instance, in one of my sketchbooks there is a page with a few hasty scribbles, together with the following written material:

Hull's Cove, Bar Harbor 7:30 P.M.
Very dark clouds at top, merging hard and soft with white clouds turning to fog or haze directly above farthest outer islands.
Thin strip of white light along water at lower edge of distant islands.
Dark rocks at lower right, water middle gray. Beach very dark (wet gravel).
Nearer islands dark, distant islands lighter.
Long horizontal composition, showing whole stretch of Hull's Cove. 8 × 30?

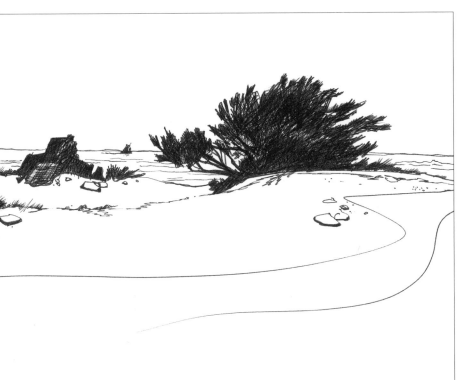

POINT JOE, PEBBLE BEACH, CALIFORNIA, 1969, INK ON PAPER, 11 × 24".

This sketch was drawn on location with a felt-tip pen on a large Monroe pad. Although felt-tip pen drawings usually fade badly unless kept in the sketchbook or stored in a portfolio away from the light, I prefer the felt-tip's crisper lines and blacker blacks to those available with the graphite pencil. I wanted to get the full panoramic spread of landscape, so I used a larger-than-usual sketchpad; this drawing would have been much too cramped in my regular sketchbook.

POINT JOE, 1969, GOUACHE ON ILLUSTRATION BOARD, 4 × 30". PRIVATE COLLECTION.

An exaggeratedly slender horizontal (or vertical) format is a favorite of mine, and was especially appropriate for this subject.

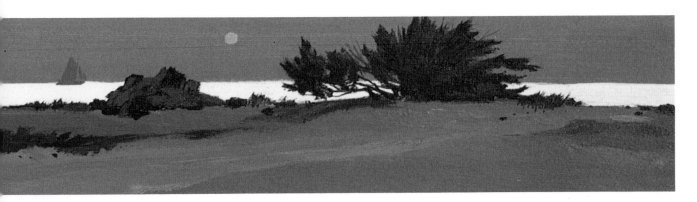

MATERIALS

I am listing here two sketching kits that I use: One is very basic and one is an expanded set of sketch equipment for a wider range of media and effects.

Basic kit

- Sketchbook, spiralbound, 11 by 14 inches
- Sketchbook, bound, 8 1/2 by 11 inches
- Pencils: 6B or Ebony sketching pencil
- Razor blade, single-edged (for sharpening pencils on location)
- Pens: felt-tip pen with black ink and India ink sketching pen

Expanded kit (in addition to the items listed above)

- Sketchpad, 13 by 26 inches
- Watercolor block, rough, 9 by 12 inches
- Pencils: 2B and carbon (Wolff)
- Pens: bamboo pen and felt-tip marking pen
- India inks: black, neutral tint, sepia

- Tube watercolors: ivory black, burnt sienna, yellow ochre, and ultramarine blue
- Brush: No. 5 sable
- Small plastic watercolor palette

- Plastic water jar (1 pint), with lid
- Pocket pack tissues (for use as paint rags—for cleaning, wiping, and so on. These are preferable to rags because of their small size.)

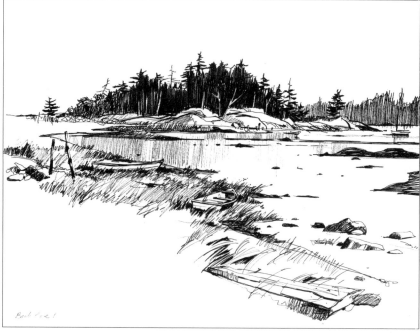

BACK COVE, SEBASCO, MAINE, 1985, INK ON 98-LB. PAPER, 11 × 14".
This sketch was drawn directly in ink without a preliminary pencil blocking-in.

BACK COVE, SEBASCO 3, 1985, WASH ON 98-LB. PAPER, 11 × 14".

This sketch shows the same vantage point and subject as that above, but closes in on the two boats for greater foreground interest and less emphasis on background and peripheral areas. Masses are established with broad washes and value contrasts, the idea being to define areas entirely by means of tone and pattern, not line.

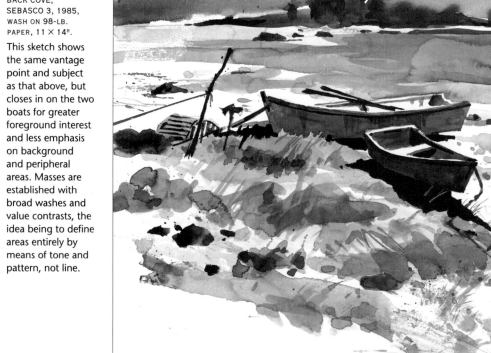

Sketchbooks and Sketchpads

I customarily use the spiralbound variety, although because of that very binding they are somewhat awkward to store. On the other hand, unsuccessful drawings are more easily removed than from a bound sketchbook, where pages that are torn out can loosen the other pages farther along in the book. My favorite sketchbook is the Aquabee 808 Super DeLuxe, 14 by 11 inches, 98-lb. paper.

In addition to my regular sketchbook, I keep a small sketchpad in the glove compartment of my car. In the past, there have been several occasions when I wanted stop and note something down quickly as a sketch and found to my dismay that I had nothing more to draw on than a frayed matchbook pulled somewhere from the depths of the front seat. In recent years, therefore, I have always kept an extra pad available for just such emergencies.

Watercolor Block

Since the average sketchbook does not have paper sufficiently heavy to take watercolor without wrinkling or buckling, I like to have on hand a very small watercolor block of rough paper. As a rule, I have no fondness for watercolor blocks, but in terms of convenience and portability during travels they are quite satisfactory.

Pencils

I like a soft pencil for its ease of handling, breadth, versatility, and ability to produce a full range of tones. Over the course of a few years, however, pencil sketches tend to smudge and smear. For that reason I frequently use a felt-tip pen.

Pens

With a pen it is harder to build up masses of tone and there is less line variation than with a pencil, but the drawings stay clear and sharp indefinitely, as long as they are kept in a closed sketchbook. Most of the standard felt-tip pens I have used have ink that fades when exposed to daylight for a few months. The black ink, for instance, does not fade out completely, but turns a pale version of burnt sienna or burnt umber. These drawings are quite satisfactory while they remain within the sketchbook, but if one should be torn out and sold, it is quite likely that the irate buyer will soon come around demanding his money back.

I use felt-tip pens nevertheless—either alone or in conjunction with an India ink sketching pen, whose ink, of course, is absolutely permanent.

Felt-tip marker pens have very broad points and are excellent for quickly blocking in large, dark masses.

In addition to pens, I occasionally draw with the stopper from the ink bottle or with a sharpened matchstick of the 9-inch decorator variety. I like them for the varied, unusual line quality I can get with them. Somehow they help me draw in a freer, more explorative, abstract manner.

Inks and Watercolors

For a painterly type of sketching I use either India inks and brush and pen or a limited palette of watercolors. There is no particular basis for deciding when watercolors are to be used; either my mood of the moment or the subject itself will suggest that a wash treatment is appropriate. These are not color notes (I rely on memory for that), but sketches stressing tone and pattern rather than line and detail.

Palette

On sketching trips I carry along a tiny (8-by-9 1/2-inch) plastic watercolor palette that was once part of a watercolor sampler set. It has two central mixing areas and quite a number of depressions around the edge to hold the pigments. It is more than sufficient for the small scale in which I work and the very limited number of colors I use. If I need to isolate the dirty palette from other equipment (to keep the paint and water from leaking off onto other things in my sketchbag) I wrap the palette in a plastic envelope.

Water Jar

Here I prefer a 1-pint plastic jar, with lid. The main idea is to have a water container that is unbreakable and as light as possible.

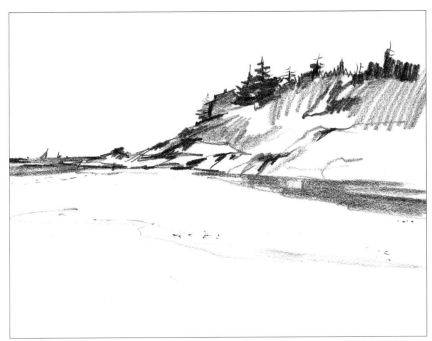

TOWARD ONTIO BEACH, 1972, PENCIL ON 98-LB. PAPER, 11 × 14".

Pencil is the most natural and versatile medium for on-location sketches. If smudging becomes a problem, as it often does, fixative should be sprayed on each sketch soon after completion.

I do not believe that exhibition paintings can be done outdoors, so your sketchbook is the main link between your first view of a subject and its subsequent evolution into a painting. Note in your sketchbook anything and everything that might be of possible value to you later in the studio, and try also for a wide variety of subjects. In a single sketchbook of mine there are drawings of rocks and surf, dune grass, a dead seagull, a boatyard, driftwood, burnt trees, and a farmhouse.

Even if something strikes you as being only vaguely interesting or useful it may be worth drawing anyway; you never know when you might need it.

Walk as much as possible rather than drive. You see a great deal more when going at a leisurely pace in areas a car cannot get to, and you have many more opportunities to stop and look behind you at things you have already passed, possibly getting a more interesting viewpoint than the one you had as you first approached them.

Use your sketchbooks as a means of familiarizing yourself not only with the look of things but also with their less tangible attributes—light, mood, atmosphere, the feel of weather, and the seasons. Your sensitivity to such things can differentiate your work from that of painters who see only the surface aspects of their world.

OARWEED COVE, 1972, INK AND WASH ON 98-LB. PAPER, 7 1/2 × 11".

This sketch was done in midsummer, but it led to several versions in both casein and acrylic, all of them snow scenes. It's one way to get extra mileage out of sketchbook material, to imagine or remember motifs in other moods or seasons. The more extensive your experience in painting outdoors, the more convincingly you can bring it off.

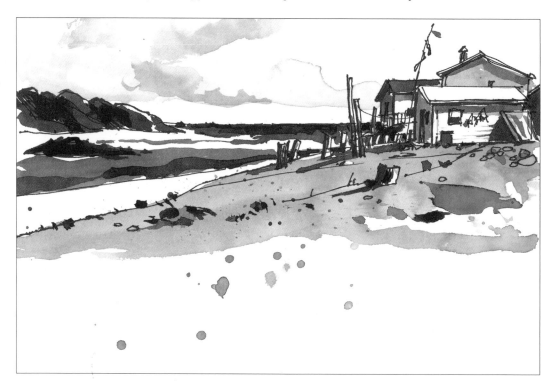

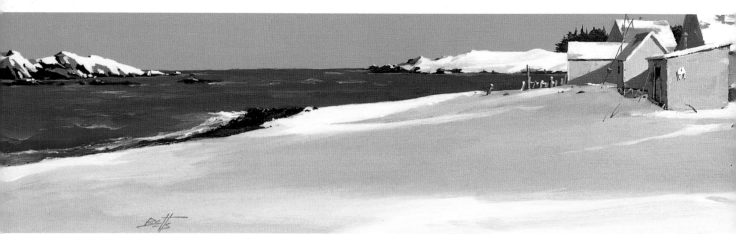

WINTER, OARWEED COVE, 1990, ACRYLIC ON MASONITE, 7 × 25".

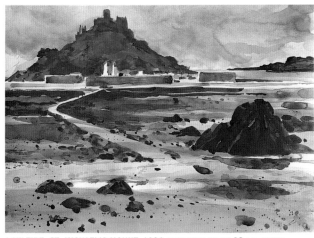

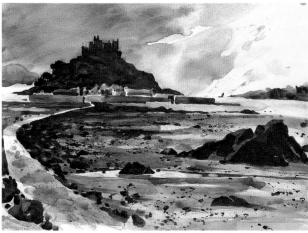

LOW TIDE, ST. MICHAEL'S MOUNT, 1984, WATERCOLOR ON 98-LB. PAPER, 11 × 14".

STORM CLOUD, ST. MICHAEL'S MOUNT, 1984, WATERCOLOR ON 98-LB. PAPER, 11 × 14".

Two more Cornish sketches. I often do several sketches of the same subject to help determine the treatment of the fully developed watercolor later on in the studio. I do only sketches outdoors now, realizing that actual exhibition-quality paintings done on location are the exception rather than the rule.

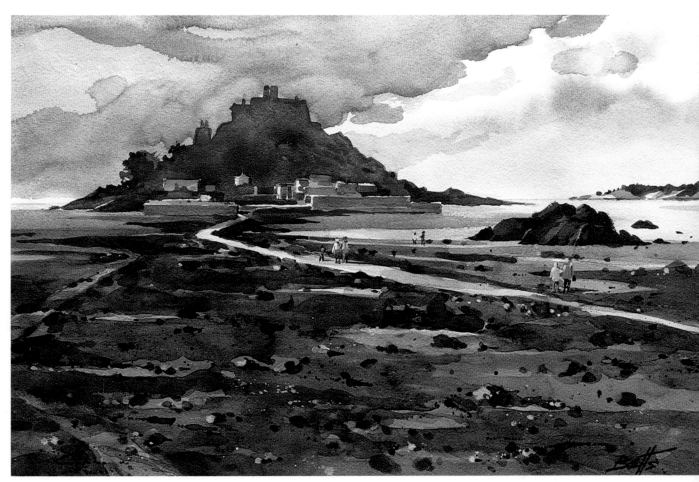

PASSING STORM, 1985, WATERCOLOR ON 140-LB. FABRIANO COLD-PRESSED, 15 × 22".

LITTLE BEACH, 1980, WASH ON 98-LB. PAPER, 11 × 14".

This is what I call a "rehearsal sketch." Some of them are in limited color or even full color, while others, like this one, are in Winsor & Newton Neutral Tint watercolor or Pelikan Gray ink. The "rehearsal" is done in order to ascertain well in advance what problems of shape, design, and pattern (or color) might have to be dealt with in the final watercolor. It is a great help in planning the watercolor, preparing not only for those unexpected problems that might arise, but becoming familiar with the subject matter before painting it in earnest. I resist putting so much of myself into the rehearsal sketch that I could become bored or mechanical while doing the watercolor itself.

LITTLE BEACH, 1980, WATERCOLOR ON 140-LB. ARCHES COLD-PRESSED, 15 × 22". PRIVATE COLLECTION.

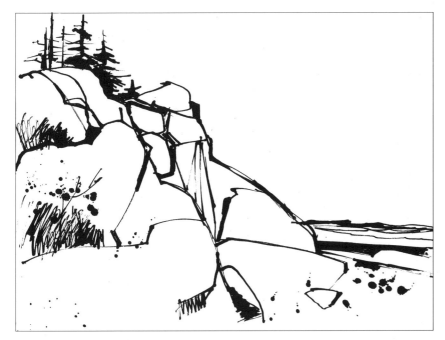

ROCKS AT SCHOODIC, 1960, INK ON 98-LB. PAPER, 11 × 14".

My sketches are not necessarily the standard representational kind. I sometimes draw more freely or abstractly if the subject's forms move me in that direction. This was done with ink and a long matchstick (though a bamboo pen would give much the same effect), and I was more interested in stressing some of the abstract qualities of the rocky coast than I was in doing a literal rendering.

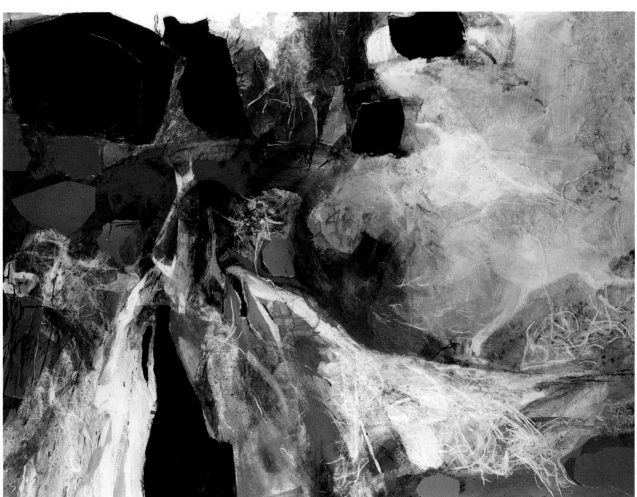

CASCADE, 1962, MIXED MEDIA ON ILLUSTRATION BOARD, 22 × 30". PRIVATE COLLECTION.

The material in the sketch was considerably transformed in the acrylic and collage painting that grew out of it. The downward-tumbling movement of the rocks in the drawing struck me as being reminiscent of a waterfall, so although I used the general composition of the drawing, its real value to me was as a stimulus for a free association of ideas that led me to a different subject than the one originally sketched.

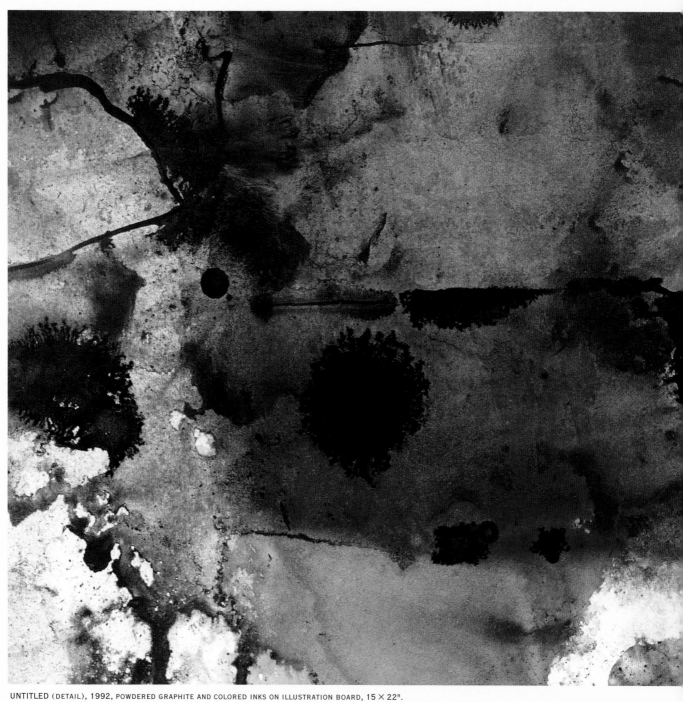

UNTITLED (DETAIL), 1992, POWDERED GRAPHITE AND COLORED INKS ON ILLUSTRATION BOARD, 15 × 22".

Color glazes can be applied over graphite in the same manner as oil glazes over a monochromatic underpainting in traditional oil painting techniques. (See pages 34–35 for the complete painting.)

SKETCHING IN THE STUDIO

While sketching on location is an observational, descriptive kind of drawing, studio drawing and sketching should be more creative, more experimental. Once the subject matter has been assimilated in outdoor sketches and in the artist's mind, then it is time to explore the material further; to condense, intensify, organize, and transform it with the idea of discovering its full potential as a painting.

Aside from being preparation specifically for paintings, studio sketches can also be done simply for their own sake. These visual exercises drawn in an improvisational spirit can evolve new forms, establish new relationships between forms already known, and reveal more personal ways of relating random brushstrokes, blots, and accidental effects to the natural forms that have been observed during sketching trips.

The greatest advantage of doing drawings in a studio environment is, of course, that the working conditions are fully controlled, and all necessary art materials are conveniently at hand. This permits artists to concentrate fully on their ideas and drawings, without being distracted by wind, dust, rain, irritable dogs, and amateur art critics. Also, at a distance from the subject matter, artists are less inclined to be slaves to their sources— there are more opportunities for thought and planning and for developing fresh ways of dealing with the subject.

Sketchbook

Your studio sketchbook is another 11-by-14-inch spiralbound book, a supplement to the ones used for sketching on location. The drawings in this book are not done from nature, but are a collection of compositional studies, thumbnail sketches, tentative ventures into abstract reorganization, and intuitional drawings or "doodles." I keep the two completely separate as to both the material they contain and the function they serve: Sketchbook No. 2 functions principally as a mini-laboratory for visual experiments, a workshop for testing pictorial ideas.

Drawing Pads and Papers

Studio sketching has none of the restrictions inherent in sketching outdoors, so large (18-by-24-inch) drawing pads can be used, as well as any other drawing or printing paper favored by the artist. In addition to large newsprint and Monroe pads, I have an assortment of papers in various sizes, weights, and surfaces, and I select whichever seems best for the ideas and the medium I am working with.

Tissue Paper and Newspaper

In addition to standard drawing methods, I often place tissue paper over the drawing and paint heavily on it with ink, watercolor, or acrylic paint. The tissue lets a good part of the ink or paint soak directly through onto the sheet beneath it, creating interesting shapes and strangely mottled textures. These in turn stimulate me to pursue the ideas suggested and to elaborate further with washes and ink lines.

I use newspaper to lift up ink or paint from the drawing (a good method for achieving textured halftones), or I apply paint directly to the newspaper and then flip it over quickly and transfer it onto the drawing surface, again in order to create accidental effects that I can respond to and incorporate into the finished drawing. Occasionally, such improvisations are nothing more than ugly blobs or smears, but more often they suggest fascinating possibilities. It then becomes a

challenge to integrate the accidentally arrived-at forms and those that are derived from my on-the-spot sketches.

Pencils

A carbon, or Wolff, pencil, or a Conté pencil, works well in combination with watercolor washes to produce deeper blacks and richer surfaces of texture and value than can be obtained with graphite pencils.

Crayons

I use wax crayons in the lighter color range as a resist, rather than for application of color.

Conté crayon in stick form can be used alone, or the surface of the Conté drawing can be brushed with turpentine for wash effects.

Brushes

I tend to favor a type of drawing that is closely related to the spirit of my painting, so I am more involved in what might be called a painterly approach to drawing, in contrast to traditional draftsmanship featuring a beautifully wrought line. I therefore use a number of brushes of various kinds—sable, bristle, and Japanese

sumi—many of them so incredibly worn that to anyone but another artist they might seem virtually unusable.

Painting Knife

Although this is primarily a painting tool, I like the sharp, incisive lines I can make by drawing with its edge held against the paper. To paint broadly with the knife in ink or watercolor would be suitable only in a format larger than that of a sketch, so here I limit its use to linear accents.

Water Containers

I keep four l-quart glass jars filled with water on hand at all times, for diluting inks or paints and for rinsing brushes. I also use plastic 1/2-gallon ice cream containers; these are so wide that a quickly aimed brush finds its mark without difficulty.

Roller or Brayer

A hard rubber ink roller, or brayer, is good both for its breadth of application and for the textural masses that are possible with it. I prefer to use it with opaque acrylic paints rather than drawing inks, which are too thin and runny for maximum control.

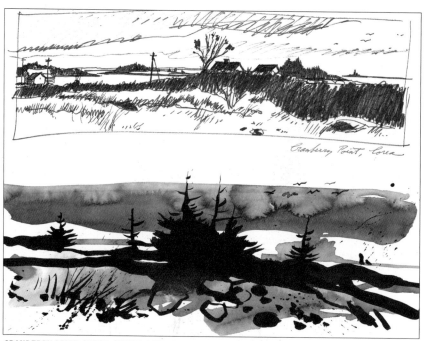

CRANBERRY POINT, COREA, MAINE, 1972, FELT-TIP PEN ON PAPER [ABOVE] AND JAPANESE SUMI INK AND BRUSH ON PAPER [BELOW], 11 × 14".

The drawing above was an on-the-spot drawing. Back at the studio, I did the sumi-e drawing as a variation on the theme from the first sketch. Both sketches refer to the same general subject, but there is material here for two quite different paintings.

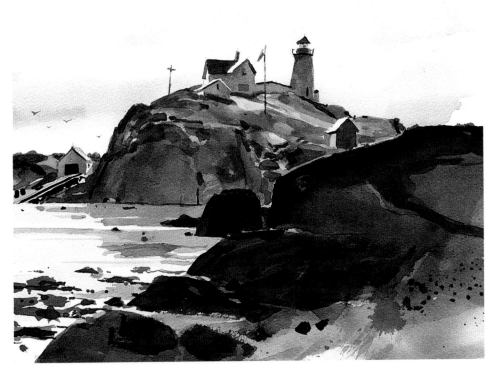

NUBBLE LIGHT, 1972, WATERCOLOR ON 140-LB. WINSOR & NEWTON COLD-PRESSED, 10¼ × 14".

This is a "rehearsal painting," but done in my studio, not on location. I had painted the subject many times before but had never used backlighting. When painting against the light, darks are very closely related to each other, and I wanted to be sure that such subtle value differentiations could be clearly distinguished in the final watercolor. This study was a means of showing myself how the big masses would relate to each other in value, and how to suggest depth and atmosphere between the foreground and the rocks in the middle ground. A rehearsal painting puts you in firmer control of the development of the picture, and in this medium you need all the help you can get.

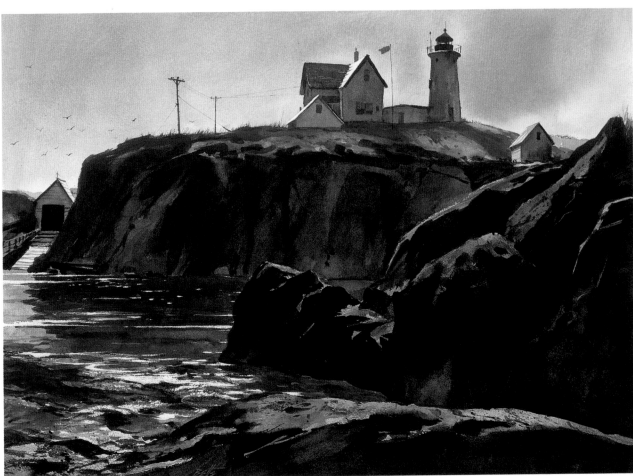

NUBBLE LIGHT, 1972, WATERCOLOR ON 300-LB. ARCHES ROUGH, 22 × 29". COLLECTION OF THE ARTIST.

DRAWING AS PREPARATION FOR PAINTING

It may be possible to leap directly from a sketch into a representational painting, but in abstract painting it is not ordinarily advisable. There should be a period during which the artist mentally absorbs the subject matter, sorting out alternatives, clarifying attitudes and objectives, determining what is to be expressed and by which means. These same processes can be worked out overtly in the form of drawings, and toward the same purposes.

If you find that preparatory studio drawings tend to lessen the force of your creativity while painting— that some of the air is let out of the balloon, so to speak, because you gave everything to the drawings and have nothing left for the actual painting—then it might be best for you to dispense with this phase altogether and prepare yourself for painting through a period of contemplation and meditation. Letting your subconscious faculties work on the material over a long period of time can be just as productive for the creative imagination as days or weeks at the drawing table.

QUARRY STUDY (COLOR-LINE ANALYSIS), DESIGN MARKERS, 11¼ × 18".
Compared with outdoor drawings (see page 20), studio sketches are a way of investigating shape, pattern, and spatial relationships, of moving away from realism to stress the design aspects of the subject. The line in these sketches can be monochromatic, using black ink only, but colored design markers add a bit more visual enjoyment and also begin to suggest how various colors might be brought into play later. The line aspects should be thoroughly studied before going ahead with value and color treatment. Remember that markers will fade, and that such drawings are simply for the artist's own use and should not be hung on walls. (Refer also to page 121.)

Ink painted through tissue paper. With the outdoor sketches behind me, the time comes for playing with ideas and exploring various ways of creating imagery through experimental technical methods. One such method is to paint with ink or acrylics on tissue paper that has been placed upon a sheet of drawing paper: With the tissue being so thin, it lets most of the paint soak through onto the paper beneath it. In doing so, accidental edges and curiously mottled textures are created, and I often find these a stimulating source of pictorial ideas.

Transfer method (acrylic paint on illustration board). An alternate way to arrive at accidental forms that lead to picture ideas is to paint freely on newspaper, then quickly flip it over and transfer the ink or paint to the picture surface. This could be considered the ultimate form of doodling, but automatist techniques such as these are not only a legitimate means of stimulating the imagination in a search for unexpected new forms and relationships, they are also a way of breaking old habits of drawing so as to be free to engage in the challenge of improvisational drawing.

ROCKS AND PINES, 1968, INK ON PAPER, 12 × 18". PRIVATE COLLECTION.

When an assortment of accidental brushstrokes of ink or acrylics is painted through tissue, or transferred from newspaper to the surface of a drawing, it is often possible to push it toward recognizable forms, as in this case. It is a matter of being able to capitalize on free play and put random marks to more serious use.

ROCK CLUSTER, 1992, INK ON PAPER, 8 1/4 × 11".

The principal black forms were painted through tissue paper, then washes of tone, followed finally by linear elements that helped give meaning to the drawing.

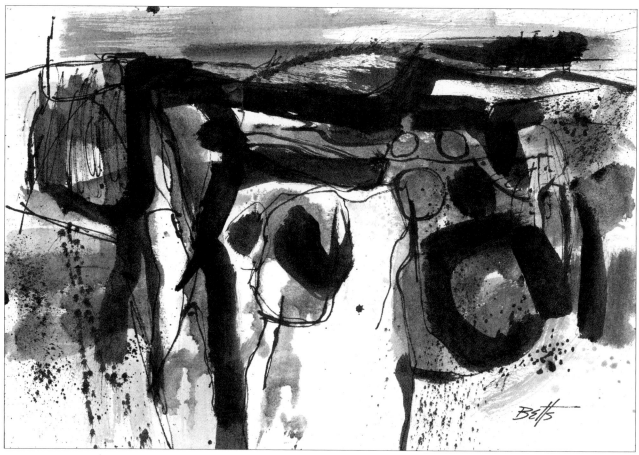

ROCKS AT STILLWATER COVE, PEBBLE BEACH, 1971, ACRYLIC, INK, AND WASH ON 200-LB. WATCHUNG ROUGH, 15 × 22".

Drawings, as opposed to *sketches,* are fully developed to the point of being self-contained works of art, not just the raw material. In doing these drawings I painted the gray washes first, added the black gestural strokes later, and the ink lines (drawn with a sharp twig) last of all. There was no preliminary idea in mind, no preparatory blocking-in in pencil; I simply worked in a relaxed manner, following wherever the drawing led me, but always with the rocks or arroyo at the back of my mind.

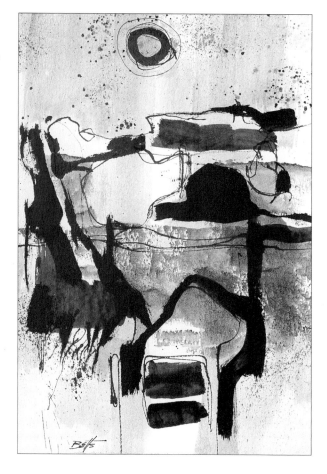

ROCKS AT STILLWATER COVE 2, 1971, ACRYLIC, INK, AND WASH ON 200-LB. WATCHUNG ROUGH, 22 × 15".

30

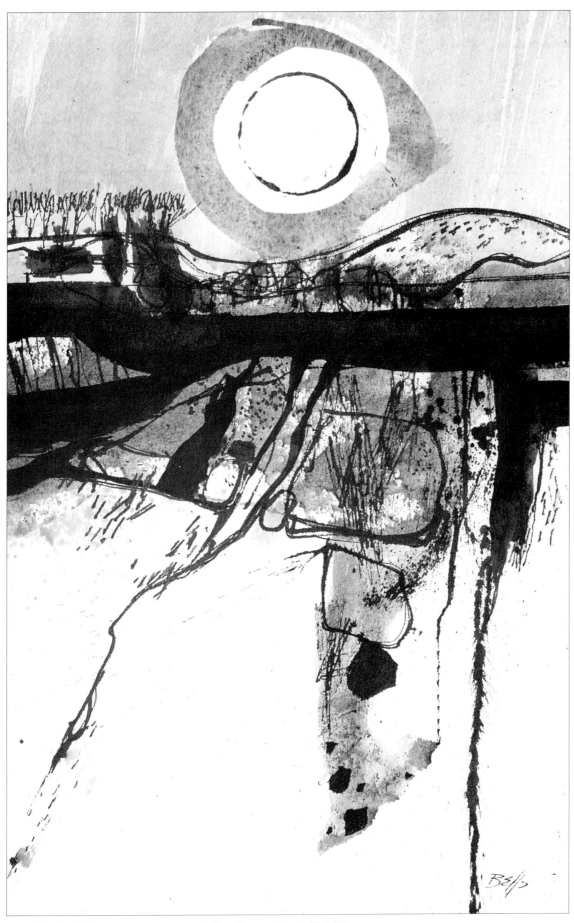

ARROYO SECO, 1971, ACRYLIC, INK, AND WASH ON 200-LB. WATCHUNG ROUGH, 22 × 15".

EXPLORING THE SUBJECT THROUGH DRAWING

If you choose to do sketches and studies as a means of exploring your subject, there are three general approaches.

Analysis

The first approach to drawing is more or less intellectual: analyzing the motif in regard to line, shape, and value.

Line analysis can range anywhere from severely simplified contour drawings to a very complex, overall linear network, depending on which seems best to express the subject.

Shape analysis is concerned with simplifying, distorting, and overlapping shapes, changing their scale, and examining how they can be related to each other. The artist plans a wide range of shape sizes and sets up oppositions that range from tiny areas to large, open spaces.

Value analysis is important for planning the total pattern, for working out a contrast of values from shape to shape. The aim here is a constant alternation of lights and darks throughout the entire surface, which is designed so that no two areas of similar value are adjacent to each other.

Breakup and Reorganization

In the second approach to drawing, the subject is broken down, pulled apart, shifted about, and put back together in another order. This is comparable to smashing an object on the floor and then reassembling all the shattered parts into a different structure that is more aesthetically effective than the original form. Some artists even tear or cut up a drawing and push the pieces of paper around into arrangements that suggest new approaches to their composition. This is one way of getting out of stale habits and allowing unpremeditated combinations of parts in the drawing to provoke further creative decisions.

Intuitive Drawings

The third approach to drawing is intuitional, evoking a flow of ideas by doing a series of variations on a theme in spontaneous fashion. Feel your way into the motif; try out all sorts of wild notions, however impractical they may seem. Work quickly, keeping your mind open and pliable, ready to be stimulated. As the sketches pile up, select and reject rigorously: Which sketches have genuine promise? Which ones are personal solutions and which are clichés?

In these drawings you may even reverse the standard procedure: Begin with seemingly aimless forms and gradually direct the picture back toward recognizable images; the subject is implied rather than described or identified.

The act of painting must be prepared for, but your aim should be to provide yourself with general, not specific, solutions before you begin painting. If all your conceptual and technical problems are too completely solved at this stage, you may find that the painting is merely a stiffly rendered version, a mechanical filling-in, executed without a sense of real involvement on your part.

Conserve yourself in the drawings. Leave a few things unresolved. You will be sure enough about your own intentions and feelings, and about the general format, so that while you are painting there will be no fumbling or indecision. Instead of plodding through the picture unthinkingly, you will preserve the risk and excitement of dealing with unexpected situations and the chance to project with intensity and enthusiasm your original responses to your subject.

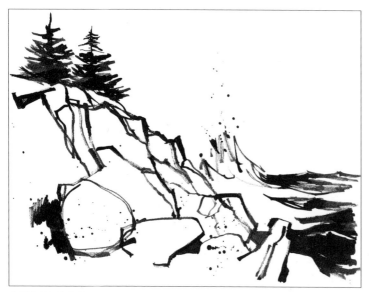

CLIFFS AND SURF, MONHEGAN 1, 1964, INK ON 98-LB. PAPER, 11 × 14".

In these two drawings, done back at my studio, I began exploring the motif, playing with variations of the rock and boulder forms and making more of the surf to add drama and action. That idea in turn suggested the vertical format and emphasized the abstract qualities of the subject. In a way, the basic look of the initial phases had not changed, but at the same time a lot had changed. It's a question of being ready and willing to flow along with whatever notions arise out of this analytical and exploratory stage of putting together a finished painting.

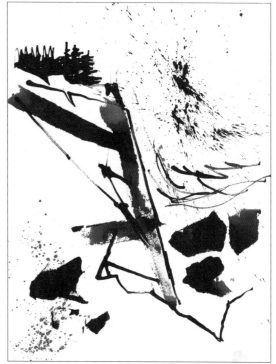

CLIFFS AND SURF, MONHEGAN 2, 1964, INK ON 98-LB. PAPER, 14 × 11".

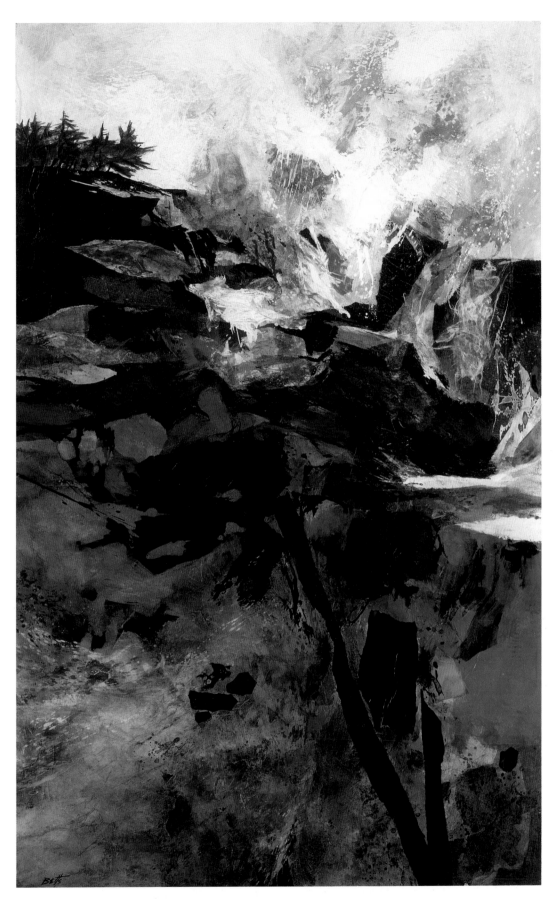

NORTHEASTER, MONHEGAN, 1964, MIXED MEDIA ON MASONITE, 48 × 30". PRIVATE COLLECTION.

The studio sketches opened the way toward a more creative approach to handling a traditional subject. In the painting the rock forms were freely rearranged and the ocean spray was purposely exaggerated. Nevertheless, the completed picture, though it is an expressive interpretation of the pencil sketch, bears a close compositional relation to the drawing without mindlessly repeating or imitating it.

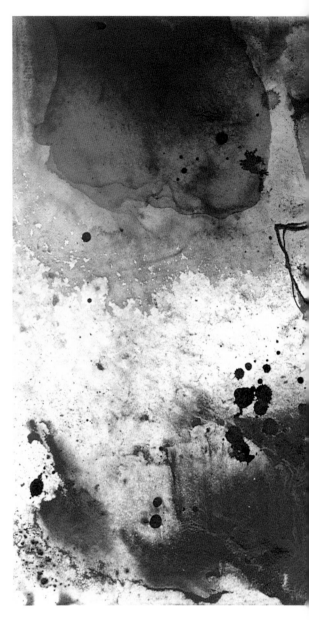

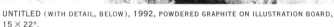

UNTITLED (WITH DETAIL, BELOW), 1992, POWDERED GRAPHITE ON ILLUSTRATION BOARD, 15 × 22".

Another form of exploratory drawing is to shake powdered graphite sparingly onto paper or illustration board, then spray it with water or with diluted acrylic medium. Water is not much of a binder, so the graphite image has to be sealed in place with an all-purpose fixative; that is not necessary when using diluted acrylic medium, which is an excellent binder. The water spray allows some of the fine graphite particles to remain in place in dense, dark clusters, whereas others spread and drift, forming unpredictably fascinating textural effects with a wide range of values, from solid blacks to the most delicate filmy grays. Unexpected blendings of edges and textures produce a rich variety of surfaces and suggest many creative avenues to pursue in developing a composition that evokes recognizable forms.

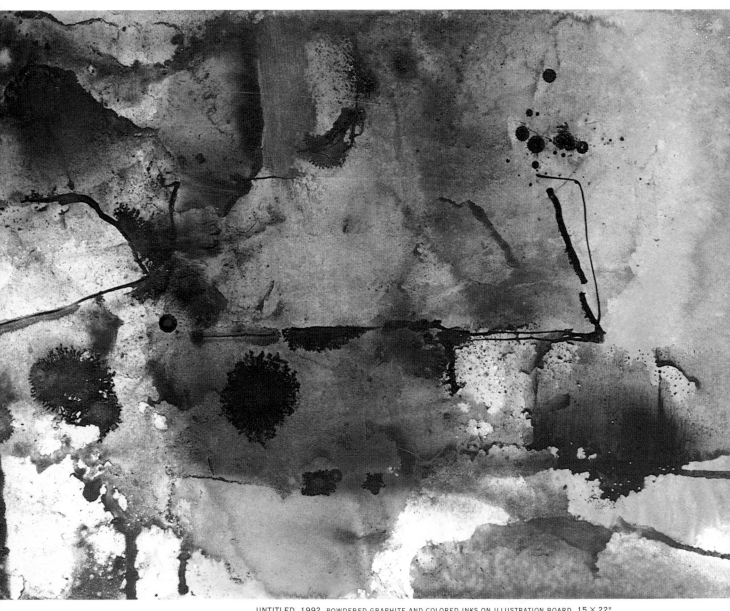

UNTITLED, 1992, POWDERED GRAPHITE AND COLORED INKS ON ILLUSTRATION BOARD, 15 × 22".

When applying color glazes over graphite, line, form, and pattern must be fully established in the first stage, then followed with transparent color washes as the final stage—a complete separation of value and color layers. I make sure the graphite is sealed off with fixative or diluted acrylic medium before brushing on thin acrylic paint, ink, or watercolor.

SUNCOAST, 1974, ACRYLIC ON MASONITE, 17¼ × 26". PRIVATE COLLECTION.

This painting was begun improvisationally without any subject in mind. The area that first fell into place was the top section of the composition, suggesting sea or sky. When the developing yellows began to suggest dunes or beach, I referred briefly to both my sketchbooks and my photographic files in order to check on various possibilities as to shape and design. Freshly armed with these reminders of beach configurations, I put away the snapshots (all black-and-white) and concentrated on creating color patterns and painterly surfaces that referred only generally to the coastal theme. The photos had served their purpose but were not allowed to stifle the creative process.

WORKING CREATIVELY FROM PHOTOGRAPHS

Some artists look upon the camera as a form of cheating; others consider it a boon to modern painters in that it liberates them from having to imitate nature and leaves them free to spend their efforts in more profoundly creative pursuits. Of course, the artist's use of mechanical aids in drawing goes back many centuries. Leonardo da Vinci was well acquainted with the camera obscura, and there is good reason to believe that Vermeer and others of his period used a similar device.

After the invention of the camera in the nineteenth century, photographs were used as a source of reference by such artists as Delacroix, Degas, Cézanne, Eakins, Toulouse-Lautrec, and Sickert. In more recent times, photographs have inspired such noted artists as Charles Sheeler, Ben Shahn, Francis Bacon, Rico Lebrun, Ellsworth Kelly, and Andy Warhol, to name only a few.

A camera used responsibly and creatively can be a constructive tool for any painter. But the reasons for strong feelings against using cameras in painting are not difficult to imagine. Some painters, and particularly amateurs, tend to use a camera as a substitute for a sketchbook, sparing them the trouble of having to observe carefully and draw skillfully. They rely on photographic effects, deceiving themselves into believing that if something is there in the snapshot or on the color slide, then it certainly must be worth copying into the painting. I've noticed that group shows of exclusively photo-realist painting look as though the entire showing had been painted by one person. The only variable is technical skill, and as we all know, that by itself does not constitute art. And finally, they forget that what the human eye perceives and what the camera sees are two quite different things. The camera view is a distortion, and this is something the inexperienced painter cannot afford to ignore.

There are ways, however, in which the camera can function as a legitimate part of an artist's equipment, providing it plays the part of servant, not master; the artist must feel free (or even obligated) to rearrange and distort, to add or leave out. In other words, he must learn to treat photographic material inventively, and perhaps most important of all, to take his own pictures and not rely exclusively on secondary photo sources such as books, magazines, newspapers, and calendars.

It is far better to respond to your own subject matter, compose it yourself, and photograph it yourself as a record of your experience and with a view to its application to your painting, than to use someone else's photograph, already experienced, composed, and recorded by an eye and a personality other than your own. Gathering source material in second-hand fashion can never lead to the full growth of individual creative talent.

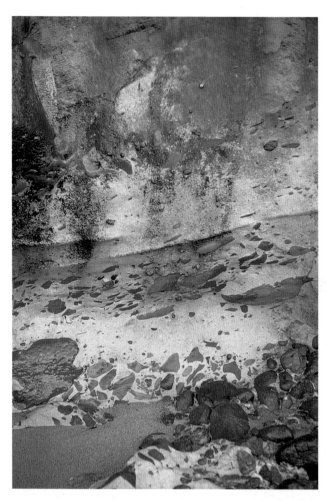

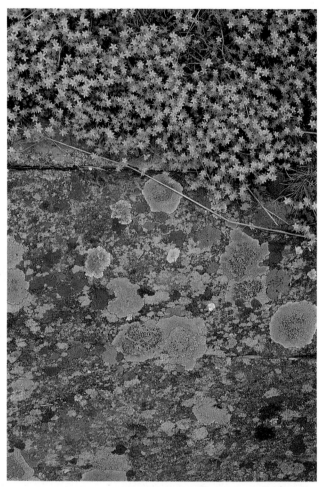

The photographs shown here are a sampling of close-up details of nature that I have taken simply as a record, for no specific purpose other than the fact that I responded to them. They never directly influence a painting, but the awareness of such forms, surfaces, and patterns certainly becomes part of the creative process and a part of the repertory of forms that I constantly draw upon both consciously and unconsciously. In addition to its helping discover and record design in nature, using the camera this way is excellent discipline for developing an eye sensitive to its surroundings. I photograph in both color and black and white; now and then color can be a distraction from a sense of design, while at other times, since I am likely to be unduly influenced by the colors in nature, black-and-white photos leave me freer to depart from reality and invent color.

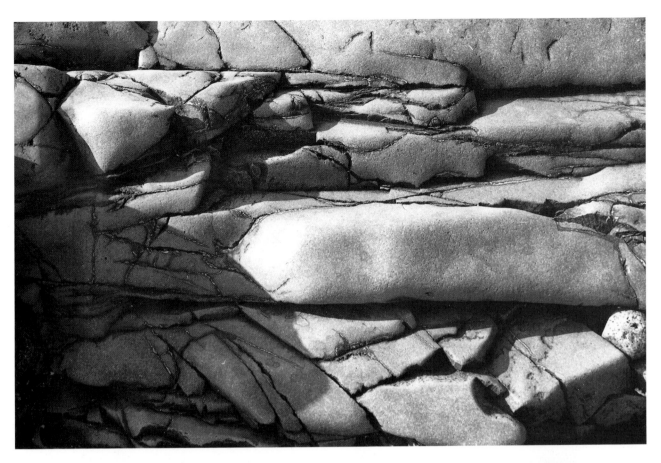

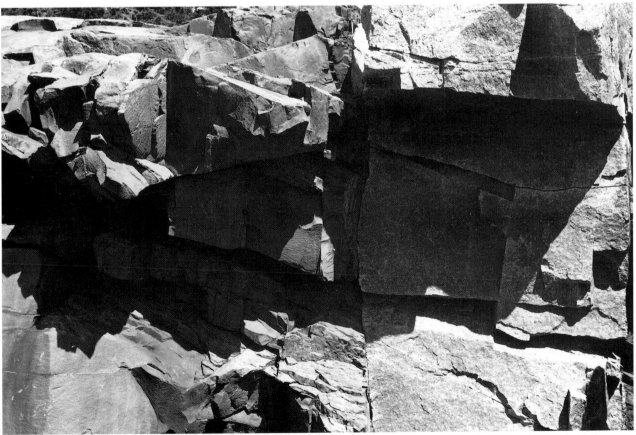

THE CAMERA AS PAINTER'S TOOL

There are two principal uses for the camera by the contemporary painter. First, it can provide a documentation of visual facts—snapshots of nature and details that are an aid to memory—that would be too time-consuming to draw fully in a sketchbook.

Second, the camera is excellent in helping the artist seek out the design that exists in nature, mainly through close-ups that stress pattern and texture.

This development of an awareness of abstract elements and phenomena, found not in panoramas but in the world at our very feet, is bound to have a beneficial effect on the art that results.

I have found that the camera functions most effectively when it is used not just by itself but in conjunction with a sketchbook. The two form a team: The drawing records the look of things to the eye, and the composition is exactly as the artist viewed it and responded to it, with an undistorted sense of the size and scale of things in true relation to each other; the camera records the details and fills in whatever the sketch may have missed. Between the sketch and the photo, just about all the needed material is on record. One without the other might not adequately furnish all the information, jog the memory, or offer insights into ways of synthesizing nature and design.

The camera can be taken along as a routine piece of equipment in gathering source material for paintings, but that does not mean that the sketchbook should be left at home.

Photograph of Grindstone Point at Winter Harbor, Maine. The play of sunlight over the flat slabs of rock appealed to me strongly as a possibility for a watercolor, but time was short and the light was changing. My camera seemed the best method of recording the scene for future reference.

GRINDSTONE POINT, 1972, CONTÉ PENCIL ON PAPER, 8 1/2 × 11".

This sketch took only five minutes, and was done purely as a reminder of my first response to the subject. The glare of late-afternoon light on the rocks contrasted against the dark water at left and the mass of pine trees at right.

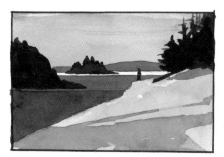

GRINDSTONE POINT (VALUE STUDY), 1973, WINSOR & NEWTON WARM SEPIA WATERCOLOR ON PAPER, 4 3/4 × 7".

Here is another example of painting against the light (see page 27, *Nubble Light*). The close value relationships had to be clearly distinguished from each other—I didn't want any two adjacent areas to be the same value—so it was important to plan the values and degrees of contrast with a great deal of care. Going into this watercolor without a value sketch could have been disastrous.

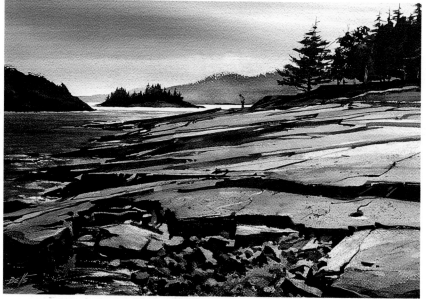

GRINDSTONE POINT, 1973, WATERCOLOR ON 300-LB. ARCHES ROUGH, 17 × 24". PRIVATE COLLECTION.
This watercolor was blocked in very simply with the fewest possible number of pencil lines. I used the photo mainly to get a clear understanding of the structure of the foreground rocks. Note that I tilted the rocks slightly downward to show more of their surface and that I enlarged and rearranged the offshore islands to create stronger forms that would occupy the sheet more fully.

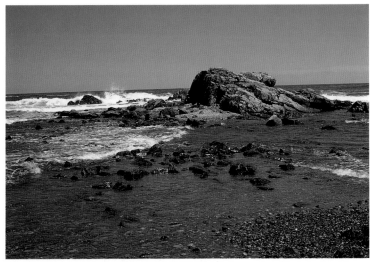

Photograph of Gull Rock at Oarweed Cove. I lived in a shack on this beach for four months and had ample time to study these rocks and the tides that came and went around them. At first glance it would not seem to be too interesting a subject for a painting.

The material contained in the photograph at left was in this case merely the point of departure for creative distortion. The rocks have been freely interpreted: Instead of presenting a rather flat, small silhouette against the sky, and receding back into deep space, the rock forms have been altered to become a strong vertical mass that is closer to the picture plane and provides a more dramatic breakup of the picture area. There is no wasted space here as there is in the photograph, and I did whatever I could to activate the surface with complex shapes, color accents of torn paper, oppositions of opaque passages to those in wet-in-wet, and flung or spattered paint.

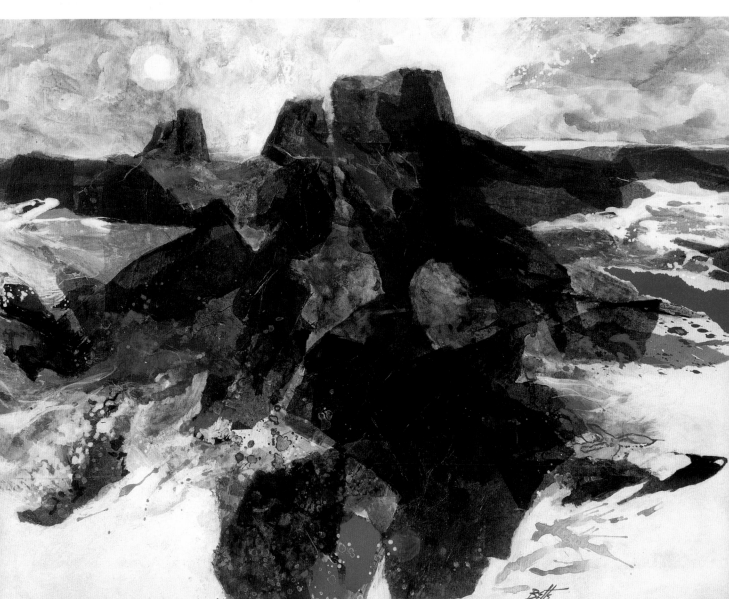

OARWEED COVE, 1966, ACRYLIC AND COLLAGE ON ILLUSTRATION BOARD, 20 × 27". COLLECTION OF THE ARTIST.

Camera

The 35mm single-lens reflex is an extremely versatile camera, and one with which I feel very comfortable. I use a camera frequently, but not so much as a direct source for my painting as simply for recording the things that interest me—a foggy evening in a harbor, lichen on a rock, the depths of tidepools, a three-dimensional collage of junk in a boatyard, patterns in the sand at the water's edge.

I divide my photographic work about equally between color and black and white, but rarely refer to either while I am painting in the studio. The black-and-white prints are occasionally useful in my realistic watercolors or gouaches. For some reason I feel more willing to trust colors to memory or to invent them when referring to black and white; with color slides I am more inclined to feel that the slide is so complete in every sense that it needs no tampering with on my part.

A 35mm camera, because of its convenient size and weight, can be carried anywhere very easily and takes sharp photographs under almost any conditions. Since a camera of this sort can be purchased for as little as $60, it does not by any means have to represent a major expenditure and is

far superior to both the general-purpose "instamatic" type and the single-use disposable camera that is the modern counterpart of the old Kodak Brownie box camera. These are adequate for minimal requirements, but since they have a single fixed exposure setting and are severely limited when it comes to taking close-ups, they cannot be considered very versatile, and the quality of the photos themselves leaves a lot to be desired.

Although I have never used a Polaroid camera, I would think that it might sometimes be an advantage to be able to ascertain on the spot the success of the photo without having to wait for the film to be processed.

When it comes to selecting a camera, the one to buy is the one that best suits your particular purposes and the one you feel most at ease with, whether it be a disposable camera or a Leica.

Film

For black-and-white work outdoors I use Kodak Plus-X film, which is medium speed, very fine grain, and quite adaptable to most light conditions. For work in less than ordinary daylight, a faster film such as Kodak Tri-X (high speed, fine grain) would be advisable.

Since I *never* use a flash attachment, I am referring to photography in which the only light source is natural or

"available" light. Flashbulbs cause glare and flatten out and distort images. To me they are highly objectionable and should be avoided unless very unusual circumstances require their use.

For black-and-white prints I specify the "jumbo" size, which is 3 1/2 by 5 inches, but excellent enlargements up to 8 by 10 inches are also possible.

All my color work is done outdoors. For color slides I prefer Kodachrome 64, which I have found to be extremely accurate in color and very satisfying under a wide variety of light conditions. Color prints can be made from Kodachrome 64 transparencies.

Slide Viewer

Mounted 2-by-2-inch color transparencies are difficult to see without the aid of a slide viewer. I have three of them: a small hand viewer that has to be held up against a strong light, a handheld viewer that operates on either batteries or electric current, and a tabletop model that is a combination viewer and projector.

I use the first of these only for preliminary viewing, to check the quality of the slides and for selection and elimination. The other two viewers are for more general use when referring to slides as the basis for sketches or drawings, or for checking detail or other specific information.

Photographs of Nubble Light, using a 35mm camera with a standard 50mm lens *(near right),* using an 85–210mm telephoto zoom lens *(far right),* and using a panoramic camera *(below).* A telephoto lens is a help in bringing distant objects closer and filling the frame to better advantage. These two snapshots were taken from exactly the same position with the same camera. In the one taken with a telephoto zoom lens, all the information is clearly visible and presented without wasted space, whereas the photo taken with the standard lens includes more of the surroundings than I might really need to remember. The view taken with a panoramic camera was shot from a closer vantage point than that taken with the 35mm camera using the standard 50mm lens, suggesting still another compositional idea for a painting.

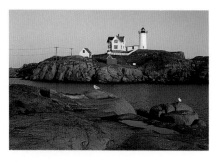

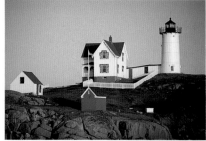

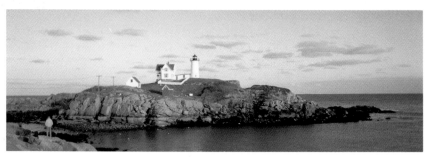

When showing slides for lecture purposes, I use a standard slide projector of the "carousel" variety, but I would never recommend projecting slides as a way of blocking in a painting. For one thing, any distortions present in the slide are perpetuated in the painting. For another, slides inhibit artists' impulses toward creative drawing, and they are less free to make the instinctive, subtle changes that relate the drawing to the rectangle of the sheet of paper on which they are working. Projection is about the most unimaginative method of drawing that I can think of; it should not be seriously considered for any genuinely artistic purpose.

Telephoto Lens

A telephoto lens is extremely helpful in bringing distant subjects closer. In contrast to the regular lens that is part of the camera, the telephoto has a more restricted angle of vision, including less of the subject in the frame than the standard lens. It is thus most useful in cutting out nonessential material and enlarging a distant subject so that it fills the frame to better advantage.

Photograph of surf at Ogunquit, Maine. The purpose of such images is to remind me of surf action—the look and feel of rough water hitting rocks—but these forms, frozen in place, are inadequate to the task of capturing flow and movement.

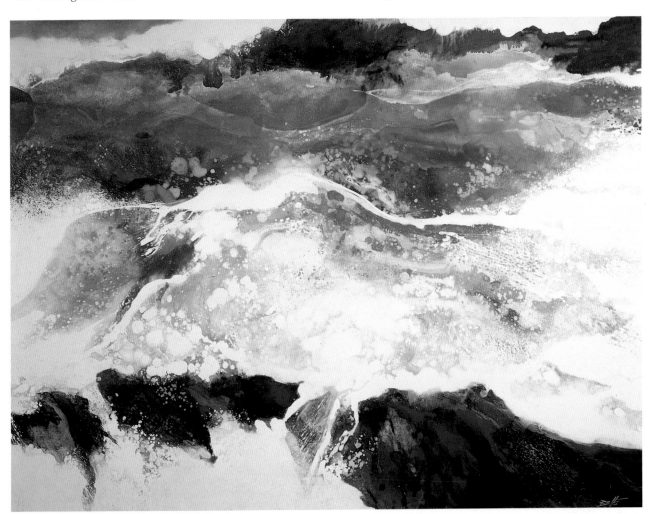

OFFSHORE REEF, 1971, ACRYLIC ON MASONITE, 36 × 48". COLLECTION TUPPERWARE INTERNATIONAL, ORLANDO, FLORIDA.

This is one of my many sea paintings, and possibly my favorite. These seascapes I think of as being abstract *equivalents* of various aspects of the ocean, and all of them have grown out of the natural behavior of the watery acrylic paints as they flow and merge on the picture surface. I had thought that referring to books on waves and oceans or my own photographic files *(see above for an example)* would help inspire me in the development of my seascape paintings, but all of them proved to be useless: There was no substitute for allowing the paint to create spontaneously the forms and motion of the surf with a minimum of interference on my part. Much of this picture resulted from pouring large amounts of thinned pigments onto the panel, then placing full sheets of newspaper on the wet paint and lifting off some color. Depth and transparency were achieved through a succession of multiple layers of color, both glazed and opaque. I worked hard to make the finished picture look as though it had almost painted itself.

PHOTOGRAPHING PAINTINGS

I should mention in passing that I photograph all my paintings for my own records, taking color slides with the 35mm camera. I bind the finished slides on the back with Leitz silver tape to mask out extraneous elements immediately surrounding the painting itself.

Concerning slide submissions to galleries and juries, keep in mind that medium-sized to small paintings photograph better than very large ones: The camera has to be set up at such a distance from a large picture that details, brushstrokes, paint textures, and delicate nuances of edges and blendings are inclined to be lost.

For shooting paintings in black and white, I use a 2 1/4-by-2 1/4-inch twin-lens reflex and 120 roll film, along with tripod and cable release to ensure sharply focused prints. I prefer to photograph paintings outdoors in open shade rather than try to cope with floodlights indoors.

For color work, on the other hand, I shoot pictures in direct sunlight, mainly because the whites seem to come out whiter; in open shade they can look slightly grayed or bluish. As long as the painting is turned away from the sunlight just barely enough to cut out any glare, there will be no undesirable shine reflected from the picture surface. I customarily photograph between the hours of 11:00 A.M. to about 2:30 P.M., summer or winter. And, as always, I *never* use a flash, any time, anywhere.

When it is necessary to photograph through reflective picture glass on a framed painting, see to it that the light is only on the picture but that you and the camera are in dark shade. In the majority of cases there will be an absolute minimum of reflections, or none at all.

FURTHER SUGGESTIONS

Since a camera is only one of several means of collecting material for future paintings, do not allow yourself to become too dependent on it alone or to resort to it too readily. Use it only when you feel you really need it, when circumstances indicate to you that the camera will do the job better than a drawing.

Keep in mind, too, that the camera is not only for documentary purposes. You can also utilize it to sharpen your powers of observation and to expand the range of your design conceptions. Do not shoot pictures at random. Put a great deal of care and thought into the selection and composition of the material. Search out the unusual, make very personal choices, and concentrate on those patterns, forms, and textures that relate to your painting generally.

When referring to the photographs as you draw or paint, treat them casually, as fragments of form, as bits and pieces that may contribute to your work. Do not fall into the trap of sticking too closely to the information they contain. Condense and revise the photographic images into simpler, more abstract forms; translate them, play with them freely to set your mind in motion. As much as possible, think of them more as a creative stimulus than as models that must be rigidly followed.

Turn the photos upside down, change around the dark and light values to suit yourself, combine several elements from several photos into a single drawing. Use them as a starting point for evolving formal relationships that in the long run may bear very little resemblance to the photos from which they originated. Once they have revealed things to you, and once a series of experimental drawings is on its way, the photographic sources can be put away and forgotten. Then the only important consideration is planning toward the painting that lies ahead.

If you use your camera with integrity and imagination as one step in the process of forming your art, there is no need to apologize to anyone.

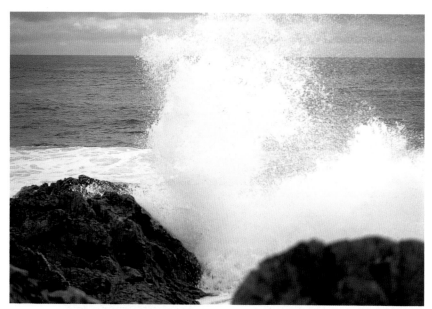

Photograph taken along the Marginal Way, Ogunquit, Maine.

TIDE PASSAGE, 1966, ACRYLIC AND COLLAGE ON MASONITE, 60 × 40". COLLECTION PORTLAND (MAINE) MUSEUM OF ART.

Whenever the surf was high I used to sit on the rocks, watching the incoming waves and studying the textures of granite washed over by sea foam. Rather than include a horizon, which might impart a static, closed quality to the composition, I opened it and used a vertical format that would make the most of the upward thrust of the splash. The Masonite panel was too large for my painting table, so I put it on the floor and worked while bending over it, splashing the paint away from me. Acrylic paint was combined variously with acrylic modeling paste, acrylic gel medium, and tissue and rice papers, along with considerable glazing of colors, to make the picture as much an experience in textures and surfaces as it is an evocation of a coastal storm. If the painting does not intensify, improve on, or in some way transcend its sources, then it is not worth doing.

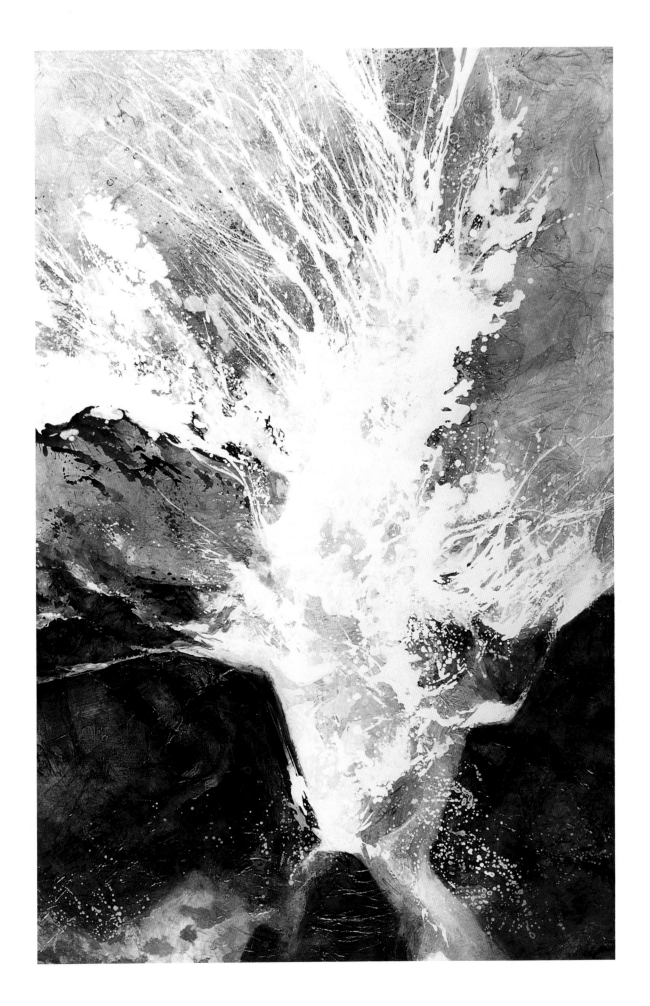

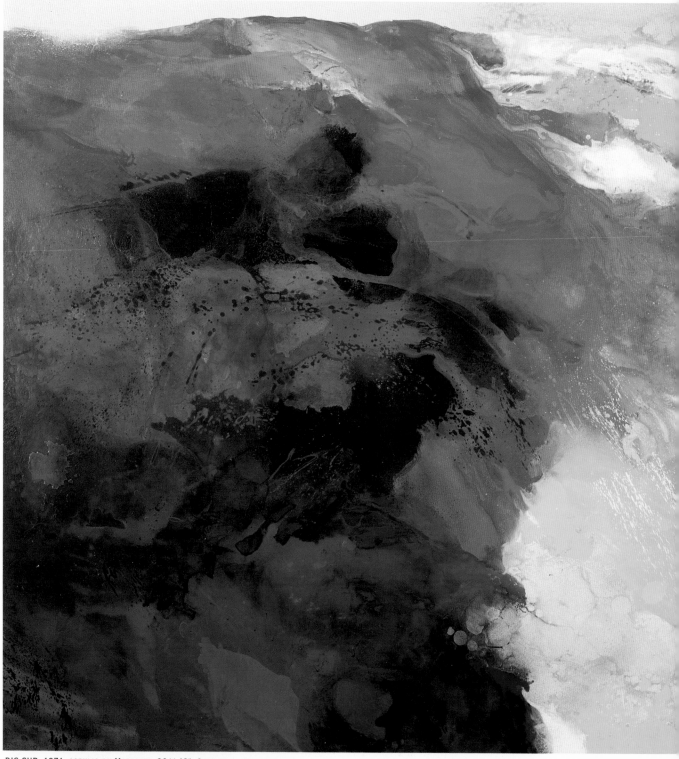

BIG SUR, 1971, ACRYLIC ON MASONITE, 36 × 48". COLLECTION OF THE ARTIST.

My intention here was to capture, from a seagull's-eye view, the sweeping contours of coastal hills dropping to the beach below. The colors of Big Sur tend toward greens and browns, but I chose to work with a range of color that was highly intensified. Most of the paint was applied by pouring then lifting away with newspaper, or pouring and dribbling then spraying with water to cause controlled spreading and flowing.

4
OTHER SOURCES FOR PICTORIAL IMAGES

Aside from direct contact with nature through observation, drawing, and photography, there are other methods of stimulating the creative impulse. In his *Treatise on Painting,* Leonardo da Vinci advised the painter to study "the embers of the fire, or clouds or mud, or other similar objects . . . because from a confusion of shapes the spirit is quickened to new inventions."

Delacroix was widely read in both prose and poetry, and most of his work clearly reflects his knowledge. The British watercolorist Alexander Cozens recommended starting a painting with accidental blots of paint, which would suggest scenes that could be developed and finished in a traditional manner. Degas often used his monotypes, done with blurry and ambiguous shapes, as the beginnings of small landscapes that he elaborated slightly and clarified with touches of pastel.

In the twentieth century, Joan Miró and Paul Klee used automatist techniques to elicit forms and compositions from their personal, subconscious worlds rather than from the outer world. Jean Arp utilized the "laws of chance" in a series of collages, an acceptance of the unplanned and irrational that later characterized much painting during the 1950s.

Many contemporary painters feel that their landscapes come from within and are brought to the surface and given form as a result of any one of a variety of stimuli. The artist's internal world is waiting to be evoked by whatever means the artist finds most productive, and it must be realized that this world is just as important as the outer, visible world. It is quite possible that the truest and most eloquent art is a successful fusion of both these worlds, visible and visionary, each enhancing and reinforcing the other.

Just as perception is one way to start the creative juices flowing, mental stimuli can be another and equally effective prelude to the act of painting.

Memory

In utilizing memory, especially in the production of representational paintings, it is essential to have a deep reservoir of visual experience based on many years of observation of people, places, and things. Memories that are not very broad or deep (and slightly inaccurate) lead to paintings that are not too convincing. If a student brings me a painting that was started outdoors but for one reason or another finished indoors from memory, I can instantly spot which areas were done where—the parts done from memory usually lack the authenticity, the feeling of having been there, that could imbue the picture with a consistent feeling of immediacy and conviction. Paintings done by an artist with a well-trained memory, on the other hand, can be of a very high order indeed.

Another aspect of the use of memory is that nonessentials are eliminated and only essences remain. Memory tends to sift and sort out in a kind of unconscious process of selection, with the result that the artist's mind is not cluttered by trivia that might weaken a picture's total impact. The important elements are retained and emphasized, and the unimportant things that do not contribute to expressivity are subordinated or even omitted altogether. In this way, memory acts as a partner in the intellectual business of ordering and arranging the raw material of art, and it is one good reason why I often favor memory in preference to sketches as a preparation for my paintings.

Memory, when used in conjunction with improvisational painting or drawing methods, can help to identify forms or give the picture a push in the direction of a motif previously seen and experienced. Through memory, a jumble of shapes can be given a reference to recognizable things. In this sense, memory and association are inseparably linked and are a way to order chaos into some kind of form that the spectator can comprehend.

I use memory as a bank from which to draw impressions and images at a later time. These are not necessarily specific details of scenes, but memories of a more general kind: a quality of light, weather, seasons, winds, shorelines, skies, textures of rocks and grasses, coastal fog, the distant glint of a band of light across a shadowed ocean.

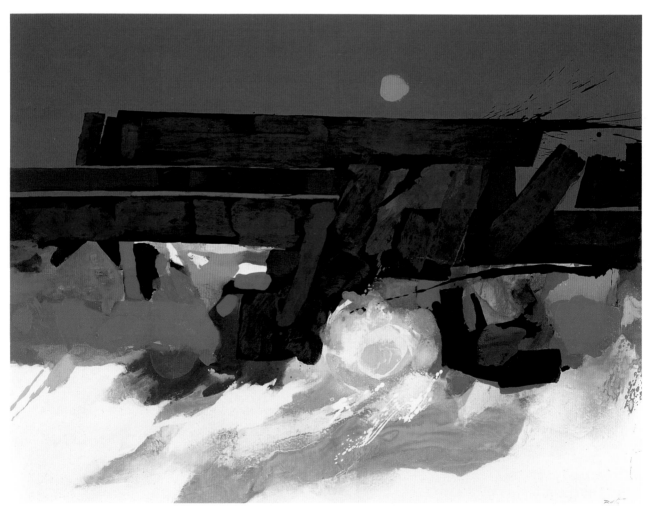

DARK CLIFFS, 1975, ACRYLIC ON MASONITE, 30 × 40". PRIVATE COLLECTION.

Memories of Maine were extremely influential in painting this picture in a beachside studio on Siesta Key in Florida. Here again the picture was begun with no subject in mind, but as I worked, the rocky coast and surf began to appear, and I flowed along with it. The Maine theme was only a point of departure; the play of color against color was my principal enjoyment and concern.

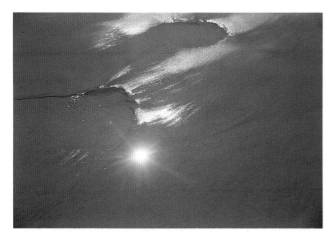

GOLD BEACH, 1973, ACRYLIC ON MASONITE, 18 1/2 × 30". PRIVATE COLLECTION.

During its improvisational beginnings, **Gold Beach** began to remind me of walks on wet sandy beaches in Oregon, and sunlight reflected as blinding spots, along with references to other forms, colors, and relationships I had previously observed in nature *(see photos above, left and right)*. These associations, once identified, serve as a controlling factor for all artistic choices and decisions that have to be made as the painting progresses.

Reading

Reading can also be a source of imagery for painting. I am very fond of the works of Henry Thoreau, Rachel Carson, Henry Beston, Loren Eiseley, and John Hay. Poet Robinson Jeffers has caught the spirit of the Big Sur area in California, and Robert Lowell, Philip Booth, and T. S. Eliot have written various poems that vividly project the mood of the New England coast. The notebooks of Gerard Manley Hopkins contain intensely observed and delineated close-ups of nature, literary parallels to Edward Weston's photographs at Point Lobos. Then, too, there are many references to sea and shore in passages from Herman Melville, Walt Whitman, Joseph Conrad, Virginia Woolf, St. John Perse, Gavin Maxwell, and John Steinbeck, to list a few.

All these and a great many other poets and writers spark my mind to conceive paintings that could be the visual equivalents—but *not* illustrations—of environments, lyrical moods, and human feelings depicted in writing. My finished painting may have no direct reference to the passage that was its inspiration, but the point is that the reading generated something in the way of an abstract mental image, hazy and unformed though it might be, that could be used as a working premise in getting a painting under way.

List of Picture Titles

My studio notebook contains not only a record of my paintings as they are done, month by month and year by year, but also a section devoted to possible titles for paintings. I never title my pictures until they are completely finished, and if by that time I have no definite title in mind I consult the list to see what might be appropriate, something that might furnish a clue to any person viewing the picture as to what was generally in my mind while I was painting it.

The list also performs a second function: It is a springboard for imagery. The list is made up of two main categories: phrases that I have heard or encountered in my reading and those that I have composed myself. Most of them have a poetic quality that I respond strongly to, and they are vague enough to permit a free development of the painting. Here are some titles I have already used: "Passage Into Spring," "Edge of Winter," "Tidemarks," "Island

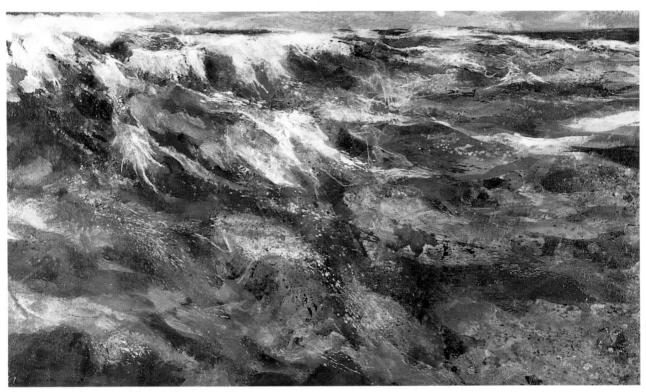

SEA FLOW, 1963, MIXED MEDIA ON MASONITE, 36 × 60".

Pictorial images can be generated by reading. This was painted several weeks after re-reading *The Outermost House.* Henry Beston's writings about beaches and the sea are intensely lyrical and conjure up a wealth of images that are intimately connected with my own memories and observations. I was not thinking of any specific passage while I was painting, though the passage quoted here seems to me a very close parallel to the mood of the painting. But I was thinking about offshore Cape Cod and Maine, Beston's writings, and of course my own remembrances of the ocean's vastness and its surge and flow. All of these elements combine at a mostly unconscious level, and then a picture is born.

The sea has many voices. Listen to the surf, really lend it your ears, and you will hear in it a world of sounds: hollow boomings and heavy roarings, great watery tumblings and tramplings, long hissing seethes, sharp, rifle-shot reports, splashes, whispers, the grinding undertone of stones, and sometimes vocal sounds that might be the half-heard talk of people in the sea. And not only is the great sound varied in the manner of its making, it is also constantly changing its tempo, its pitch, its accent, and its rhythm, being now loud and thundering, now almost placid, now furious, now grave and solemn-slow, now a simple measure, now a rhythm monstrous with a sense of purpose and elemental will.
—Henry Beston, The Outermost House

Memory," "Ledge-Split," "Night Wave," "Morningshore," and "Sea Quarry." And here are titles that have not yet made connections with specific paintings: "Red Coast," "Night Garden," "Dark Rock, Bright Pebble," "Whites of Winter," "Shimmer and Shallows," "Rivermists," and "Coastal Ridge."

Before I start painting for the day, I sometimes check over my title list, and frequently some title will seem particularly arresting or provocative. Associations are brought to mind, and at that moment I am eager to get into my painting, with a clear purpose behind what I will be doing. As we shall see in later chapters, the forms may gradually change into something quite different as the picture progresses, but a reading of the titles kindles my imagination and provides an impetus for work.

Upside-Down Newspaper and Magazine Photos

Another means I use to refresh my compositional ideas is to go through photographic illustrations in magazines and newspapers—holding them upside down—the principal goal being to escape old habits and predictable compositions and to discover new ways of organizing paintings. I squint at the photo with my eyes nearly closed, so that the composition is reduced to its simplest elements.

Many photographs that are perfectly ordinary when viewed in their normal position can offer quite unexpected and exciting designs when seen upside down or on their side. It is a way of looking at them with the subjects disguised or eliminated, so that it is possible to consider the photos strictly as arrangements of mass and pattern that can be enjoyed for their abstract qualities.

Striking distributions of shapes and of large, open spaces in opposition to clusters of small forms, as well as the interplay of line against mass, can suggest not only ways of dividing up a picture surface but also ideas as to the actual subject matter of a painting. Once the painting begins to evolve, I set the clipping aside.

A photograph from my "upside-down" file. *AP/Wide World Photo.*

BARCELONA I, 1992, ACRYLIC AND COLLAGE ON ILLUSTRATION BOARD, 15 × 11 3/4".

This painting was based on the photograph above. Note that I made no attempt to copy the photograph, but used it rather as a springboard for the painted version. The photo is merely a stimulus, a means of spurring the imagination to arrive at an image that can stand by itself.

Magazine Photos Treated with Lacquer Thinner

A variation on the techniques of improvisational drawing is the treatment of magazine photographs with swipes, spatters, or splashes of lacquer thinner, followed immediately by wiping with a paint rag or paper towel. When used on glossy magazine pages, this treatment yields a variety of accidentally arrived-at compositions that serve as still another means of beginning an abstract painting.

The lacquer thinner dissolves and lifts the printed inks, black-and-white or colored, and leaves the page with intriguing shapes, patterns, and transitions. The original subject matter of the photo is lost completely; what remains is a loosely formed composition that quite often is something to which the creative imagination can respond. Some of these exercises I toss out immediately, but many others are kept for future reference. Whether or not I ever use them in paintings, as a file of compositional variations they are another way to stimulate my mind, getting my form concepts in readiness for another day's painting.

Photomicrographs and Aerial Photographs

Although I am opposed to using secondary photo sources, there are two exceptions I would allow, although even in these instances I would never recommend direct copying. I refer here to two kinds of photographs that represent extreme opposites of scale: photomicrography and aerial photography.

Artists have been aware for some time of images recorded from the air or outer space and images made visible under the microscope. In both cases there is now available to us an astonishing wealth of abstract color structures, patterns, and textures, all of which have close affinities with the field of contemporary art. In many cases these photos could easily be mistaken for actual paintings. Science, then, has revealed to the artist whole new worlds of forms, other environments that provide rich, new sources of signs and symbols.

As I have said before, this does not mean that as painters we simply copy the forms seen in these photographs. They are not to be imitated literally but to be used as a basis for interpretation and transformation into symbols, structures, and surfaces that can be employed to arrive at an art that has greater powers of suggestion and expression.

I enjoy looking at these photographs in the same way that I enjoy looking at paintings in a gallery or in a book. They are aesthetically satisfying, and the ones that affect me most either possess very strong design qualities or a deeply poetic feeling. They might influence my concept of form, space, and color, but they are too beautiful and too complete to tempt me to try to improve on them. I accept them for what they are, enjoy them fully, and absorb and assimilate whatever they have to offer me, storing them all within me until such time as they may seem pertinent to the picture I happen to be working on. In the meantime, they may suggest an overall layout or format for a painting about to be undertaken. Once the picture is on its way, however, it will take its own form and the photograph will no longer be relevant to it.

A page clipped from a fashion magazine, then brushed and spattered with lacquer thinner and wiped immediately with a rag. Viewing these kinds of images is not a psychological test, but a method of dredging up associations and ideas that might lead to a painting.

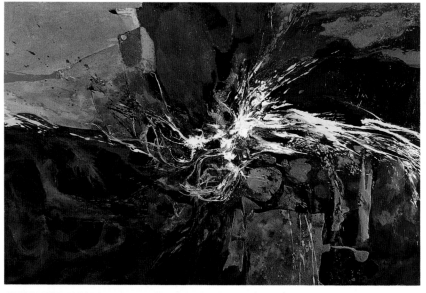

COASTAL REEF, 1964, MIXED MEDIA ON MASONITE, 32 × 48". COLLECTION ATLANTA UNIVERSITY, ATLANTA, GEORGIA.

I no longer have at hand the page treated with lacquer thinner that was the specific stimulus for this painting, but it was very similar to the one shown at left. I was not interested in repeating the blobs and spatters in the treated photo, but the general composition seemed to me to contain the bare bones of a painting, and from there it was a matter of filling it out, rearranging it, and allowing the media used (acrylic, sand, and rice paper) to further affect the character of the forms. Every once in a while I glue one of these treated photos to illustration board, and responding to its patterns I paint into it until a satisfying image emerges.

Los Angeles from space. *Courtesy Spaceshots, Inc., Studio City, California.*

Landsat false-color composite of Williams, California. *Courtesy Department of the Interior, United States Geological Survey, Reston, Virginia.*

San Francisco from space. *Courtesy Spaceshots, Inc., Studio City, California.*

Color-infrared photograph taken near Burlington, Vermont. *Courtesy Department of the Interior, United States Geological Survey, Reston, Virginia.*

Abstract qualities are evident in aerial and space photographs, with their geometric shape relationships and surface divisions, textured areas of land, flat zones of blue water, hard and soft edges, and linear elements playing against large masses, all of which function as parts of an immense organic design. Additionally intriguing to an artist are color-infrared photographs, which depart radically from naturalistic color. Such alterations and distortions ultimately broaden the possibilities of color enhancement, not only in terms of an imaginative view of our world from the air, but also in terms of creating a purely painterly world of shape, color, and texture that can be totally independent of its actual geological sources. Images such as these can serve as indirect sources of inspiration, but nothing more than just that.

WINTER MIST, 1969, ACRYLIC ON MASONITE, 40 × 50". COLLECTION CENTRAL TRUST BANK, JEFFERSON CITY, MISSOURI.

Almost from the start, **Winter Mist** took on the look of an aerial view. I was frequently a passenger on military glider flights during World War II, and aerial views have always fascinated me. While I was painting this picture I was thinking specifically of fog drifting in over Point Lobos, just south of Carmel, California, with the ocean rolling in at the bottom of the painting, a land mass in the central area, and gray mists at upper left. Even if there is no available landscape motif as definite as that, a perusal of aerial photographs can suggest forms and compositions that provide the artist with a general format out of which a painting can be begun, no matter what course it may take later.

STUDIO EXPERIMENTATION

Think of your studio as a laboratory, a place to conduct visual and technical experiments. I don't know of any major artists who stay rooted in one place; they are constantly exploring, growing, inquiring, developing, changing. This is in contrast to amateurs who want to find the foolproof way to guarantee successful paintings, the surefire technical method; having found it,

they sit back and endlessly repeat the same techniques and viewpoints.

Your studio should be a workplace, certainly, but aside from your regular artistic production it should also be a place where you do not always feel on public view, a haven for privately experimenting not only with various materials and techniques, but with ideas and concepts as well. Try something you're almost sure is crazy, and if it proves not to be a success, no one need

ever be the wiser. Take chances, take risks, sample unpredictable possibilities; don't worry about what is acceptable to your friends and to exhibition juries. Be playful, be genuinely carefree and reckless, and you will frequently come to know what is called "serendipity": discovering something better than what you had set out to find. Having stumbled onto such discoveries, use them to improve and enrich your art. Don't stand still. Stay restless.

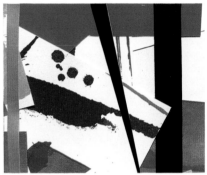
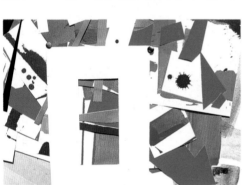

(Far left, top) Random assortment of remnants cut from old paintings and experimental exercises on 80-lb. Strathmore Aquarius. These fragments can serve as the raw material for a group of collages, or, as a variation, a white matboard "frame" can be moved around on the surface to locate and isolate areas that might suggest a design or composition *(far left, bottom)*. *(Near left and above)* Close-up segments that show promise as to a possible design structure for a painting. Realistic subject matter is frequently lying in wait to be discovered by the discerning eye.

For an art association's annual art auction here in Maine, the artist members draw or paint small compositions on illustration board that serve as auction bidding cards during the auction itself, then later are usually framed and hung by their owners. The bidding card shown here is typical of my own contributions to the selection of bidding cards offered each year. The unforeseen happy consequence of my doing them, however, is my embarking on an ongoing series of small paintings collectively titled "Divertimenti." These playful experiments introduced me to a vein of work, intimate in scale, partly calculated and partly improvised, in which I continue to take great enjoyment.

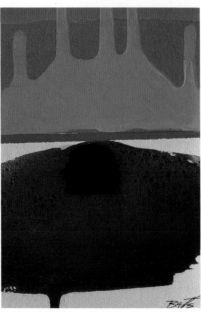

AUCTION BIDDING CARD, 1991, ACRYLIC ON ILLUSTRATION BOARD, 7 × 5". PRIVATE COLLECTION.

STORM SIGNAL (DIVERTIMENTO #4), 1992, ACRYLIC ON ILLUSTRATION BOARD, 7 × 5". COLLECTION OF THE ARTIST.

OTHER SUGGESTIONS

Each artist finds personal sources from which to work up ideas for paintings. You may find that listening to music can be very rewarding in that respect—perhaps especially those composers, such as Delius, Debussy, Sibelius, or Mahler, whose works are most evocative of nature and its moods and atmospheric effects. Or you might try some of the works of Stravinsky, Ravel, de Falla, Holst, Ives, Copland, or Barber. Remember, however, this is not "music to paint by" but a point of departure for devising visual equivalents, which might range anywhere from implications of landscape to nonobjective compositions.

Study reflections in water or the way flowers and other objects cast shadows diagonally across a wall; make rubbings; invent improvisational methods of your own. Be aware of design possibilities all around you. Keep yourself exceptionally alert to any source, however unorthodox or unexpected, that arouses in you the urge to paint.

UNTITLED, 1992, WATERCOLOR AND COLLAGE ON 80-LB. STRATHMORE AQUARIUS ROUGH, 6 × 9".

Two separate fragments have been reconstituted into an image that is completely unrelated to their original contexts. Privately I think of this as "Edge of the Sea" or "Beach Forms," but at this stage and in this form it hardly deserves a title except possibly as a reminder of what it might someday become.

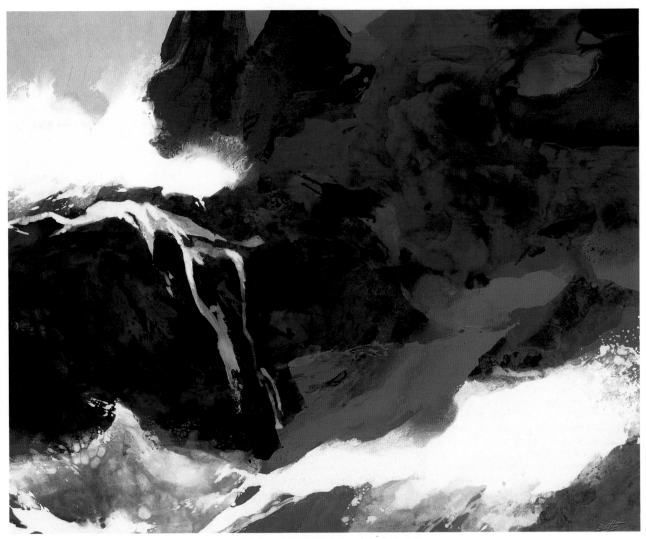

NORTHCOAST, 1983, ACRYLIC ON MASONITE, 40 × 50". COLLECTION THE SOUTHLAND CORPORATION, DALLAS, TEXAS.

Music is sometimes a source of inspiration for an artist, though a particular musical composition should never be *illustrated* literally. The more formalized the style of the music, the less it lends itself to visual treatment. A sea painting could result from listening to pieces such as Debussy's "La Mer," Chausson's "Poème de l'amour et de la mer," or Britten's "Four Sea Interludes." That was not the case here, as it happens, but artists should use whatever means are at hand to assist creative activity. A painting is more important than its sources—or its painter.

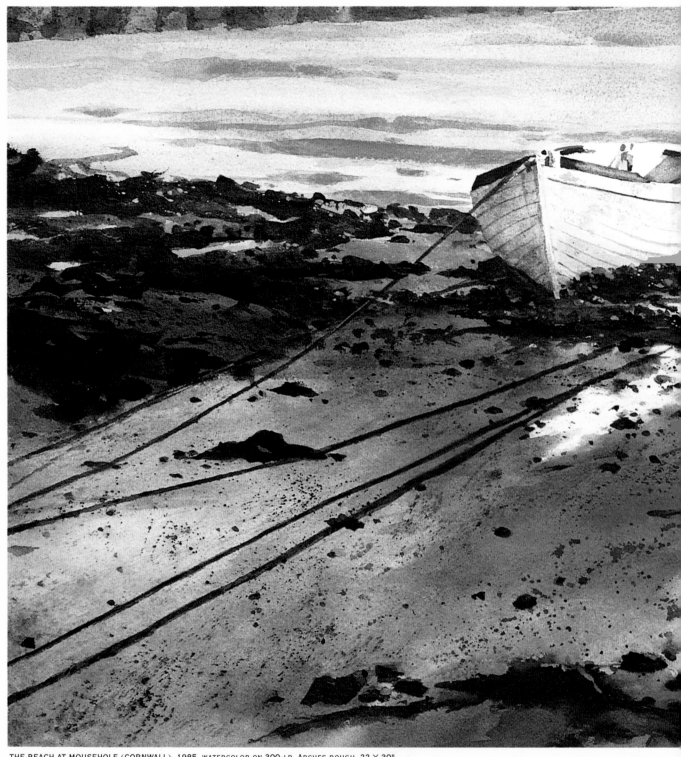

THE BEACH AT MOUSEHOLE (CORNWALL), 1985, WATERCOLOR ON 300-LB. ARCHES ROUGH, 22 × 30".
PRIVATE COLLECTION.

The gleaming white reflected in the wet sand was the whole reason for painting this scene.
It took some fancy footwork and some races against time to manage the interplay of hard and
soft edges in the foreground; there had to be subtle variations of light and dark in the sand
itself, which in turn had to be planned to dry to the correct value before darker rocks and
seaweed could be painted in. At times I felt as though another set of hands would have been a
great help. It was important to me not to let the signs of struggle show in the finished painting.

5

TRANSPARENT WATERCOLOR

My feelings about my own work in watercolor have always been a little mixed. On one hand, I have always felt the greatest enjoyment in using this medium, and for all the usual reasons: its speed, sparkle, luminosity, and freshness. Contrary to its general reputation, watercolor has never struck me as being difficult. The reason why many painters find it a demanding medium is because there is very limited latitude for change and correction, or for improvising as you go along.

I am completely self-taught as a watercolorist, learning what I could simply by reading instructional books and constantly studying watercolor paintings at national exhibitions. My technique is based on the traditional methods that reflect the basic watercolor styles of Winslow Homer and John Singer Sargent, both outstanding masters of this medium. Unfortunately, however, the two of them virtually set the pattern for several generations of American watercolorists, many of whom paint so much alike they are almost indistinguishable from one another.

My reservations about my own watercolors are based on the fact that my style is very similar indeed to that of a great many other painters who are far more technically accomplished than I; simply put, the watercolors are not as personal in approach as my acrylic abstractions. I have come to accept my transparent watercolors as a separate part of my art production: a means of staying in frequent contact with nature and sharpening my perception, and a form of recreation. Since this reduces my use of watercolor to preliminary exercises for more ambitious statements, or to little more than an activity engaged in for personal pleasure, I have made no effort at all to exhibit my watercolors nationally, and indeed do fewer of them each year.

Let us consider in the next few chapters the various options available to the advanced watercolorist, starting first with watercolor used as transparent medium, and always keeping in mind that there is more than one way to paint a watercolor.

Paper

The papers I use most regularly are the handmade, imported French Arches 300-lb. rough or 140-lb. cold-pressed. I choose the latter when I am aiming for more subtlety and nuance in the washes. I am also very fond of R.W.S. (Royal Watercolour Society) 300-lb. rough, which is handmade English paper with a beautiful surface that is a shade whiter than Arches. It does not take scratching with a razor blade very well, however; the surface tends to shred rather than to scrape smooth and clean.

I am assuming the reader is already well acquainted with the various papers, both domestic and imported. If not, it is advisable to acquire some sheets produced by different paper manufacturers and discover as soon as possible which papers seem to give the best results—which are the most enjoyable to work on, and which ones not only take color well but also retain their sparkle. Other papers that I can recommend are the Fabriano 300-lb. rough or 140-lb. cold-pressed; Whatman in as heavy a weight as is obtainable (this fine paper is no longer made, but now and then there is a chance of finding it in some art stores); or some of the Japanese white rice papers, such as Sekishu or Kozo, both of which come in a 25-by-39-inch size. Strathmore makes a synthetic paper called "Aquarius," whose major advantage is that it never requires stretching.

Standard or imperial-size watercolor paper is 22 by 30 inches, but the double-elephant-size Arches comes in a 240-lb. weight and measures 26 by 40 inches. Despite its size, it is quite reasonable in price, especially considering that it is possible to use it full size for major works, to divide up a sheet into quite a number of smaller sizes, or to cut unusually proportioned sheets that are not as easily obtained from the standard-size papers.

Economizing on paper is foolish to say the least. The cheaper, lighter papers do not take brushwork or color very well, and the machine-made papers have a monotonous surface texture. A fine paper, however, can make the most casual brushstroke look more beautiful than it actually is. Even a beginner in watercolor should use the best quality paper he can afford. Cheap paper will not in any way enhance the look of the painting and the money saved is not worth the time that may be wasted.

Brushes

This another item where quality should be considered before cost. If properly cared for, a watercolor brush of fine quality can last almost indefinitely—I am still using two that I have had since 1935—so it is worth purchasing brushes with the attitude that they are a lifetime investment. If brushes are rinsed thoroughly at the end of each painting session, washed with mild soap and warm water about once a month, and carefully shaped before drying, they will give many years of use. Cheap watercolor brushes have very little spring or resilience, lose their point relatively soon, and in general deteriorate quickly.

The brushes I use are Kolinsky sables Nos. 24, 16, 12, 9, and 4, and 2-inch and 1 1/4-inch flat sable brushes. In addition to those basic brushes, I have an assortment of enormous brushes that I acquired in China a few years ago.

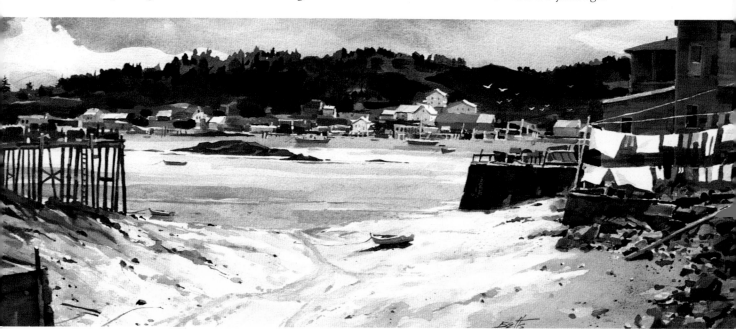

HARBOR TOWN, 1990, WATERCOLOR ON 240-LB. ARCHES ROUGH, 11 × 28". PRIVATE COLLECTION.

The principal reason for doing this painting was, of course, the laundry flapping in the breeze. Therefore, following a well-known compositional strategy, it was in that area that I set up the maximum contrast of strongest lights against strongest darks in order to direct the viewer's eye where I wanted it. The distant buildings are not painted with as much detail as they appear to be, in much the same way that the foreground rocks are slightly out of focus.

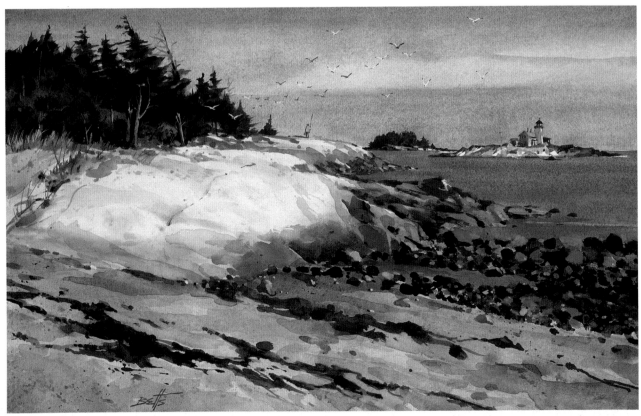

MAINE COAST, 1990, WATERCOLOR ON 140-LB. ARCHES COLD-PRESSED, 14 × 22".

What initially intrigued me about this scene were the large light rock and the sloping diagonals of the beach. The light tone of the rock was heightened by the use of darks all around it—trees, sky, water, beach stones, and the beach itself—so that no other light areas competed with the rock that was the main interest (but not a "focal point"). The small stones at the edge of the beach at right were done with dabs of opaque color, which also appears in the tree trunks and branches at upper left.

Palette

For many years I used a folding metal watercolor sketchbox as my palette. Later I switched to an enamel butcher's tray. Most recently, however, I have come to prefer a 12-by-16-inch plastic watercolor palette, rimmed with depressions for holding the pigments and having four large mixing areas in the center. The main advantage of such a design is that the paint mixtures are well separated from the pigment compartments and the paints cannot flow into each other. Adequate mixing space is the first thing to look for in selecting a palette; the one I use has plenty of mixing areas and more than a sufficient number of depressions to hold the number of paints I set out.

My system of laying out paints for both oil and watercolor was standardized early in my career. Raw sienna and burnt sienna are in the lower left-hand corner; the greens and blues are along the left-hand edge of the palette; and across the far side of the palette are the warm colors, yellows at the left, oranges, and then reds over toward the right. The particular system used is not as important as that it be a *consistent* system, so that while painting the brush automatically heads in the direction of a specific color like a homing pigeon. This should be so instinctive that no precious time is lost in trying to figure out where the color has been set out.

Drawing Boards

No matter how heavy my paper, I always stretch it before painting. I make a habit of keeping seven or eight sheets stretched in advance on drawing boards, thin plywood, Celotex, or Upson board. I prefer to use gummed tape to attach the dampened paper to the board, though there are some papers that buckle so severely when wet that only staples or thumbtacks are effective. The fiber boards such as Celotex, Homasote,

or Upson are so porous and loose in texture that tacks will not grip tightly, and taping is the only method of securing the paper to the board. It is in their favor, however, that they are of lighter weight than a wooden drawing board and consequently more convenient for sketching trips where portability is a major consideration.

Gummed Tape

Only heavy, gummed wrapping tape can be used to hold wet paper, which exerts strong tensions as it dries and tightens. Masking or drafting tape simply will not adhere to damp paper nor hold it tightly enough to the board.

Water Container

Here again I use a 1/2-gallon plastic container because it holds plenty of water and is almost 7 inches wide. When painting watercolors outdoors, though, I use a 1-gallon plastic pail with lid and handle.

Paints

The third area in which to avoid false economies is in watercolor paints. Student-grade paints lack the intensity and richness of the artists-grade, which make up for their higher price by lasting longer. It takes a smaller amount of intense pigment to get a fully saturated color mixture than it does of weaker pigment. A tube of the latter can sometimes be used up in two days of painting!

Tube colors are the only acceptable paints. Watercolor in cakes is not as rich and is very hard on brushes. The best tube watercolors, by consensus, are made in England by Winsor & Newton, but artists-grade colors by any of the major American firms are undoubtedly excellent.

My basic transparent watercolor palette is as follows:

Raw sienna
Burnt sienna
Hooker's green deep
Ultramarine blue
New Gamboge
Yellow ochre
Cadmium orange
Alizarin crimson

Colors that I may sometimes use as supplements, depending on the subject I am painting, are:

Warm sepia
Winsor (phthalocyanine) green
Viridian
Winsor (phthalocyanine) blue
Cobalt blue
Indigo
Cerulean blue
Cadmium red extra scarlet
Designers gouache white
(No black, no Payne's gray)

The simpler the palette, the better. I know several prominent watercolorists who never lay out more than five pigments on their palette; the five vary from painting to painting, but that is the limit they set themselves. This is possibly a bit stricter than necessary, but there is no doubt that it is one way of achieving color harmony.

I lay out all eight colors whether I think I will need them or not, plus any others I feel might possibly be used.

You cannot start a painting, as one of my students did, by squeezing out some "sky color," and later squeezing out some "grass color," and then later putting out some "roof color" on the palette. Every color that might conceivably be required should be set out on the palette at the very start. It really is surprising how quickly they are all put to use.

There may be times, though, when a limited palette is needed—for on-location sketches, for subjects whose color range is very restricted, or perhaps for those painters who have not yet mastered full-palette color orchestration. Here are some limited palettes I use from time to time:

- *Warm and cool*
 Phthalocyanine blue or indigo
 Burnt sienna

- *Primaries (two of each)*
 Winsor blue
 Winsor red
 Winsor yellow
 Cobalt blue
 Alizarin crimson
 Cadmium yellow medium

- *Expanded primaries (warm and cool of each)*
 Ultramarine blue (warm)
 Winsor blue (cool)
 Cadmium red extra scarlet (warm)
 Alizarin crimson (cool)
 Cadmium yellow light (warm)
 Yellow ochre (cool)
 Burnt sienna (warm)
 Raw umber (cool)

- *Miscellaneous color groups (limited color)*
 Indigo
 Hooker's green deep
 Alizarin crimson
 Burnt sienna

 Ultramarine blue
 Viridian
 Cadmium yellow light
 Cadmium orange
 Cadmium red extra scarlet
 Alizarin crimson

Value scale from 1 to 5. Since transparent watercolor technique is based on superimposed values, with the white of the paper being preserved and then washes being applied, customarily starting with the lightest, followed by the middle values, and then ending with the darkest washes and accents, and since darker washes have to be applied over lighter ones, it is essential that the artist analyze the values before beginning to paint, if only to determine the sequence of washes—which are to be painted first and which last. I always insist that beginning watercolorists—and many who are more experienced—do a pattern analysis of the subject before they start painting.

Basically, values break down into the usual three classifications: light, middle, and dark. If we consider the white of the paper as value 1, and subdivide the middle value as being light–middle (tending toward the light end of the scale) and dark–middle (tending toward the dark end), we then have five values to work with: (1) the white of the paper, (2) light values, (3) light–middle values, (4) dark–middle values, and (5) dark values.

In analyzing the value range or overall pattern, all values in the subject can be assigned a number from 1 to 5. Where two adjacent values seem to be the same, one of them has to be made darker or lighter than its neighbor, for purely pictorial reasons that have nothing to do with "truth" or "reality." The important consideration is that some contrast must be maintained in order to separate one value from another. If two adjacent values are the same, then there is a slippage from one into the other, and a viewer could be unsure where, for instance, the mountains end and the sky begins. Keep in mind that when working with values, it's light against dark and dark against light. The more an artist becomes accustomed to comprehending value relationships, in nature and in painting, the less necessary value studies are. Pattern decisions are still necessary, of course, but the process of analysis can be done mentally rather than graphically.

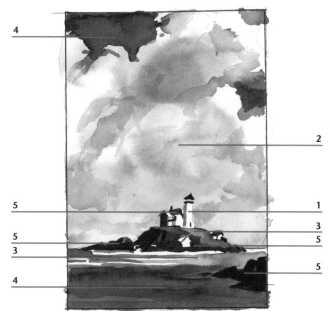

Pattern analysis for *Summer Cloud #3.* I usually do these monochromatically, using Neutral Tint or Payne's Gray watercolor. The pattern is important to the total visual impact of the watercolor, and I want to know how the values will finally relate to each other. If any problems show up I can solve them then and there, not find myself fumbling for solutions while painting. Color could be a distraction in a pattern analysis, but once the values have been decided upon, then colors can be matched to values, generally in a separate color study.

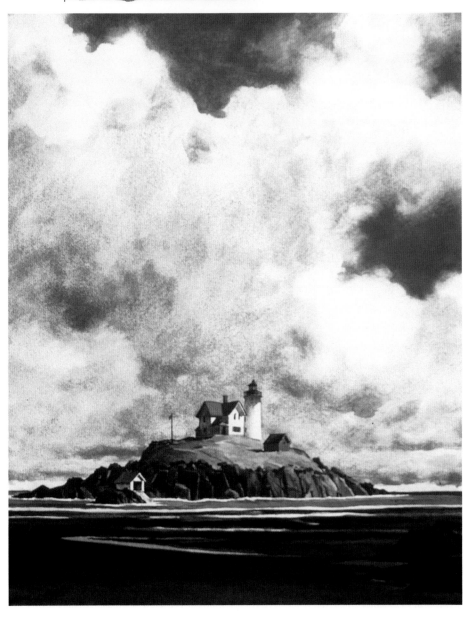

SUMMER CLOUD #3, 1984,
WATERCOLOR ON 140-LB. ARCHES
COLD-PRESSED, 27 × 22".
COLLECTION OF THE ARTIST.

TEXTURES AND SPECIAL EFFECTS

The miscellaneous materials for corrections and special textures and effects are to be used only when needed and not as gimmicks that merely call attention to themselves without really serving any expressive function in the painting. Full advantage should be taken of the behavior of the medium itself as a means of arriving at forms and textures. Nevertheless, attention to textures and differentiation of surfaces is an important part of a watercolor painting, since this lends the picture greater richness and variety.

The table below lists the materials with which to produce textures and special effects, grouped according to their uses.

MATERIALS	USES
• Razor blade • Penknife (point as well as broad edge) • Painting knife	Lines, corrections, textures
on wet surfaces • Paper towel • Facial tissues • White tissue paper • Cellulose sponge *on dry surfaces* • Sandpaper (fine) • Pink Pearl eraser	Lifting, lightening, textures, and corrections
• Salt • Epsom salts	Textures
• Ink roller (brayer)	Textures
• Matboard strips • Corrugated cardboard strips	Lines, stamped textures
• Inks	Lines, flow textures
• Toothbrush • Bristle brush	Stippling, spatter, lifting, scrubbing out, textures
• Wax crayons • Maskoid* • Masking tape	Frisket, resists
• Spray bottle • Fixative blower	Paint spray
• Chinese white or Designers Permanent white	Opaque retouching
• Ruler	Scratching straight lines (with razor blade)

** Caution: Maskoid or other liquid friskets are preferable to rubber cement because rubber cement often leaves a yellow stain on the paper that does not show up immediately, but appears a year or so later.*

Razor blade and ruler used to scratch lines into dry paint

Ink flow

Sandpaper

Toothbrush for stipple and brushed effects

Salt sprinkled into wet paint

Painting through tissue paper

Lifting with a pink Pearl eraser

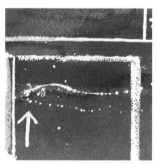

Opaque white retouch

Stampings made with a matboard edge

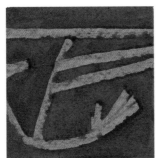

Scraping with a knife blade into wet paint

Lifting and wiping with paper towel

Lifting and wiping with facial tissue

Lines painted with the blade of a painting knife

Wax crayon resist

Liquid frisket

Masking tape as a frisket

Spatter

Glazing over tissue paper glued to surface

Brayer

Scrubbing and wiping with a bristle brush

Cellulose sponge dipped in paint

Color sprayed from spray bottle, fixative blower, or mister

GENERAL NOTES ON TRANSPARENT WATERCOLOR

Painting Outdoors vs. Indoors

While many professional watercolorists still work outdoors, their on-location paintings are mostly in the nature of sketches that are preparatory to finished work done later in the studio. In my own case, I look upon my representational watercolors as a form of note-taking and a way of remaining in touch with the visual aspects of nature, and I hope that the knowledge gained from such an experiencing of nature will ultimately enrich my abstract paintings. I feel that it is quite possible for painters to drift away from their primary sources and end up painting pictures about painting, with the result that their art begins to feed off itself, eventually becoming sterile and repetitious.

You must keep in mind that watercolor should be used as creatively as possible so that your paintings will stand out from the mass of highly competent work that is so uniform in content, style, and viewpoint. With the aim of fully exploiting the possibilities of the medium, but without opportunities for opaque overpainting, it is not very likely that a highly complex image can be worked out casually in a painting done on location. This means that a good amount of preparation on your part, artistic as well as practical, must precede a well-constructed and controlled but expressive painting. In a transparent medium it is essential to plan sufficiently so that the full freshness and clarity of the washes is maintained right to the end. When I say "plan sufficiently," however, I do not mean to the extent that nothing is left to chance and you find yourself filling in the colors as you would in a coloring book.

If, in the long run, you find that work done on the spot has the freedom and directness you are after, then that is the best method for you. In general, though, working up a watercolor in the studio based on sketches and color notes seems to be the method most painters prefer.

Between these two approaches, however, there lies still a third way, used successfully by several watercolorists of my acquaintance: They begin the painting on location, carry it only to a certain point, then return to the studio to finish work there. The advantage of this method is that it combines the assets of both methods previously mentioned: the inspiration and authenticity derived from direct contact with nature, together with the opportunity for deliberation, contemplation, and precise adjustments of color and value afforded by studio conditions.

The disadvantage of this method is that there is an interruption in the continuity of the painting process. This continuity is often important in sustaining both the conception of the picture and the consistency of technical or stylistic treatment. Nevertheless, it is a perfectly valid way of bringing forth a painting and is worth a fair trial if you are to discover which of the three methods is most congenial to both your painting and your personality.

Preparation vs. Spontaneity

There are two general methods for approaching the creation of a watercolor. The first is one in which you immerse yourself in your subject: Observe it, meditate on it, and get to know it thoroughly through sketches and a series of preparatory studies such as rehearsal paintings. You develop a vision of the subject, how it will look as a painting and what it will express, and then just before you start to paint, you plan the picture clearly as to color, values, and pattern, and the sequence in which the washes will be applied. With these preliminaries behind you, you can begin the painting with all your energies intent upon projecting your vision through the immediacy of the watercolor medium. You have decided what you are after, and you pursue that idea with singleness of purpose, treating the subject matter so that there are no distractions from the idea you are determined to put across. You can paint at white heat because you have the security of knowing where everything will be, and accidents are held to a minimum.

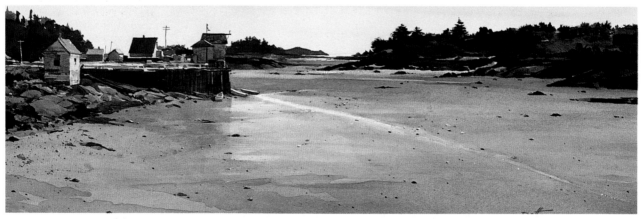

LOW TIDE, 1990, WATERCOLOR ON 140-LB. ARCHES COLD-PRESSED, 10 × 30". PRIVATE COLLECTION.

I have not yet begun to explore the full pictorial possibilities of wet tidal mud and sands, whose delicate nuances of color, tone, and texture have an appeal for me that borders on the addictive or obsessional. Many years ago I was very deeply impressed to learn that the nineteenth-century British watercolorists could lay thirty-two washes, one on top of another, without the colors becoming dead or dirty. That was the major challenge in doing this picture: to capture the quality of light and the wetness in a series of multiple washes, and to sustain visual interest across a large, uneventful area. The natural landscape itself was little more than a vehicle for an exciting afternoon of painting.

The other method is the spontaneous approach. Here again you should thoroughly explore your subject, but this time you will not carry the advance planning of the technical details quite so far. Here the dependence is upon inspiration during the act of painting—a more intuitive way of attacking the picture. You are closely attuned to your subject, and the aim is to capture both your idea and your emotional response through the most direct means, without hesitancies or second thoughts.

If you adopt this method, however, you must be prepared to accept the many risks involved. This is transparent watercolor, and one misstep can be fatal to the entire picture. It is very likely that three or four attempts at painting will have to be discarded and the picture begun over again—and to be able to sustain genuine enthusiasm and spontaneity for that length of time is not easy. With this unplanned approach you stake everything on the chance that even though you may lose a few, when you *do* succeed the painting will have an inescapable impact, touching the spectator with its inspired blending of painterly technique, observational insight, and intense emotional response.

Both these methods have their strengths and weaknesses. The planned method may be *too* well planned and turn out to be dull and unexciting if not carried off with a certain degree of flair and vigor. Still, it assures control during the evolution of the painting, as well as a readable, ordered assembling of its elements.

The spontaneous approach can get out of hand, relying as it does perhaps a bit too much on happy accidents, and the mortality rate of such paintings is relatively high. On the other hand, in those few pictures that are brought off successfully the effect can be an extraordinarily powerful aesthetic experience. By trying both these methods over a period of time, you will find the one that is most natural to you and produces the most effective results.

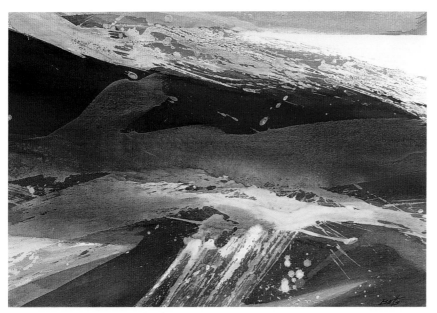

SEA-MOVEMENT #1, 1982, RESIST, WATERCOLOR, AND ACRYLIC ON 300-LB. ARCHES ROUGH, 22 × 30".

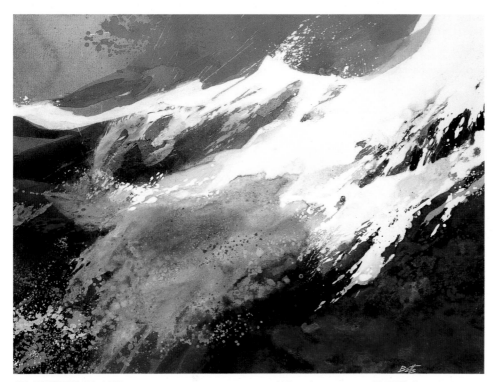

SEA-MOVEMENT #10, 1983, RESIST, WATERCOLOR, AND ACRYLIC ON 300-LB. ARCHES ROUGH, 22 × 30". COLLECTION OF THE ARTIST.

For several years I have been engaged in doing a series of paintings combining a resist process with the use of both watercolor and acrylics in separate phases. Two of the paintings from the first series are shown here. The method itself may not be especially unique, but it has continued to fascinate me. It started out purely as a set of technical experiments in watermedia with a sea-movement theme as a "constant." Later on it also led to minor variations in terms of both subject and technique. The early ones in the series were quite abstract improvisations (#l), but the later works became somewhat more realistic (#10), so I felt encouraged to note that the method was applicable to more than one stylistic viewpoint.

Exploring the Resources of Watercolor

Feel free to experiment with watercolor and make an effort to use the watercolor medium itself to create forms and textures in your pictures. I think it goes without saying that any painting should be true to its medium, stressing its special qualities, whether it is watercolor, acrylic, oil, encaustic, or egg tempera. And I think it should be added that whenever possible the forms, shapes, and surface appearance of the painting should be to some extent the direct result of a manipulation of the medium.

In the case of transparent watercolor, the wet-in-wet treatment produces transitions, blendings, and gradations. The paint spreads of its own accord, forming shapes and areas that can be seized and used as part of the picture, and these effects occur partially as a result of the behavior of the medium itself. The same idea holds when you spatter or fling paint, or use stipple or drybrush. In a certain sense your painting can be considered the outcome of a collaboration between you, nature, and the intrinsic qualities of the medium in which you are painting. All three collaborators have something vital to contribute to the look of the picture.

The very fluidity of watercolor makes it an ideal medium for gestural painting—the brush in combination with movement of the fingers, wrist, and entire arm swinging freely over large expanses of paper. You can be thinking of nature in the back of your mind, but you are working with paint. You are first and foremost using the watercolor medium, but at the same time you are fusing it with nature's own forms and movements— the hard planes of a rock, a tree thrusting upward, the flow of water, grasses bent in the wind—making the two inseparable. Now you are really *painting* in the deepest sense, not just using paint as a vehicle for rendering a surface view of things.

Sunshore, Stage 1. In this painting, I began with free gestural brushings, dripping and flinging of 50/50 acrylic gloss medium and water, preserving some untouched white paper. When dry, these areas (shown here as whites or very light passages) acted as a resist to watercolor applications of Quinacridone red and Aureolin yellow. This was followed by some lifting and wiping, the main idea being to keep all washes light in value and my options open.

Sunshore, Stage 2. After I had established the color grouping that I would be working with and was satisfied with the progress of the painting, I sprayed the entire surface with three light coats of 50/50 gloss medium and water using a fixative blower or spray bottle. Without that isolating coat the areas of watercolor could be smeared as I brushed on new color, or might even bleed through some of the acrylic washes.

SUNSHORE, 1992, RESIST, WATERCOLOR, AND ACRYLIC ON ILLUSTRATION BOARD, 14 × 20".

The completed painting. When the previous stage had dried, I then made the switch from watercolor to acrylic paints. I began to unify the surface by using a few new colors, mostly Cadmium yellow medium, along with accents of pale blue-green, Cadmium red light, yellow-green, and violet. The acrylic was applied both transparently and opaquely, and the horizontal bands were integrated with the picture surface by means of splashes and spatters.

If I had chosen to do so, I could have used watercolor over the dried acrylic passages for any desired stains, blots, or color effects, or opaque whites could have been used to change or obliterate unwanted or unsuccessful areas, and then glazed over with color.

Selecting Subject Matter

Above all, paint the things that move you—genuinely move you—not those things that are obvious or merely fashionable. Paint them because you *must* paint them, not because you have seen them done well by someone else. The greatest painters paint out of necessity, out of almost obsessional urges. Picasso acknowledged this artistic truth when he said, "The artist does not choose his subject; his subject chooses him."

A number of years ago Andrew Wyeth painted a picture of a wagon in a barnyard. Wyeth painted it beautifully because it meant something to him; it was part of the environment to which he responded so sensitively and with which he has so many associations. One thing he did not foresee was this scene's impact on a multitude of lesser painters.

Serving on art juries during one period, I saw countless wagons—wagons in barnyards and in deep grass; wagons seen from the front, back, side, and three-quarter view; wagons of all colors and varying stages of weathered decay. It all seemed too coincidental. Barring the idea that one classic wagon had been taken on a nationwide tour for the edification of artists everywhere, the only logical assumption seemed to be that Andrew Wyeth had had a disastrous influence on painters looking for a surefire subject with built-in appeal and a seal of approval.

What these painters had missed was that Wyeth had seen it first, in terms of his personal vision and style. The imitators saw only the obviously picturesque aspects of the subject, and their versions of it added little or nothing in the way of a viewpoint, idea, meaning, or technical skill.

Therefore, when selecting subjects try to avoid the things that have been done too often or too well. Or, if you must paint them despite all warnings, try to find some attitude behind your painting that will lift those subjects out of the routine and the overdone. Stress the mood or atmosphere, the drama of light, the feeling of weather; use color and space or shape relationships as your prime reasons for painting, or approach the subject with the idea of revealing its essential design structure.

The important thing is to look deeply into *yourself;* ascertain exactly what qualities of your subject appeal strongly to you and just what the nature of your response is. Then enjoy every means at your disposal to concentrate on transmitting, in painterly terms, your involvement with your subject matter with the utmost economy, vividness, and clarity.

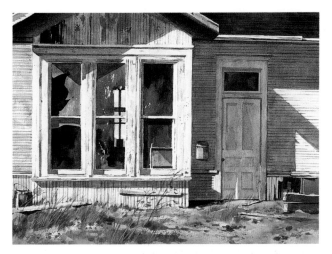

DESERTED DEPOT, 1981, WATERCOLOR ON 300-LB. ARCHES ROUGH, 22 × 30". COLLECTION OF THE ARTIST.

This is a favorite of mine because it is such a satisfactory blend of realism and abstraction. My student class painted the entire building as seen from some distance, but I felt they had overlooked its real possibilities.

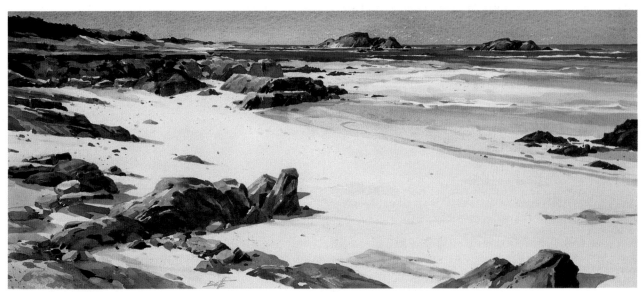

SUN AND SAND, 1990, WATERCOLOR ON 140-LB. ARCHES COLD-PRESSED, 12 1/4 × 29". PRIVATE COLLECTION.

The concept behind this painting of Pebble Beach, California, is featuring a totally empty area as a major part of the composition. The beach is the central subject, but nothing is happening there: no people, no seaweed, no flotsam and jetsam, no boats. Whatever visual interest exists is confined to the rocks and water. This sort of reticence is difficult to maintain, since the natural urge is to fill empty surfaces with something, *anything,* but I was more interested in the playing off of the complex rock forms against the flat expanse of sunlit sand.

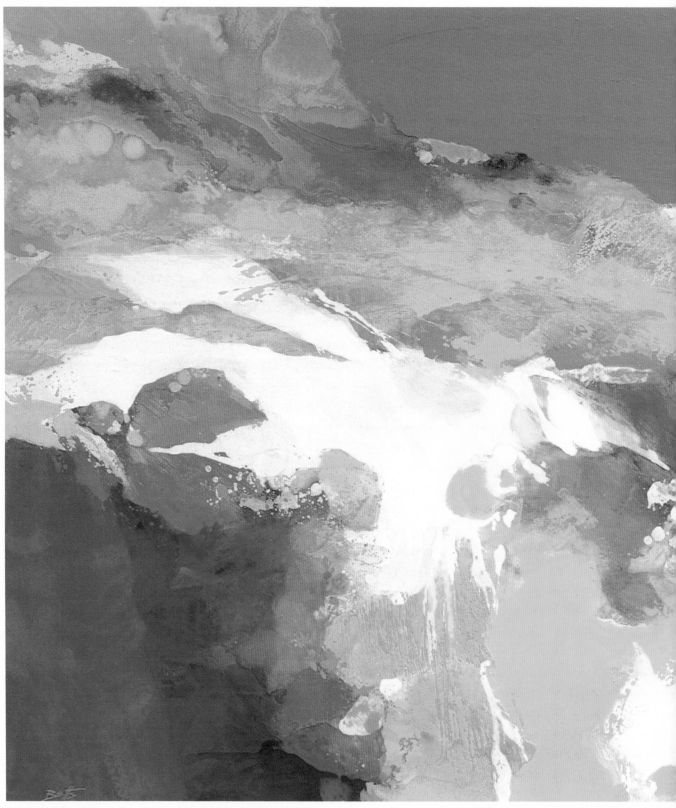

SUN-TIDE, 1982, ACRYLIC ON ⅛-INCH MASONITE, 40 × 50". PRIVATE COLLECTION.

The greatest part of this picture's surface is covered by primary colors and a couple of secondary colors; there are no neutrals at all. What makes color function well or poorly is the proportion of each color to all the others. There are no rules for successful color relationships. I have never let consciousness of arbitrary "rules" stop me from at least trying something to see if it will work. Color systems may occasionally help in controlling color, but they are not to be unquestioningly followed. Personal discovery counts for more than blind obedience to the rules.

THE OPAQUE MEDIA: GOUACHE, CASEIN, AND ACRYLIC

Transparent watercolor is quite versatile up to a point, but every watercolorist will admit that it does have limitations. The opaque aqueous media, because they do not depend on utilization of the paper for whites and lighter tones, have far greater flexibility and an almost unlimited range of paint textures and color effects, as well as possibilities for juxtaposing opaque and transparent passages in the same picture.

The principal difference between transparent watercolor and the opaque media is self-evident: Watercolor is done with transparent washes that show the white paper beneath, and water is added to dilute and lighten the color; in the opaque media the paint covers the surface with a thicker application, and it is white paint that is used to lighten the colors.

Opaque water paints have several advantages, the most obvious being that unsatisfactory areas can be painted over and corrected, and this overpainting can continue for as long as necessary to achieve the desired effect. In addition, opaque paints give an appearance of solidity and substance; in contrast to the thin, washy look of transparent watercolor, these colors have more the look of oil paint.

Because of their ability to build up layer upon layer of opaque color, opaque water paints provide a far greater variety of surfaces and textures than is possible in transparent watercolor. These range from transparent glazes to semitransparent washes, scumbling, and moderate impastos. And finally, two of the three most commonly used opaque paints (casein and acrylic) become waterproof and washable after they have dried.

The three opaque media most suitable for use by professional artists are gouache, casein, and acrylic.

GOUACHE

Gouache is a general term that refers to *any* opaque watercolor technique, but is usually applied most specifically to ordinary transparent watercolor paints to which opaque white has been added. Therefore, any painting in which Chinese (zinc) white or Designers Gouache white has been mixed with colors in greater quantity than simply for accents or retouching can be called a gouache.

Although this is more a manner of painting than a particular type of paint, some manufacturers, such as Winsor & Newton, produce gouache-tempera, or "Designers" colors, which are paints made with a filler that gives them more body or covering power than watercolor. These are of quite satisfactory quality, and the paints in which standard, approved pigments have been used are considered permanent and not subject to fading; however, those made with dyes or artificial pigments should be viewed with suspicion. Designers Gouache colors remain water-soluble after drying, so a coat of paint tends to pick up and merge with previous paint films unless applied heavily and quickly enough to reduce the chance of lifting earlier applications of paint. A note of caution, however: When used too thickly, gouache paints are likely to chip or crack.

CASEIN

Casein is a binder made from curd of skim milk, and before the development of acrylic paints it was regarded as the best of the opaque aqueous paints. It has slightly more covering power than most of the acrylics: It dries matte and a bit lighter than when it is wet, and the paint film is comparatively brittle. Heavy impastos are possible, but to avoid cracking casein should be built up in several successive moderate layers rather than in a single pastose application. Casein becomes waterproof only after a considerable lapse of time; the longer it has dried, the more waterproof it is.

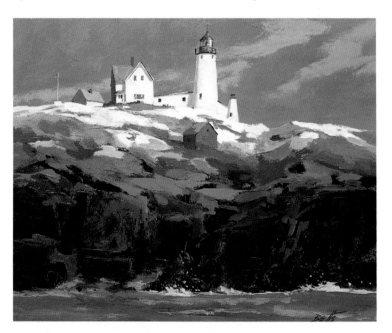

WINTER AFTERNOON, NUBBLE LIGHT, 1965, GOUACHE ON ILLUSTRATION BOARD, 13 × 21". PRIVATE COLLECTION.

In realistic gouaches I begin without a preliminary blocking-in, starting broadly with a large brush and working area against area, color against color, doing the sky first, then the land mass and buildings, and finally the foreground rocks and water. In general I worked from background to foreground. Even though revisions are always possible in an opaque medium, I try from the very start to avoid approximate color mixtures and aim as closely as possible to what the final colors and values should be. I chose to light only the upper part of the island and keep the rocks and water in shadow, a very late afternoon effect I had often seen.

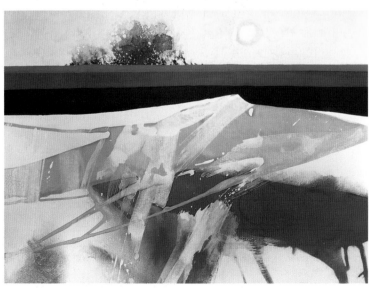

WINTERSHORE, 1978, CASEIN ON STRATHMORE AQUARIUS PAPER, 22 × 30".

Casein is as appropriate to an abstract treatment as it is to the realism of my earlier work. The gestural, improvisational foreground where the paint was allowed to drip, streak, and run, was the beginning of the picture, which had no subject until I sensed the icy or snowy quality. Next came the black area that defined the shape of the snowdrift, then the sky, and finally the red and blue horizontal bands. I enjoyed juxtaposing geometric hard edges with the soft edges and casual paint surfaces elsewhere. The entire picture is a "mingling of contraries"—plan versus accident, spontaneity versus control, flat versus textured, and hot color versus cold color.

ACRYLIC

Acrylic, or acrylic polymer, paint has as its binder a synthetic resin emulsified in water. Although artists' acrylics have been in use only a relatively short time, they appear to be durable and permanent and just about the most versatile paints imaginable.

Acrylic is quick-drying and becomes waterproof as soon as it is dry to the touch. Therefore, since it cannot pick up previous paint films and since prolonged drying periods are unnecessary, it is possible to glaze or overpaint immediately. Some manufacturers produce a retarder that slows down the drying so that the paint can be manipulated for longer than would ordinarily be possible, but to most watercolorists this is of no particular advantage. A retarder would probably have more appeal to painters who want to use acrylic as a substitute for oils.

Acrylic has notable adhesive properties, which makes it ideal for collage techniques and ensures permanent adhesion of paint films to any absorbent, nonoily, nongreasy surface, whether rigid or flexible. In contrast to oil paints, acrylic paint layers do not lie one on top of the other; upon drying they fuse into a single paint film. This quality, together with their great flexibility, just about eliminates any chance of cracking.

Unusual opportunities for broken color, scumbling, and obtaining rich, luminous glazes, are possible with acrylic, affording a very wide range of surface textures, an interplay of opacity and transparency, and an illusion of depth. Heavy impasto can be built up with acrylic modeling paste or gel emulsion.

Finally, it should be mentioned that acrylic is nonflammable, nonyellowing, nontoxic, and will not darken, and that either a gloss or matte surface finish is possible. It seems to be an ideal medium and by now is the most commonly used of all the aqueous media, particularly because it can be used for traditional transparent watercolor techniques as well as for opaque treatments that rival the effects of oil painting.

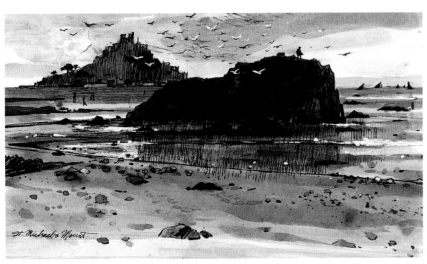

ST. MICHAEL'S MOUNT, 1984, INKS ON 98-LB. PAPER, 6 1/2 × 11".

This drawing is from my Cornish sketchbook, and was done with Pelikan inks, mostly raw sienna, sepia, turquoise, and black felt-tip pen.

ST. MICHAEL'S MOUNT, 1985, ACRYLIC ON 1/8-INCH MASONITE, 7 1/2 × 14 1/2". COLLECTION OF THE ARTIST.

This is very much the same viewpoint and composition seen in the on-location drawing, the most obvious difference being the change of light and weather. The distant island and the foreground rock and beach called for a simple flat treatment of the sky; I felt clouds would have cluttered the composition. Acrylic paints in tubes handle very much like oils, as can be seen here, but they dry so very rapidly that the reflections in the water and the partially submerged sand had to be painted at top speed in order to achieve soft blending while the paint was still wet.

Supports

The most widely used painting supports for opaque aqueous media are watercolor paper and illustration board. I happen to prefer the latter for casein and acrylic, mainly because there is less warping and buckling of the picture surface, but when I do use paper I select a medium or medium-rough surface. It is more difficult to paint on a very rough surface because the paint, being thicker than watercolor, tends to hit only the high spots and has to be worked into the little pits and depressions in order to cover an area thoroughly. So unless very fluid paint is used, rough paper is not very practical and can even be annoying. For small paintings I use standard-weight illustration board; for anything over 15 by 20 inches I use the double-thick heavier-weight (110-lb.) board.

Masonite can be used as a support for casein or acrylic, but it is important to remember that only the standard, or *untempered,* Masonite "Presdwood" should be used. Tempered Masonite has never been considered as a support for fine arts paintings because of

oils that are present in it that might react unfavorably with the paints used. There is always the risk of discoloration of the paint film or of poor adhesion of the gesso ground to the support. Untempered Masonite can be difficult to find, especially since the building trades no longer use it very much. During the period when only tempered Masonite was obtainable, I would sand the surface thoroughly with rough sandpaper and then with medium sandpaper, followed by an application of three or four coats of acrylic gesso on the picture side of the panel, and one coat of gesso on the reverse side.

If paper or illustration board are used, there is no need to apply gesso before painting, unless a more "brushy," or textured, surface is preferred to that of the untouched paper.

Paints

The choice of paints for the aqueous media of course depends on which medium you use.

Gouache. For gouache techniques there is a considerable latitude of choice as to what paints to use. I have used watercolors in conjunction with

Designers Gouache permanent white, or Chinese white, for small, informal paintings, using the same palette as the one used for transparent watercolors. White added to those paints produces soft grays and delicate tints that are quite unlike anything possible in watercolor alone.

Casein. I used casein paints exclusively for about twelve years and still return to them occasionally. They seem to be particularly effective on rice paper, and the quality and covering power of the washes and glazes is actually slightly superior to those obtainable with acrylics. Casein is adaptable to both knife and brush application, and dries to a matte finish that I find very pleasant. Ammonia is the only solvent for casein after it has dried for a time. My list of casein colors is the same as the one for watercolor and gouache.

Acrylic. Acrylic colors are made with permanent pigments approved for artists' use, and although some of the paints have mysterious names they are nothing more than chemical substitutes for some of the colors that were found to be of questionable permanence or that did not intermix satisfactorily with other colors.

Like oils and watercolors, individual acrylic colors vary as to opacity and covering power, and if I object to some of these pigments it is because sometimes certain areas have to be painted two or even three times in order to get a completely opaque film that successfully hides the color beneath. But this is a small price to pay for all their advantages.

My palette for painting representationally in acrylics is the traditional one used in representational painting. My palette for painting abstractions in acrylics eliminates some of the subdued colors and tends toward a more brilliant group of pigments:

Titanium white
Phthalocyanine green
Permanent green light
Phthalocyanine blue
Cobalt blue

MONHEGAN AFTERNOON, 1967, GOUACHE ON ILLUSTRATION BOARD, 8 X 12". PRIVATE COLLECTION.
This is an example of "forced color," an intensified version of the actual colors. Both sky and foreground contain passages applied with a painting knife, though a very thick impasto was avoided. In gouache or casein, thick paint has to be built up in several successive applications rather than in a single heavy layer. For gouache the standing rule is: If it doesn't crack in twenty-four hours, it won't crack at all.

Ultramarine blue
Cadmium yellow light
Cadmium yellow medium
Orange yellow azo
Indo orange
Cadmium orange
Naphthol red light
Naphthol crimson
Acra red
Acra violet
Dioxazine purple
Mars black

Since most of these colors are used full, or almost full, strength without much intermixing, the addition of black is permissible; it is used as a pure color in its own right for abstract purposes rather than for modifying other colors. When painting realistically, I generally select colors with an eye to *tonal* relationships; when painting abstractly, I employ a more *coloristic* range, selecting colors for their richness and intensity.

The three brands of acrylic paint that are most to my liking are made by Binney and Smith, Inc. (Liquitex), Grumbacher (Hyplar), and Golden Acrylics. All are sold in jars as well as tubes. The paint that comes in jars is more fluid than that in tubes,

which has more gel in it and has more the brushy consistency of oils.

Brushes

I use a great variety: oil bristle brushes, flat and round red sable or imitation sable, and a selection of housepainting brushes ranging from 3/4 to 3 inches in width. For my gouaches I use both sables and bristles, depending largely on what the subject matter suggests. For my large abstractions I use housepainting or nylon utility brushes exclusively. The majority of my acrylic brushes are in disreputable shape, but they seem to accomplish what I demand of them. If I worked in a somewhat more polished style, it would be more important to have brushes that were in prime condition.

Painting Knife

Most opaque watercolors are best done with brushes, though a painting knife can be very useful in casein or acrylic for applying color either thinly or thickly, or for scraping and scratching into paint to reveal color beneath.

Drawing Board, Tacks, and Tape

Since paper and illustration board will buckle when wet, I always mount

them on a drawing board or on plywood, Masonite, or Celotex. Dampened paper is stretched on a board with gummed tape; illustration board in small sizes is attached with thumbtacks placed around its outside edge, not pushed through it as when stretching watercolor paper. With larger-size illustration board, I attach paper to the drawing board with masking tape. Although large amounts of paint cause the board to buckle temporarily, it flattens out again after drying and remains flat once the surface is covered with acrylic paint and made fully waterproof.

Water Containers

For the average gouache painting a single water container will suffice, but for acrylic painting any brushes not in active use should be kept submerged in water; once acrylic paint dries and hardens on a brush, the brush becomes unusable and must be discarded. So it is a good idea to keep three or four quart jars handy, two for rinsing brushes and diluting paint and two for keeping brushes wet until they are needed again.

SURFSPILL, 1978, CASEIN ON STRATHMORE AQUARIUS PAPER, 22 × 30".
PRIVATE COLLECTION.

Before beginning to paint I applied three very thin coats of acrylic gesso to the surface of the fiberglass paper (Strathmore no longer uses fiberglass as an ingredient in manufacturing Aquarius), for no particular reason other than I had heard it might provide a more ingratiating surface for painting and wanted to try it. The rocks were painted entirely with the transfer process of painting loosely on newspaper, then flipping it over and transferring it quickly to the picture. The design was based mainly on diagonals that impart a sense of dramatic action. Whites stippled with a toothbrush created the feeling of spray and atmosphere existing between the upper and lower rock forms.

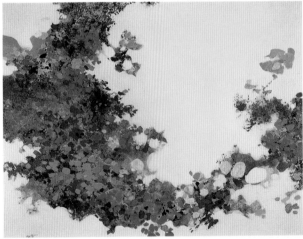

FROZEN GARDEN, 1968, ACRYLIC ON 1/8-INCH MASONITE, 36 × 48".
PRIVATE COLLECTION.

This painting was begun with random splashes and broad areas of color covering the entire panel. I then decided that instead of working with larges masses of color, I would paint with smaller units of bright color touches and open up a major part of the surface as pure white. The spots of color came to suggest flowers and the empty white space became snow. I was very much concerned with the size and scale of the clusters of color spots, as well as their relative placing, so that the dabs of color would not appear too uniform or move in too regular a rhythm across the picture.

OTHER ACRYLIC MEDIA AND EQUIPMENT

Acrylic Gesso

Work that is being done on paper or illustration board does not require a gesso ground, but when I work on Masonite or other hardboard I always give the panel at least three coats of acrylic gesso to act as a binder between the Masonite support and the paint application and to provide the white undercoat that any kind of painting should have as a base for colors.

I like a rather brushy, textured surface, so I put the acrylic gesso on generously with a wide nylon brush. If smoother surfaces are needed, then each coat of gesso must be thoroughly sanded before applying the next coat, and the gesso should be brushed on in alternate horizontal and vertical layers—that is, each layer stroked on at a right angle to the preceding layer. Some painters apply as many as seven coats of gesso in this fashion, and by the time the preparation has been completed and given a final sanding, the gesso surface is almost too beautiful to paint on.

When acrylic paints are to be used on canvas and framed as oil paintings, without glass, it is important to choose raw or unprimed linen canvas and not the commercially primed canvas meant for oil painting. Canvas with a moderately rough weave is preferable to one that is too smooth; a good part of the pleasure of painting on canvas, technically and sensually, is its surface texture and the way it takes the paint. Acrylic gesso (though not a true gesso in the traditional sense) should be used to prepare the canvas for painting in acrylics. I recommend using a broad putty knife or wide brush to apply a first coat of gesso that is slightly diluted with water, followed by two more coats at full strength. Presumably, painting directly on unsized, unprimed raw canvas is reasonably permanent for acrylics, but such canvas is, in fact, almost too absorbent; gesso is still the ideal surface on which to apply color, assuring a maximum bonding of paint and support, and protection of the fabric from moisture, pollution, and possible rotting.

Direct, flat, opaque

Transparent wash

Scraping through to reveal color beneath

Staining

Coarse-fibered rice paper, glazed with color

Impasto glazed, then wiped

Lifting with crumpled paper

Stipple with toothbrush

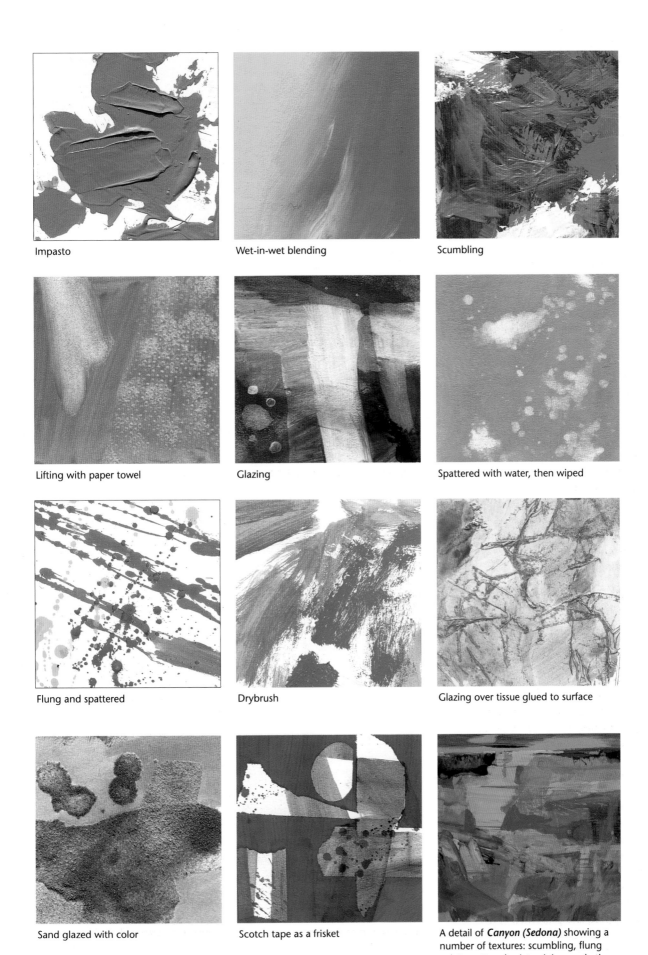

Impasto

Wet-in-wet blending

Scumbling

Lifting with paper towel

Glazing

Spattered with water, then wiped

Flung and spattered

Drybrush

Glazing over tissue glued to surface

Sand glazed with color

Scotch tape as a frisket

A detail of *Canyon (Sedona)* showing a number of textures: scumbling, flung paint, spattered paint, wiping, and others.

For informal studies or preliminary gouache sketches, I often gesso scraps of old matboard, coating both sides and edges thoroughly. This protects the material, which is not rag content but wood pulp, from the effects of air and moisture and pretty well assures the permanence of the material. I would not recommend this procedure for major paintings since it does have its risks, but for sketches whose purpose may be ephemeral anyhow, it is a perfectly satisfactory—and cheap—surface for painting.

Gesso can be applied in its pure white state, or some neutral acrylic color, such as raw umber, can be added to it to provide a toned surface on which to paint. I do not recommend white gesso as a substitute for white acrylic paint, since the gesso is manufactured strictly for use as a primer underneath layers of color. Gesso is not as high-quality a white as Titanium white, so there is always the chance that it might darken or yellow slightly. Gesso should be used only as it was intended to be.

Gloss Medium

This is the pure form of acrylic emulsion before any paint has been mixed with it. It is milky in appearance but dries to a clear, glassy finish. It is used as an alternative to water for diluting color, particularly in glazing. It can also be used as a final gloss varnish.

I use gloss medium principally for two other purposes: as an adhesive in collages (see Chapters 7 and 8) and as an isolating coat between paint layers, most especially in abstractions. Since it hardly ever needs to be used full strength, I dilute the gloss medium with about 1/2 to 1/3 water and brush it over the entire painting every so often. By that means I achieve an illusion of considerable depth in the picture: With all the layers of color locked between layers of clear plastic medium, looking at the painting can be like looking into a deep pool. Because of its excessive shine, I never use gloss medium as a final varnish on my work.

Any water paint can be transformed into an acrylic paint by the addition of some gloss medium to each paint mixture. This gives casein, for example, the extra water-resistance of acrylic.

There is no need for alarm if the medium gives casein a temporary milky appearance; as it dries, the milkiness vanishes and the color emerges as it was intended to be. For more luminous washes or glazes, a greater proportion of medium can be added to the casein or gouache paint, and as it dries it will become clear and transparent.

Matte Medium

This is the same as gloss medium, except that wax or other inert substances have been added to remove what is, to most artists, the objectionable shine of acrylic medium. It simply means that any paint surfaces in which matte medium had a part will dry dull, or matte, instead of glossy. The choice of gloss or matte medium is purely a matter of personal taste.

Gel Medium

Acrylic medium in a more pastose, jellylike form is called gel medium; it is more concentrated and has more body to it than the gloss or matte mediums, which are more liquid.

Gel is added to tube acrylic paints to make them brushable and more the consistency of oil paints. It is useful not only for adding body to the paint for moderate impastos but also for pastose glazing—adding some color to the gel and applying it with a painting

STONY FIELD, LAND'S END #2, 1986, ACRYLIC ON 1/8-INCH MASONITE, 8 1/2 × 24". COLLECTION OF THE ARTIST.

Over a thin wash of Yellow ochre covering the gessoed panel, I began painting by directly brushing in the sky, ocean, and foreground, omitting any preliminary drawing, and working to establish the big relationships of color and value. By painting on the toned surface I could paint with both lights and darks simultaneously and be rid of the distracting white of the gesso. In less than ten minutes, and at some distance, I could get a good idea of how well areas related to each other and how the final picture would look. Breadth and simplicity reigned in the early stages, and details were saved for the end. The tiny red accent at far left does not mean or refer to anything—I just felt the need for a red accent.

knife over a lighter underpainting. This produces a textured surface with deep, transparent colors built right into it—a unification of color and texture.

Gel can also be used as an adhesive, replacing acrylic medium in collages where heavy materials such as thick papers or cardboard are being used.

Modeling Paste

For very heavy impastos, modeling paste (which is marble dust combined with acrylic medium) can be applied and then covered with paint, either opaquely or with transparent glazes, or paint can be mixed directly into it before applying it to the picture.

It has been my experience that modeling paste, if built up too thickly, will sometimes crack. This can usually be avoided by mixing the modeling paste with an equal amount of gel medium. It is not ordinarily desirable in watermedia paintings to have very thick, impastoed areas because the paintings will look too much like oils and not enough like watercolors. However where textures are needed, modeling paste is the most efficient way to achieve them.

When as an art student I first discovered textures, I went wild. Every square inch of my oil paintings had sumptuous gobs of paint, festoons of gooey pigment, stuccolike paint applications, sand mixed with pigment,

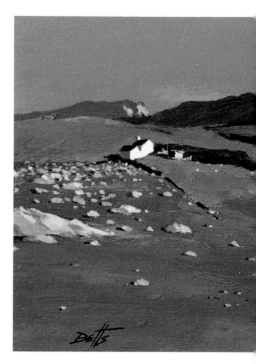

and very generous applications with the painting knife. They were like overly rich meals—too much of a good thing to be really digestible—and it was only later on that I learned that texture has to be used with restraint. I have never lost my love of texture, but now I keep it in its proper place as only one of many elements in a painting.

Matte Varnish

Although a gloss varnish is available, shiny finishes are no longer very popular; in addition to the slick, commercial effect they give, they make it more difficult to see the picture. Matte varnish, however, has a dull gloss, a kind of velvety finish, which is very pleasant. It gives the picture a consistent, all-over finish, not glossy here and matte there, as frequently happens when no varnish at all is used.

Since matte varnish has wax in it, and wax resists water, varnish should not be applied to the picture until the artist is satisfied that his painting is absolutely and irrevocably finished. Once matte varnish is applied, no further painting is possible. Moreover, because the acrylic varnish fuses into a single film with the acrylic paint, it cannot be removed in order to make revisions. I sometimes apply the varnish fairly soon after the picture is done, just to keep myself from "tickling" the picture for

another four weeks, adding refinements that may be academically correct and make it more perfect in one sense, but which at the same time diminish the painting's freshness and vitality.

Denatured Alcohol

The solvent for most acrylic paints is denatured alcohol. Water has no effect on acrylic paint after it has completely dried, but alcohol can be used to remove paint. In most instances, I repaint any areas I want to change, but sometimes accidental blots or splashes have to be taken out, and it may be easier to wipe them off with alcohol on a rag or a cotton swab than to cover them over with more paint. Some delicacy is required here since there is always a chance of taking off more paint than is intended.

Work Surface

I have not used an easel for many years. All my work is done on a 4-by-8-foot painting table situated next to the studio wall. Although paintings done with tube acrylics can be executed on an easel, most of my large abstractions are done in such a fluid technique that they must be done flat, on a table. Since my transparent watercolors, too, are done horizontally, I have simply gotten into the habit of doing all my drawings and paintings in that position and propping them upright against the wall when I

want to study them for a time. I always stand, never sit, while I am painting. I prefer to be free to move around easily and to stay at arm's length from my work, thereby maintaining a more overall view of the entire picture surface.

GENERAL NOTES ON OPAQUE PAINTING TECHNIQUES

Working on a Toned Ground

Gesso is necessary as a ground for acrylic painting on board or canvas, but I do not care for the glaring whiteness of a gesso panel nor the whiteness of illustration board. In transparent media, of course, that whiteness is required and accepted, but in opaque painting I consider it something of a nuisance, to be gotten rid of as soon as possible. I choose instead to tone the gesso with a transparent wash of ochre, sienna, or gray in my representational paintings, and to flow or brush on random areas of bright color as a preparation for my abstract pictures.

I like a surface with a middle-range tonality that can be painted into with both light and dark right from the very start. Lights show up clearly against it and so do darks, so a three-value pattern is established almost from the first stroke of the brush. There is no covering up and filling in of little white spots, just a painterly brushing in of color masses.

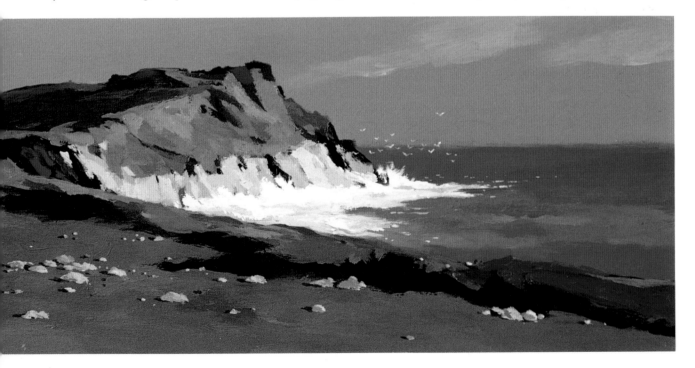

Glazing

Glazing—the application of transparent washes over light underpainting—is the basic element of traditional watercolor technique. It is not quite as applicable to gouache, however, because it is not water-resistant or waterproof when dry, and glazes lift or smear the undercolor much too easily.

With casein, though, and especially with acrylics, glazing is an additional technical method for achieving greater subtlety, depth, and a variety of surfaces in a painting: Areas that are a bit too bright can be subdued with a glaze; colors washed one over the other have greater depth and luminosity than if they had been mixed together on the palette first and then transferred to the painting; and the use of transparent passages contrasted to opaque ones makes the picture more varied, more visually interesting as a surface.

It is not necessary to use gloss or matte medium with color for glazing. In most cases I use hardly any water to thin the paint. I apply the color full-strength directly from jar or tube, and depend on wiping or rubbing with a paint rag to adjust the color glaze to the desired value. While glazing, I paint with the brush in one hand and a paint rag in the other, constantly ready to wipe at the paint. Sometimes both hands are working simultaneously, side by side, on the painting panel.

The only other glazing method I have used with some frequency is to combine color with acrylic gel medium and apply it with a painting knife.

Acrylic Used as Transparent Watercolor

Although acrylic paints are classed as an opaque medium, it should be mentioned again that they can also be used for traditional transparent watercolor techniques—still another example of their unusual versatility. When they are greatly diluted with water, not acrylic medium, they are capable of producing the look and all the effects of transparent watercolor, with the added advantage that since the paint is immediately waterproof, subsequent washes or glazes cannot dissolve or pick up the earlier washes. (For those who like to work back into washes, lifting or sponging out, this would not be considered an advantage. In such a case, they had better stick with pure watercolor.)

My reason for thinning acrylics with water rather than medium is that the medium, even the nongloss variety, gives the watercolor washes a very faint sheen which I personally find objectionable in a transparent watercolor. Water does the job just as well, and apparently without destroying the bond between pigment and medium. To be absolutely sure, however, it is not a bad idea to dilute paint with just a couple of drops of the gloss medium in the water to ensure that the pigment particles are well-bonded and that the paint film is permanent.

The other advantage to using acrylics transparently is that whole passages that turned out less than satisfactory can be painted out with thin gesso or white acrylic paint and repainted with transparent color washes. My sole reservation concerning the use of such corrective techniques is that the surface texture of the paper itself is often lost in the process; it is up to each artist to decide for himself just how important that is to him, and to his painting.

Painting Outdoors with Acrylics

Here is one of the limitations of acrylic paint: Although it is possible to paint outdoors on a gray, humid day, to paint with acrylic in the sun on a breezy day is almost impossible. Acrylics dry rapidly enough under studio conditions, but outdoors in the sun and wind the paints laid out on the palette can dry into rocklike lumps in a matter of minutes, thereby causing all sorts of frustrations for an artist. I would not advise outdoor painting with acrylics, but if you want to take the chance, and the weather does not seem too much against you, go ahead. I wish you luck!

TRANSPARENT OR OPAQUE?

An experienced painter can look at a subject and instantly visualize it as a painting, determining whether it is more suited to a transparent wash treatment as a watercolor or could be better realized with opaque paints.

Any watercolorist will admit that there are certain subjects, certain textures, that are best avoided because watercolor cannot do them justice. In such situations perhaps an opaque medium would be far more appropriate for dealing with them successfully.

From a purely stylistic standpoint, watercolor may not necessarily be the right medium for building up color surfaces in a detailed, complex manner. It is too likely to lapse into dirty color or look too tired and worked-over. Gouache or acrylic may be just the answer for a painter who wants to develop a painting slowly and thoughtfully, changing, revising, relishing texture and exquisite subtleties that might be out of his range in watercolor.

On the other hand, some subjects and some painting styles lend themselves about equally well to both transparent and opaque techniques, so in the final analysis it is up to each individual artist to assess his subject and in terms of his own skills and outlook decide for himself which is the most appropriate medium for that subject.

Noonlight, Stage 1. The Aquarius paper was coated with three thin layers of acrylic gesso. When dry, washes of Yellow ochre were applied at random, using the transfer method along with dripped, flung, and spattered paint. The process was purely improvisational, encouraging the accidental paint effects to suggest the direction the picture would take.

Noonlight, Stage 2. More ochre and Cadmium red extra scarlet were next introduced sparingly into the composition, and after they had dried thin whites were applied over much of the surface. Since these whites were semitransparent, the colors underneath partially showed through the paint film—the beginnings of textural interest and the creation of depth. No identifiable subject had yet emerged.

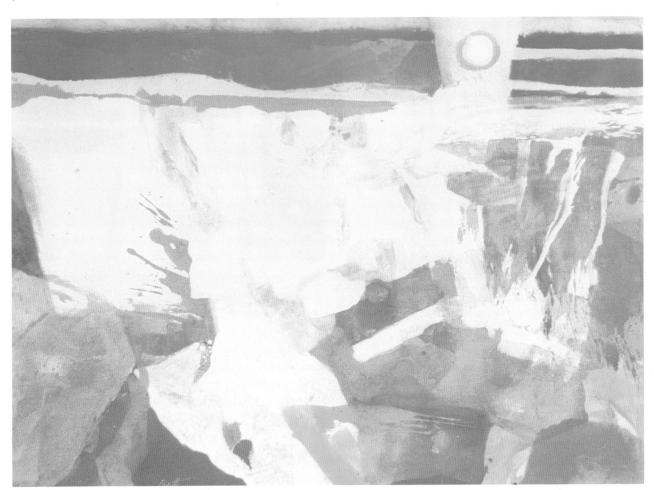

NOONLIGHT, 1978, CASEIN ON STRATHMORE AQUARIUS PAPER, 22 × 30".

When the horizontal bands were painted at the top of the painting, they instantly evoked an association of mine with a quarry by the ocean, and the subject of the picture was decided at that moment. From here it was only a matter of developing the quarry forms, but only generally, not too specifically and not too realistically. My goal was to imply landscape without describing it. The title refers to the glare of sunlight on granite. Titles, by the way, are principally for identification purposes—or as clues to what an abstract design refers—but I am always put off by pretentious titles, or by whimsical or wisecracking titles that are less than droll.

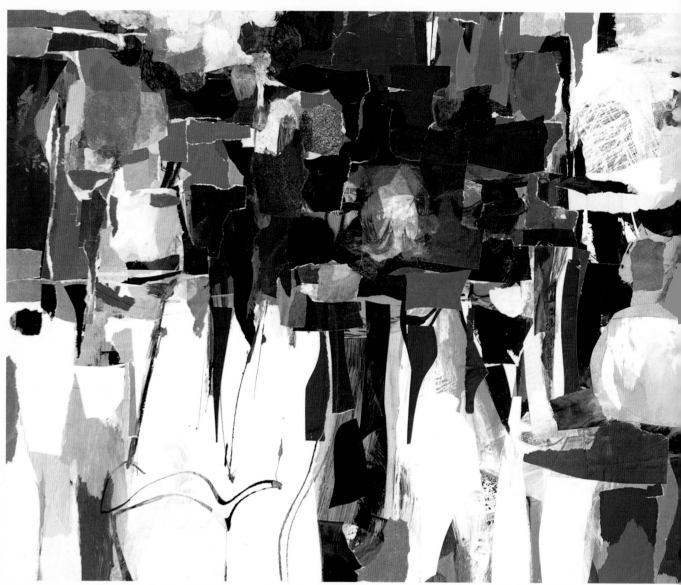

MORAINE, 1970, COLLAGE ON ILLUSTRATION BOARD, 17 × 29". PRIVATE COLLECTION.

This is a highly complex surface built of many small units, and represents the use of collage not as preparation, but as an end in itself: a sustained statement. The various shapes were either cut gesturally with a razor blade or were carefully torn, using some of the torn edges as delicate white linear elements in the design. With such an active composition, and so many small units, a controlled orchestration of the surface was a top priority; I wanted it complex but not confusing.

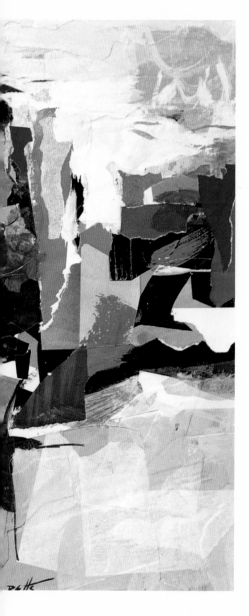

7

DESIGNING WITH COLLAGE

Collage in its purest form can be classified as still another aqueous medium. After all, paper is a major part of the surface; the papers are customarily colored with water-based paints; and because of the somewhat fragile nature of the materials used, collages are usually framed under glass.

The word "collage" derives from the French *papiers collés* ("glued papers"), referring to the early cubist works of Picasso and Braque in pasted papers. Collage has since become a major art form and has evolved from simple paper shapes combined with charcoal lines or a bit of paint to a more complex type of surface that is frequently large in scale and involves an incredible range of materials (sandpaper, canvas, bus tickets, fabrics, paper currency, string, glass, metal, beads, wood, tar, oil paint, stone, flowers, and scorched plastic are only a sampling).

Collage as a major medium is not our immediate concern in this chapter. I am thinking of it here primarily as a way of studying and grasping abstract relationships, using simple methods and materials and a minimum of paint, on a scale at which there is maximum control of the total surface design. Although collages of this sort are primarily studies, they often transcend their purpose and become works of art. Since such compositions are modest in size and framed under glass, they are eligible for submission in the watercolor category in most regional and national exhibitions.

Papers

The main thing to consider in selecting papers for collage is whether and how much they fade when exposed to light for long periods. Although it could be argued that collage is to be used mostly as a form of study here and that permanence is of secondary concern, I think it is worthwhile to use high-quality materials, since there is always the possibility that a small collage study may turn out to be a gem worth keeping and perhaps even exhibiting.

Therefore I recommend a large pack of colored paper, such as the Color-Aid assortment, which has an enormous range of colors in different values and is probably reasonably colorfast. There are also packs of paper of varying quality, mostly construction paper, that come in a range of blacks, white, and grays only, which could also be used in these collage studies.

If such paper assortments are not available locally, it is possible to paint medium-weight paper with acrylic in whatever range of colors or neutral values is necessary. Though this may seem like a good deal of trouble just to have colored paper with which to work, acrylic-painted paper is the one form of colored paper I trust to be colorfast. And if acrylic is painted onto an all-rag paper, the result is not only colorfast but incredibly strong and durable as well.

For studies that are considered to be of only transitory use, to be thrown away as soon as they have served their purpose, almost any colored paper will do—wrapping paper, painted newsprint, colored tissue paper, pages torn from magazines, or whatever. Most of the colors used in magazine printing are made of ink dyes that are not expected to last. They are comparable to some of the exceptionally brilliant colors that contemporary illustrators use: If they retain their brilliance just long enough to be processed at the photoengraving plant, it doesn't matter that they will become pale and faded a month later.

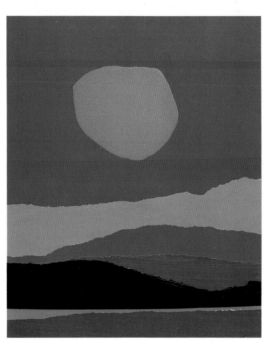

POINT LOBOS, 1969, COLLAGE ON ILLUSTRATION BOARD, 16 × 12". PRIVATE COLLECTION.

Collage is an appropriate method and medium for simplifying natural forms and configurations, and stressing consciousness of shapes and planes. This picture is an exercise in relating flat color planes in a two-dimensional design, but it also could be read as severely simplified realism.

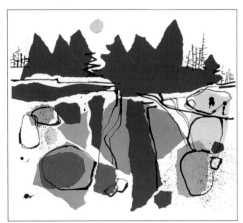

ROCKS AND PINES (COLLAGE SKETCH), 1962, COLLAGE AND INK ON ILLUSTRATION BOARD, 14 × 14".

I frequently do loose improvisational "collage sketches" as a warm-up before starting a painting, to become familiar with the motif in terms of an interplay of shapes, lines, and values. I find working in this medium is nearer the look and spirit of a painting than a drawing is. The subject matter itself, of course, often suggests the most suitable treatment. This is not a rigorous intellectual analysis, but a casual trying-out of ideas.

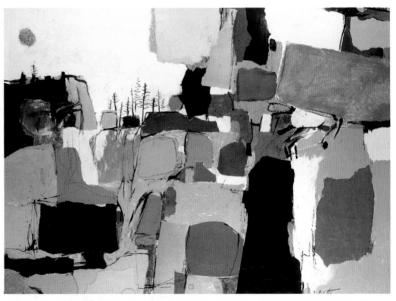

BOULDERS AND PINES, 1962, COLLAGE ON MASONITE, 18 × 24". COLLECTION OF THE DAVIS ART GALLERY, STEPHENS COLLEGE, COLUMBIA, MISSOURI.

I did not try to copy the preliminary collage sketch, but let the picture grow in its own way to become a fresh version based very freely on original sources in nature. Too close an adherence to preliminary studies can restrict freedom to follow impulses or to respond to what is happening on the panel, and so with only the most general plan in mind, I let the painting come to its own conclusion.

Glue

Almost any glue or paste will do except rubber cement, which eventually dries out, loses its adhesive qualities, and bleeds through and stains the surface of the colored paper. I use Elmer's Glue or acrylic medium, both diluted by half with water. Using them full strength just to paste paper is not at all necessary.

There are two methods for adhering paper to the support:

Method 1. Take the paper that is to be glued and place it face down on cardboard or wrapping paper. Then apply white glue (such as Elmer's) or thinned acrylic medium all over the back of the collage paper, right out to the edges, either by brushing or smearing it on with the finger. For stiff, heavy papers, acrylic gel would be the preferred adhesive. Next, carefully place the paper face up on the picture surface, cover it with a protective piece of clean wrapping paper, and smooth it out with very firm pressure to distribute the glue evenly, fill in air pockets, and squeeze out any excess glue. Glue can be picked up with a finger or a damp piece of cloth; if done deftly enough, the procedure will not soil the surface of the paper or lift its color.

Method 2. Brush the acrylic medium or glue generously all over the part of the picture surface that is to receive the collage shape. Then place the collage paper face down on a clean board or on wrapping paper. Also brush the back of this collage paper with adhesive, quickly place it face up on the picture panel, then brush more adhesive over it. This fastens it into place and seals it there. Now brush the whole surface using extra pressure on the brush to force any air bubbles to the edges, where they can escape. After the paper has dried, it is taut and smooth and adheres firmly. Apply a final layer of acrylic medium to the entire collage to give it a consistent finish and sealer coat.

Collages done in the first method (for small studies) are left dry and unvarnished, with no final application of acrylic medium, and are framed under glass. Collages done in the second method (for mixed-media paintings) can be treated with matte varnish and framed either with or without glass.

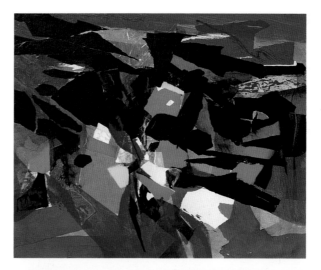

January Thaw
(early stage)

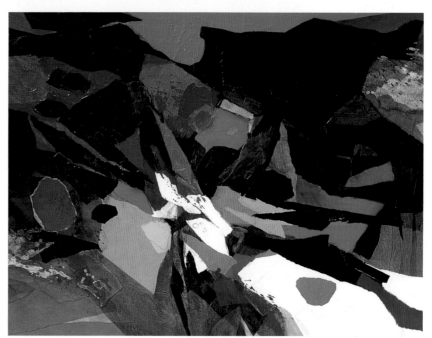

JANUARY THAW, 1968, COLLAGE ON ILLUSTRATION BOARD, 24 × 30". COLLECTION CHESAPEAKE AND OHIO RAILROAD, CLEVELAND, OHIO.

Instead of being influenced by preliminary collage sketches, this composition began with a purely random placement of shapes. As the picture evolved I could accept or reject various passages as I went along—simplifying, covering over, correcting—until some semblance of order emerged from the early chaos. In painting, the play of shape against shape is of the utmost importance, and one of the prime advantages of collage is the opportunity for the artist to actually take the shapes in hand and move them around on the picture surface until an ideal placing can be found. Collage also develops a sensitivity to edges—cut or torn, hard or ragged—and an awareness of the visual possibilities resulting from the juxtaposing of opaque and transparent areas.

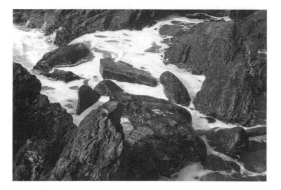

I came across this photograph of mine several years after I had painted *January Thaw.* I had not used the photo as source material, so there was no direct relation between them; at the same time I cannot help but feel that if I had not observed the arrangement of rocks and water seen in the photograph, I would not have designed the collage of rocks and snow in the particular way I did.

Illustration Board

The best surface to use as a support for the average collage is illustration board. Cardboard or other hardboard is usable, but after a time the chemical impurities in them can bleed through the papers and stain or discolor them. For large collages, a better support would be Masonite.

Drawing Board

Because collage papers will cause illustration board to bend or buckle, the board should be tacked or taped with masking tape to a drawing board or plywood board and left secured in place until thoroughly dried out. If removed too soon, the illustration board may still buckle, perhaps ruining the collage.

Acrylic Paints

These paints are used to color the collage papers or to paint large-scale color masses as backgrounds for the paper shapes. If the collage is carried beyond the preliminary study stage to a more fully realized statement, then acrylic paints may be freely brushed on to partially submerge colored-paper areas, or they may be applied as glazes, linear accents, and textural spatter.

Razor Blade

When cutting paper I prefer to use a single-edged razor blade, with which I can cut freely and sweepingly, in a motion akin to drawing. To me this is more natural than carefully cutting with scissors, in which the motion, and consequently the shape, is somewhat cramped and stilted. A razor blade can be used for thin slicings and adjustments or to cut long arabesques. Also, it responds faster to mental or emotional impulses than does a pair of scissors. Of course, one of the greatest collagists of all time, Henri Matisse, used scissors to form his breathtaking, monumental last collages—so who am I to scorn scissors?

In most of my collages I try for a variety of edges. I utilize both cut and torn paper forms; the opposition of softer, more accidental edges with precise, clean-cut edges. Edges that are torn can be controlled to a certain extent by the manner in which they are torn. Also, you can add dimension to your collage by simply alternating the direction in which the paper is torn: If you hold the paper and tear it *away* from yourself, it leaves a shape on which color continues out to the very edge; if you tear the paper *toward* yourself, the outer edge is not colored, but reveals an irregular strip of white that generally follows or reflects the path of the torn edge. These ragged white areas can be used as linear accents in the composition.

Wrapping Paper

I keep a supply of brown wrapping paper on hand as a surface for gluing, always seeing to it that the colored papers are not put down on wet glue; I also use it on top of collage papers as they are being glued onto the picture so that I can rub the surface and exert heavy pressure to smooth the collage paper down as flat as possible, getting rid of excess glue. To rub the surface of the collage paper itself might remove color or streak it with disfiguring marks.

STILL LIFE, 1968, COLLAGE ON ILLUSTRATION BOARD, 18 × 11". PRIVATE COLLECTION.

Collage is an excellent way to undertake a series of exploratory exercises without the pressure of having to end up with an acceptable work of art every time. It is healthy to allow room for error and failure every so often, with perhaps the chance of discovering the germ of something previously unreleased, without message or meaning. I welcome the freedom of not being too solemn and earnest, of using collage to create conditions that might reveal to me things I would not ordinarily have come upon in the course of my daily painting.

USES OF COLLAGE

Explorations

Working in collage can be of great help to you as a watercolorist in several ways. First of all, collage provides a means of exploring abstract relationships and clarifying your thinking in regard to some of the fundamental aspects of picture-building: shape, space, pattern, color planes, and design. It is a means of manipulating those elements in a manner even more direct than drawing or painting. There is the opportunity to actually hold a shape in your hand, alter it if necessary, then place it in several trial positions until the precise placing is found.

By severely limiting the complexity of forms, by reducing forms to basic shapes or even symbols, you find yourself working with the very bricks and mortar of art and design rather than being diverted by the technical considerations of watercolor or acrylic. As a result, you can refresh your thinking and try out ideas that might not occur to you as readily or would not be possible to do as easily in the other watermedia.

A few years ago, when I felt that my mixed-media paintings were becoming overly "busy" with too many little forms, I embarked on two collage series. One was called "Coastal Fragments," numbered from 1 through 36, and the other "Sea-Edge," numbered from 1 through 20. The purpose behind doing these was to make a change from painterly brushstrokes and a multiplicity of forms and to see with how few elements I could create a feeling of those places where land and sea meet.

The idea was not to change course in my work but to take a side-trip, so to speak, to investigate the possibilities of severely limiting forms and reducing natural forms to essential shapes or symbols—and, generally, to revitalize my thinking. I was not much interested in exhibiting my collages, though I did do so occasionally. Their principal function for me was a temporary period of exploration.

COLLAGE SKETCH, ACRYLIC ON PAPER, 7 3/4 × 11 1/2".

This is an example of taking scraps from old or unsuccessful paintings and drawings and recombining them into different relationships. This sort of exploration can lead to discovering pictorial concepts that are fresher, more arresting, more offbeat, than a body of work that may have become stale and predictable. Just being able to physically handle a shape and try it out here and there, is far easier and more immediate than painting, wiping out, and repainting over and over. Collage somehow lends itself to relaxed and playful experimentation, and efforts that don't work out can be cheerfully thrown away.

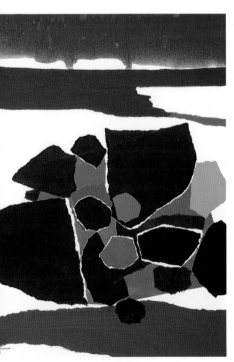

COASTAL FRAGMENT #4, 1970, ACRYLIC AND COLLAGE ON ILLUSTRATION BOARD, 16 × 12". COLLECTION OF THE ARTIST.

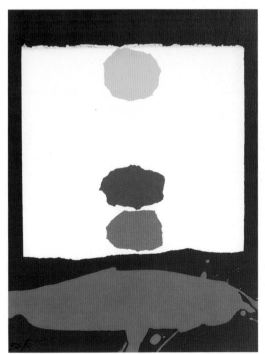

COASTAL FRAGMENT #17, 1970, ACRYLIC AND COLLAGE ON ILLUSTRATION BOARD, 16 × 12". PRIVATE COLLECTION.

COASTAL FRAGMENT #24, 1970, ACRYLIC AND COLLAGE ON ILLUSTRATION BOARD, 16 × 12". PRIVATE COLLECTION.

These three paintings are from a series of thirty-six collages based on coastal themes: ocean, beaches, rocks, splashes, pebbles, suns, moons, and horizons. I embarked on this series as a reaction against the complexity and fussiness of my work in acrylic and mixed media. I wanted to work with simple, condensed, compact, almost symbolic images. I enjoyed this art of extreme reduction and condensation, and I saw no need to apologize for it simply because it seemed to be uncharacteristic of my usual work at that time. In this case collage was used not as a preliminary step toward other paintings but as a chance to explore alternative design concepts and situations.

Shape Analysis

Collage can be a way of analyzing nature's forms through a process of extreme simplification. Look at a landscape, for example. Ask yourself about the general character of its forms: Are they organic (natural, irregular) or geometric (regular, straight edges, circles, rectangles) or a mixture of both?

Through collage reduce the entire subject to only three, or at most four or five, shapes. Play with those few shapes until you arrive at the greatest intensification of the sense of place, as well as the most sensitive adjustment of the shapes to each other and to the intervals between them. Apply this same thinking to some barns, a city scene, or a room interior. Analyze, condense, and simplify, until only the most essential elements are left to form a strong design and still express or suggest the original subject.

This is an excellent way to increase your awareness of shapes—the basic character of their form, their relative size and scale, and the importance of their interrelationships. Shapes are one of the most important considerations in any painting, and you cannot spend enough time observing and manipulating them.

Analysis of Color Planes

A plane is any flat shape or surface that is connected to the picture surface or moves into the space within the painting. The basis of cubism was a fracturing and analysis of planes, whether in still life, figure, or landscape, as a part of the translation of three-dimensional subjects onto a two-dimensional surface.

Where some planes remain parallel to the picture surface (or picture plane), other planes tilt in space, toward or away from each other, and set up tensions that imply space and movement within the imaginary picture space. Hans Hofmann called this "push-pull."

A sense of depth is created not by linear or aerial perspective but by the way planes shift and move into a limited or controlled pictorial depth. Volumes are no longer regarded as volumes, but are handled as though they were so many sheets of cardboard, positioned in front of or behind each other, overlapping or interpenetrating, projecting toward or receding from the spectator. All this, as I say, takes place in a shallow pictorial space rather than an illusionistic deep space.

In terms of the push-pull activity I have mentioned, an equilibrium must be established by these planes in relation to each other so that the flatness of the picture plane will not be violated. Just as in representational painting, every effort should be made to see that there are no holes or projections in the picture: Areas that recede too far back are brought forward with brighter color, and areas that pop out too far are suppressed by means of subdued color.

Therefore color, too, can be a means of implying depth within the picture. Instead of relying on light and dark to control the planes in space, you should think of the planes most specifically as being *color planes*. The old notion that warm colors advance and cool colors recede is a generalization that is not always true; certain intense, cool colors will obviously advance, whereas deep, warm ones will tend to recede.

Since planes occupy various spatial positions in the picture and since colors also take various spatial positions, analysis of these color planes is important to understanding your subject and its organization as a painting. Colored collage papers are the logical and most convenient method for investigating color-space-plane relationships and their variations.

MAINE BARN, 1974, COLLAGE ON ILLUSTRATION BOARD, 14 × 18".

This is a color and shape study, not a painting. It was made with prepainted papers—medium-rough watercolor paper coated with acrylic paints. I was more interested in color harmonies and juxtapositions than in realistic color, so the emphasis was on using colors that either related well or produced striking optical effects. The main idea here was to treat the barn and its surroundings in terms of color planes acting within a shallow picture space, and to create a clear sense of each plane's position relative to the others, accomplished by means of color rather than line, value, or perspective. Some blues recede, others come forward; one green remains behind another green that is situated closer to the picture plane.

Recession into space by perspective. When planes converge in one- or two-point perspective, they create an illusion of depth and recession into the picture that is characteristic of most representational painting since the Renaissance. By the late nineteenth century many artists felt that this illusionistic space was a denial of the flatness of the canvas or wall on which the picture was painted, and there was a move to restore an awareness of the picture plane by translating three-dimensional volumes into frankly two-dimensional planes that were more consistent with the actual surface of the painting.

Overlapping planes. If the planes are not allowed to shoot back into a deep space—no converging lines or reduction of the sizes of shapes—then those planes must be situated in front of and behind each other in a restricted or controlled depth. Planes can be staggered and overlapped or built vertically from the front planes at the bottom to the rear planes at the top, in the manner of traditional Chinese and Japanese art. In any case, this is done without reference to linear or aerial perspective, and is comparable to several overlapped sheets of cardboard that recede only a very short distance into the picture space.

Tilted planes. If the planes are slightly tilted along one edge or another, there is a more interesting and complex expression of the planes existing in space, but still within the strictly two-dimensional context. In this design, certain tensions have been set up between the axes of two planes, which is a much less static way of positioning planes than in the preceding example, where only the horizontal-vertical axes were uniformly parallel to the picture plane.

Tilted planes combined with line. By combining lines with the tilted planes, even more tensions are brought into play. The lines are not used to define or contain planes but are an almost independent composition that is coordinated with the planes, and at the same time occasionally opposes the planes, resulting in an even more intricate visual and spatial activity than is possible by means of the planes alone.

Color planes. When the element of color is added it is then possible to manipulate planes in still another dimension: Colors advance toward (push) or recede (pull) from the picture plane depending on their relative intensity and whether they are warm or cool. Because color alone can situate a form or plane in the limited depth of the picture space, each one has to be chosen carefully so that it holds its specific position; the notion that warm colors always push forward and cool colors recede does not necessarily hold true. (An intense blue, for instance, can come forward more than a deep red, as can be seen here.) The planes should relate to each other so that there are no holes or projections on the picture plane without a compensating push or pull elsewhere on the surface. Although Hans Hofmann, the distinguished artist and teacher, articulated this principle for modern abstractionists, it is a timeless principle observable in most great painting from the pre-Renaissance right up to the present.

Design

The third viewpoint from which to analyze nature through collage is that of design—to do compositional variations that will express the fundamental relationships of the forms in their largest, simplest sense and also suggest ideas as to arrangement and pattern that are inventive or daring. By moving collage shapes about, you can try out various compositional relationships of masses: Overlap them, enlarge them, combine them into unanticipated new forms. Generally freshen your ideas as to what can be done with your subject in terms of its overall interaction of parts.

In drawing or painting, you are inhibited by old habits of seeing and composing; in collage you can approach the components in your composition more imaginatively, setting in motion ideas you would probably not think of if you drew or painted each changing possibility.

A photograph of a quarry at Estremoz, Portugal.

Collage sketch (hard-edged) for *Quarry Forms, Stage 1.* The panel was given a flat coat of bright blue, then the major lines were pencilled in as a guide for collage shapes that were cut from prepainted sheets of Strathmore Aquarius paper. The horizontal strips were applied first, and also some red shapes that might be used as color accents peeking through here and there in the finished painting.

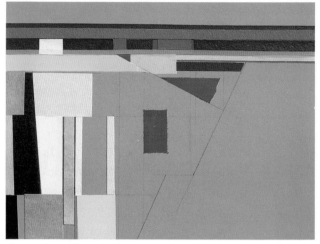

Quarry Forms, Stage 2. The stone surface of the quarry excavation was interpreted as blocks of color. Shadows were used not as shadows but as shapes and as dark color notes. Those dark shapes also served to contain the left edge of the painting so that it would not slide out of the composition, and additionally, to repeat the color and value of the dark mass that would be introduced at right.

QUARRY FORMS, 1·992, COLLAGE ON ILLUSTRATION BOARD, 12 × 16 ¹/₄".

In its final form the strongly contrasted areas convey the idea of sunlight and shadow on the quarry wall, yet the darks were handled as *colored shapes,* not just dark values. There was no attempt to overlap planes; I simply placed them adjacent to one another and let the colors define or imply the spatial relationships.

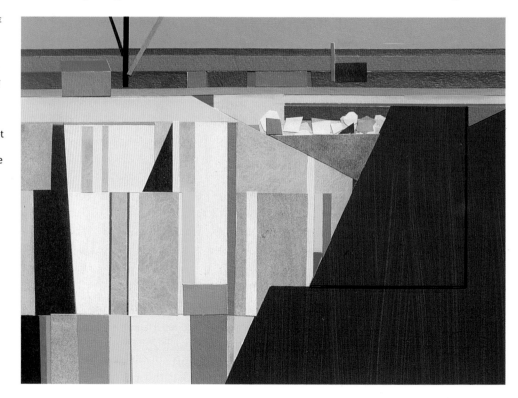

Aside from deriving your collage shapes directly from reference to the general basic forms of your subject, you can attack the problem from the other end. Instead of asking yourself what can be done to simplify or abstract the elements in your subject, start out with an area of random paint application as a background form, or sky, then tear or cut out collage shapes that may seem to have little or no reference to your subject.

Now try to relate them to the painted area and at the same time relate them in some way to the subject that was your initial starting point. In other words, creep up on your subject in reverse, beginning with a chance situation and then bringing the composition back toward natural forms and arresting relationships of shape and pattern. It may take a little nerve on your part to try this, but it is a sure method for shaking yourself

out of familiar, standardized attitudes toward analysis and design.

Collage exercises of this sort are not isolated games that have no application to your work in painting media. You can use them to firm up and expand your design concepts and your personal synthesis of art and nature. What you learn through such exercises should be transferred and put to active use in any painting you do, whether representational or abstract.

Collage sketch (painterly) for *Sedona, Stage 1.* Following an overall coat of Yellow ochre acrylic, some semiopaque whites were applied with the transfer method. I gave the panel a coat of 50/50 acrylic gloss medium and water, poured on some Cadmium yellow medium and Aureolin watercolor, then added another layer of the 50/50 mixture.

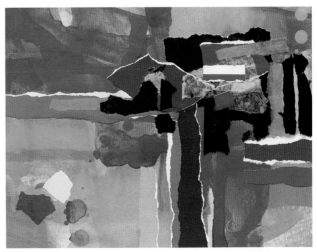

Collage sketch for *Sedona, Stage 2.* Collage elements were added to firm up and clarify the design structure. Shapes were torn with an eye toward varying the character of edges—some torn so as to leave rough, ragged edges that function as linear accents, while other edges are clean and sharp.

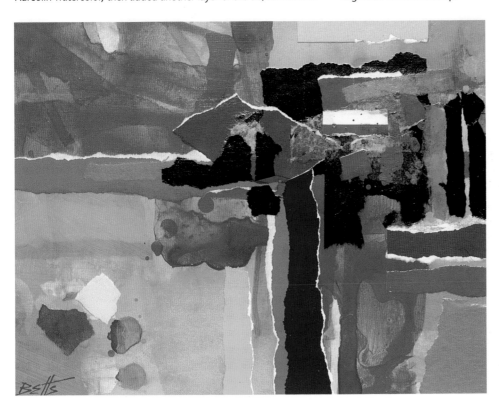

COLLAGE SKETCH FOR SEDONA, 1992, WATERCOLOR, ACRYLIC, AND COLLAGE ON ILLUSTRATION BOARD, 9 1/2 × 12 1/2".

Final adjustments resolved the total surface into a loose but readable orchestration of colors and shapes. The colors are all rich in saturation, with a minimum of neutrals. If all the colors in a painting are intensified to about the same degree, then no one color is out of key with the others. Color relationships will be inconsistent if you begin with daring choices and then lose your nerve with those that follow later.

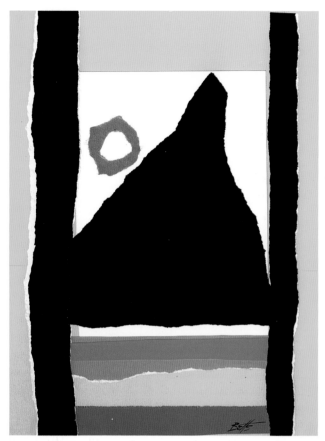

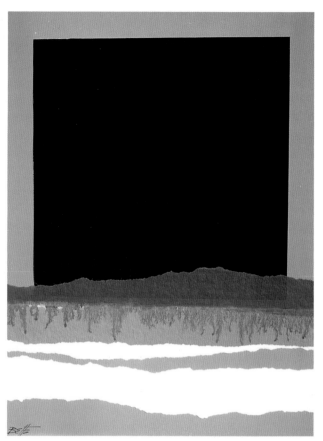

SEA-EDGE #10, 1971, COLLAGE ON ILLUSTRATION BOARD, 18 × 14". PRIVATE COLLECTION.

SEA-EDGE #19, 1971, COLLAGE ON ILLUSTRATION BOARD, 18 × 14". COLLECTION OF THE ARTIST.

The *Sea-Edge* series followed the *Coastal Fragments* and included twenty collages that in turn led to several others done in the same spirit but horizontal in format. Reticence, restraint, and calculation are stressed in these images; certainly these works are far removed from any painterly exuberance. My goal was to minimize seductive surfaces and see how much could be expressed with how little. As a temporary discipline these collages represented a side-trip from the general course of my art, but I felt no urge to pursue them longer or in greater depth than I did. But I must admit I'm very glad I did them.

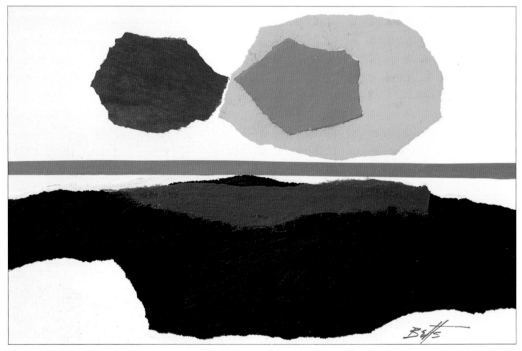

WHALER'S COVE, 1970, COLLAGE ON ILLUSTRATION BOARD, 11 ½ × 15". PRIVATE COLLECTION.

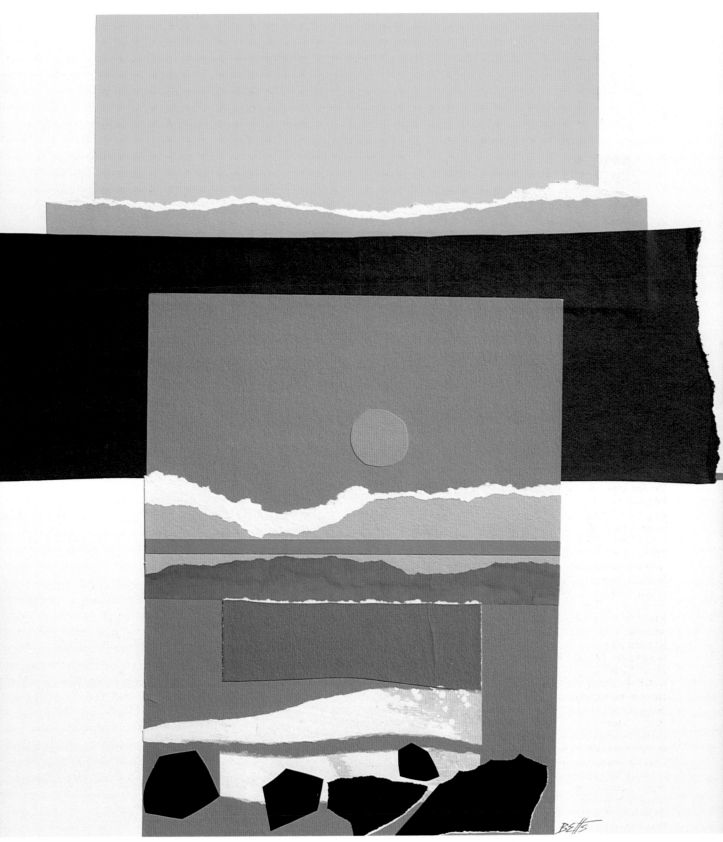

SETTING SUN, 1977, COLLAGE ON ILLUSTRATION BOARD, 26 × 26". PRIVATE COLLECTION.

Collage is also a way to discipline yourself to make clear-cut decisions in your painting. Some pictures are so complex, so unresolved, that you wish the painter had been clearer and more decisive in the way they were constructed. I always find the square format a tremendous challenge to my designing abilities. Furthermore, as is the case here, I like to play with color and shape relationships handled in ways that are thoughtful, precise, and polished, but still expressive of nature, which is seldom any of those.

Detail of **Red Rockscape.** This shows not only the use of collage papers and sand, but also the traditional oil painting use of a separate textured underpainting which is overpainted later with glazes of color. An essential part of the experience of looking at a painting is the sensuous brushwork and the wide variety of textural effects. The caution here is that too much texture is like too rich a meal: It is indigestible. (See page 98 for the complete painting.)

8

MIXED MEDIA

In contrast to the somewhat limited textures of transparent watercolor, or the flatness of collage, the possibilities of mixed media are almost unlimited for achieving rich surfaces in combining opaque and transparent passages, and exploiting resists, glazes, impasto, and flung paint in addition to collage. The effects are far more varied than those obtainable in gouache, casein, or acrylic alone. There is an even greater illusion of color depth with mixed media, which together with the interplay of collage materials, provides an unusually handsome, complex surface with considerable tactile quality. A mixed-media painting appeals not only to the eye; it invites the touch. I consider mixed media one of the most exciting and fascinating methods in the watercolorist's repertory.

Since this is an acrylic technique, continual experimentation and overpainting are possible. The concern here is not with the freshness and fluid washes of watercolor, but rather with a fully developed, intricate interweaving of many pictorial elements in a more solid, painterly sense than is characteristic of transparent media or even of the opaque media as we have previously used them.

With mixed media it is possible to build up areas of paint and collage and then add, subtract, scrub, paint out, wipe, spatter, scrape, scumble, and glaze until all the forms on the surface are functioning together exactly as the artist wants. As ideas come along, they can be tried out immediately; when something does not work, it can be repainted until it does. The only limits to this way of working are the artist's powers of invention and perhaps his skill as a scavenger when it comes to collecting materials to be introduced into the painting.

Colors

I use my usual palette of acrylic colors—the coloristic selection rather than the tonal.

India inks are brilliant and very useful, though they may lift or blur slightly when painted over. You should be able to capitalize on that effect rather than fight it. The only colored India inks that are truly permanent are those made from the same pigments that are traditionally acceptable for fine arts painting. The inks I prefer are made by Pelikan and contain pigments rather than dyes. The best rule in selecting colored inks is to choose only those that are labeled according to pigment, rather than by vague hue designations.

Colored Papers

In selecting colored paper for mixed-media work, I try to avoid papers that will fade with prolonged exposure to light. It is best not to use pages torn from magazines, since they are often printed with inks or dyes that are not lightproof. Especially to be avoided are the bright-colored tissues sold as gift wrapping: These seem to contain the most fugitive colors of all. They look very appealing, and yield some attractive effects of transparency, but they should be used only in experiments or studies you expect to discard after they have served their purpose.

Years ago one of my major paintings—in which those colored tissues were used extensively—was hung in the south window of a New York art gallery for three weeks. When I eventually saw the painting, all the intense blues and greens and luscious purples had faded to a sort of mousy gray. The surface was so greatly changed that at first I scarcely recognized my own work.

Having learned my lesson, I now paint whole sheets of lightweight or medium-weight watercolor paper or rice paper with acrylic colors. These papers can be incorporated in a picture with full confidence that the colors will not change or fade.

Japanese Rice Papers

These papers are particularly fascinating for their wide range of textures and fibers and for their ability to produce the most delicate effects of transparency. There is a great variety to choose from, ranging from the most fragile to those containing thick, tough fibers that tear beautifully and can be guided and used as lines in a painting.

When wet, most rice papers become somewhat transparent. Thus, they can be used to subordinate or modify color areas and to achieve extremely subtle effects. After the paper has dried in place, I generally wash some color over to integrate it better with other areas. Occasionally, as I have mentioned before, I prepaint rice paper with thin acrylic color, closely approximating the look of colored tissues.

Onionskin

This 9-lb. typing paper is partially transparent, but less so than tissue. It is excellent as a glaze over previous paint applications, and can, in turn, be given a wash of color. It tears well for collage shapes, but because of its relatively small size, several sheets have to be torn and overlapped randomly in order to cover a large area.

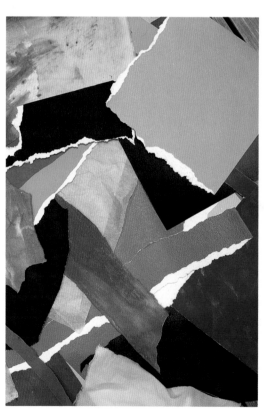

Collage papers *(near right)* can be obtained from a variety of sources: sets of assorted high-quality colored papers, paper towels, magazine clippings, synthetic papers, onionskin typing paper, or sheets of drawing or watercolor paper coated with acrylic paints. Colored tissues are to be avoided because their colors fade rapidly under even the most ordinary light conditions. Coloring your own paper is the only way to ensure nonfugitive colors.

Japanese rice or mulberry papers *(far right)* come in many weights, surfaces, and textures. Some are thin enough to be almost transparent after they have been adhered and dried, while others have very coarse fibers imbedded in them. Though these papers are usually selected for their glazing and transparent qualities, or for their textures, the rice papers that are flat white, heavier weight, and somewhat more opaque, are excellent for prepainting with casein or acrylic colors.

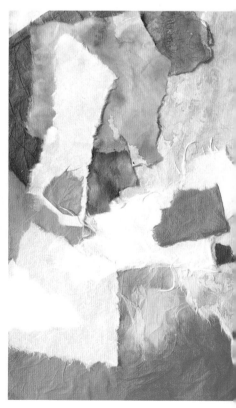

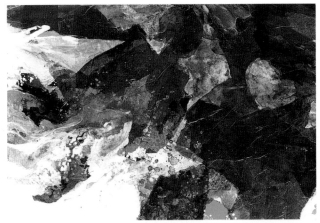
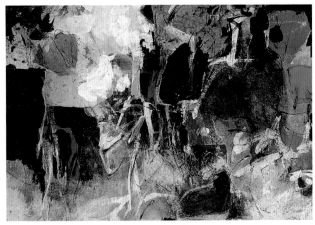

Details of collage textures. Some pasted papers are relatively flat and untouched, while others were glazed or spattered with color, or drawn into with linear strokes of a small sable brush or pen, achieving a feeling of depth and sensuous, sumptuous surfaces.

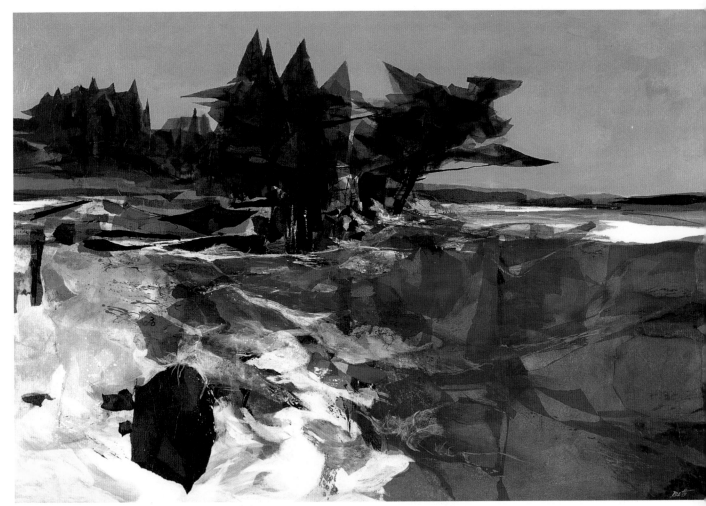

SUMMERTIME SEA, 1964, MIXED MEDIA ON MASONITE, 40 × 60". PRIVATE COLLECTION.

Colored tissue papers were the principal materials in this picture. The lower right quadrant was painted with light color and then torn pieces of blue tissue paper were applied in random fashion. As they overlapped each other in superimposed layers, various shapes and lines were formed that had a sort of design quality that reaffirmed consciousness of the flat surface rather than implying a deep space receding into the picture. The pine trees were done by superimposing tissues of several intensities of green. Rice papers and white paint were used for beach and surf respectively, then glazed with color. Although the subject matter of this picture appeared at quite an early stage, it does not always happen that quickly; it is just that here I was luckier than usual. Colored tissues are not to be recommended for anything more serious than private color experiments that are meant to be thrown away. Most of this painting faded almost beyond recognition in a couple of years, and despite the fact that I retouched it, it never looked quite the same again.

White Tissue Wrapping Paper

White tissues are something I often use to build up texture in the very earliest stages of the painting. I moisten the general area where the tissue paper will go, lay the tissue on it, and then seal it by brushing on diluted acrylic medium swiftly and casually, so that the wrinkling and crumbling of the paper remains. This creates linear textures that take subsequent glazing and scumbling very beautifully. After it has dried, the paper is so transparent that it scarcely affects any color beneath it, and as fragile as the paper is, once sealed under acrylic medium it is hard and permanent.

Synthetic Papers

In recent years, several manufacturers have developed synthetic papers made of plastic or fiberglass, most of which I have enjoyed using. They are very much like other papers but usually are far less likely to buckle or wrinkle when wet. These papers are undoubtedly permanent and nonyellowing and they can often be used to obtain effects surprisingly similar to those of the rice papers. I have found that most of them tear easily in almost any direction, but there are a few that will tear only in parallel strips.

Sand and Other Textural Fillers

If I am going to use sand, I first brush diluted acrylic medium on any area that is to take the sand. While the surface is still wet, I sift sand over it—lightly for a thin, semiopaque surface or very generously for a heavier covering. After the medium has dried

Surface prepared with ordinary tissue paper randomly applied to the surface with diluted acrylic medium and allowed to dry.

Surface glazed with transparent washes of color. The textures can be left as is, or they can be wiped while still wet, with a paint rag.

SEA-FRAGMENT, 1979, MIXED MEDIA ON MASONITE, 22 × 30". PRIVATE COLLECTION.

This is an example of working on a prepared surface. Many layers of white tissue paper were randomly applied to the gesso with diluted gloss medium. This creates a unique kind of texture because of the various wrinkled effects that come from brushing on the medium loosely over the tissue while adhering it to the panel. (Other materials can also be used in conjunction with the tissue: sand, gel, modeling paste, paper.) Once the surface had been prepared, the painting was developed according to my customary procedures. The preliminary textures affect the look of the finished painting, however subtly.

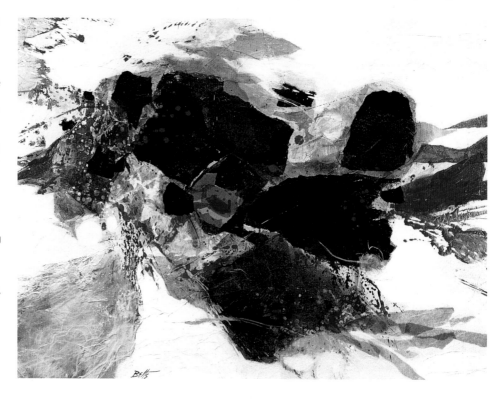

thoroughly, I tilt the panel and all the excess sand falls away. Only the areas where the sand came into contact with the wet acrylic medium remain covered. I then apply two more coats of acrylic medium to seal the sand thoroughly on the panel. If an almost sculpturally built-up area is desired, this can best be achieved by several successive applications of sand and diluted acrylic medium rather than a single coat.

In addition to sand, there are other textural fillers such as mica, talc, Celite, birdseed, sawdust, or wood flour. Experimentation will suggest when they can be used most appropriately or whether they are needed at all.

Fabrics

I do not use fabrics very often in my work, but when I do it is usually in the form of old sheets, shirts, or used paint rags. To me, the most intriguing aspect of cloth collage is the loose threads at the torn, frayed edges of the material. The cloth can be applied to the picture by brushing diluted acrylic medium over it, just as though it were paper. As the acrylic medium is applied to fix the fabric in place, I watch for stray threads and guide them with my finger, brush, or painting knife. I literally use the threads to draw with, creating lines that tie in with other parts of the composition. Once the placement of the lines looks right, threads are allowed to dry and become a permanent part of the painting. They can be left as they are or glazed with color.

Spray Bottle

A spray bottle or atomizer is useful for blowing water into wet painted areas to soften the edges or to thin the paint and cause it to blend or flow accidentally. The bottle can also be partially filled with very thin acrylic paint or ink and used to apply color as a spray. (Spray paint textures are occasionally useful and will be dealt with in more detail in the next chapter.) To prevent clogging, the spray mechanism must be cleaned out with very hot water after each day's painting.

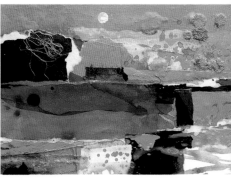

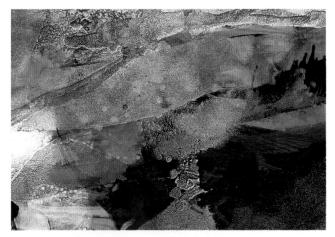

Much variety is possible with painted acrylic textures alone, but that range of textures can be extended even further by including other materials such as fabrics, threads, sand, and assorted papers such as tracing paper, ordinary typing paper, and rice papers.

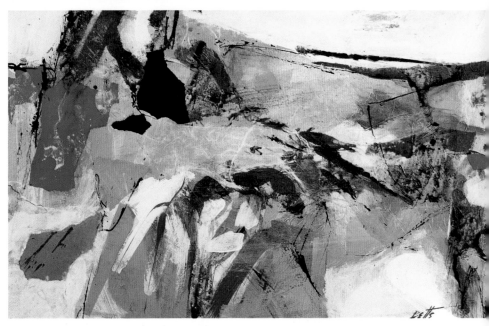

FACE OF THE ROCK, 1968, MIXED MEDIA ON MASONITE, 11 × 23". PRIVATE COLLECTION.

The panel was covered haphazardly with paint, then coated with 50/50 acrylic medium and water. Using black India ink I drew quickly and impulsively, using the bottle stopper as a drawing tool. After drying, another coat of 50/50 was applied to seal off the ink lines. While being brushed over with the diluted medium the ink sometimes blurred slightly, not a serious problem since it partially softened the lines and furnished a greater variety of line quality. The next stage saw the introduction of collage shapes, then another layer of diluted medium, then more ink drawing and more diluted medium and more paint, both glazed and opaque. One of the considerations is to retain the freely gestural in order to keep the picture fresh rather than tired and overworked.

IMPROVISATIONAL PAINTING IN MIXED MEDIA

In handling mixed media, I prefer an improvisational approach. Having cleared my mind of any preconceptions as to subject matter, I let my manipulation of paint, cut and torn papers, sand, and so on, provoke unexpected color and shape relationships out of which my composition evolves.

I regard the beginning of each new panel as a fresh adventure, an exploration into uncharted territory. I try to avoid habitual ways of working, allowing accidents to happen and then finding solutions, ways to incorporate new forms into the fabric of the picture. This is mentally stimulating and far more of a challenge to me than simply rendering a preconceived idea.

I feel that one of the drawbacks to representational painting is that the artist more or less knows before starting what the finished picture will look like. For me, at least, this lessens some of the excitement of creation. With my approach to mixed media there is risk, a sense of walking a tightrope, perhaps, but one must be willing to take chances now and then. With my approach you do not force your will upon the painting; you cooperate with the materials and share in the challenging process of bringing order out of chaos.

BEGINNING THE PAINTING

After I prepare my panel with three coats of acrylic gesso (remember, no ground is required on illustration board), I begin the underpainting by brushing in big, haphazard areas of color with absolutely no subject matter at the back of my mind. Once those areas have been established in as accidental a way as possible, I coat the entire panel with an isolating layer of diluted acrylic medium.

When this has dried, I may draw into it improvisationally, using carbon pencil, India ink, or paint. Following that I add still another coat of acrylic medium. The layers of acrylic medium between layers of paint and paper help achieve a feeling of depth and luminosity in the finished painting.

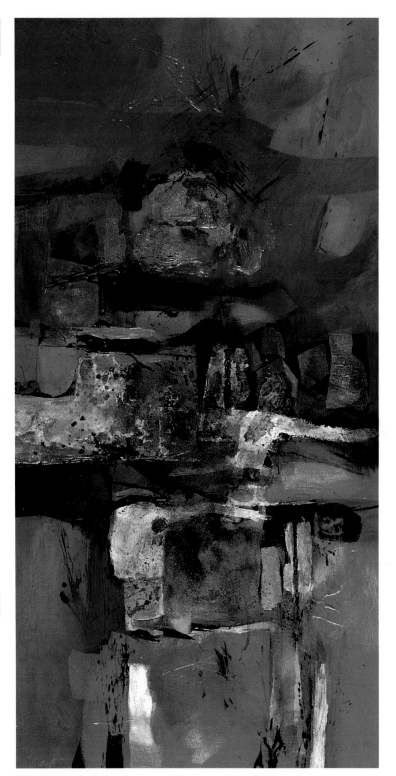

RED ROCKSCAPE, 1965, MIXED MEDIA ON MASONITE, 48 × 24". COLLECTION OF THE ARTIST.

This is one of those paintings that are quite mysteriously apart from any of the paintings done before or after it. The surface of the Masonite was prepared by adding some acrylic gel to the gesso, so it had a more brushy texture than most of my panels. Next I coated the whole surface with ITR Light, which, when dry, I glazed and wiped with ITR Crimson and some Acra violet. Other materials were added—acrylic modeling paste, paper, and sand—all of which were glazed, scumbled, rubbed, scratched, and spattered. At the very end I built up one area of gold powder mixed with acrylic gloss medium. The final image is elusive—perhaps half rock, half person in an ambiguous environment—but to this day this painting remains one of my favorites.

DEVELOPING THE PAINTING

At this stage I begin to introduce collage elements, tearing out both large and small shapes in either tissue or colored papers and affixing them to the surface with diluted acrylic medium. Then I paint into the surfaces again, freely and playfully, responding intuitively to lines, shapes, and masses that may (or may not) be forming relationships that suggest an image or design.

I try to postpone finding any image too soon. Instead, I continue the process of natural growth, keeping the painting open and flexible, susceptible to any changes and revisions that occur to me. If I have an impulse, I follow it. Anything is possible, because at this stage of the work nothing is fixed or permanent.

As the painting proceeds, an image begins to emerge that evokes ideas, memories, and associations, and this image or conception then becomes what I call the "control" for all subsequent decisions. Everything that I add to the painting from this point on refers very specifically to, and is determined by, that overriding concept or pictorial idea.

Photograph of the boatyard at Perkins Cove, Ogunquit, Maine. Coming upon this three-dimensional "collage" while wandering through the boatyard, it struck me that the collage medium was just what I should try using at that particular time in my art. Designing with collage was one thing, but painting with collage, combining it with other media and materials, seemed to offer even richer and more varied visual experiences. Happily my newly chosen direction coincided most fortuitously with the appearance of acrylic paints on the market.

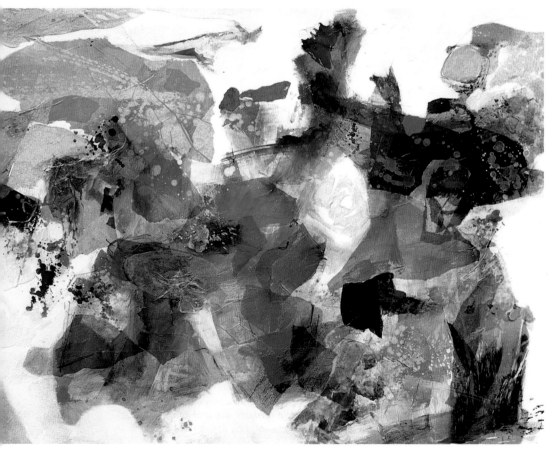

ROCKPOOL, 1964, MIXED MEDIA ON MASONITE, 28 × 36". PRIVATE COLLECTION.

I really let out all the stops on this one, which is a veritable orgy of textures. I did not want it to be too ordered and controlled since I was working for that jumble of forms, colors, and textures; that tangle of lines, dots, and masses that one sees in the depths of a tidepool. Almost everything here has its equivalent in nature, in a real rockpool: water, seaweed, kelp, periwinkles, bubbles, encrusted rocks, and shadowy half-seen forms that could be animal, vegetable, or mineral. Here are sand, tissue paper, synthetic paper, ink, watercolor, and acrylic paint that has been brushed, glazed, sprayed, wiped, scumbled, spattered, and flung.

SUGGESTIONS FOR MIXED-MEDIA PAINTING

When you are painting in mixed media, especially in the early phases, your mood should be relaxed, carefree, and uninhibited. You must learn to trust your intuitions and tell yourself that the picture will come out beautifully even though at the moment it may look like a hopeless mess.

Feel free to block out any areas that are not functioning successfully. Moreover, if an unusually beautiful passage does not relate well to the total effect, then that, too, has to be eliminated or brought into adjustment. The effect of the whole is far more important than any one part.

Let the picture grow naturally— nudge it, baby it, guide it, but look upon it as being more like a Japanese garden than a formal French garden. If it becomes too neat and rigid, throw on some paint, get mad at it, loosen up the design, and bring it along less self-consciously. Take delight in handling the paint and collage. Immerse everything in rich color. Enjoy watching unplanned things appear. Later, you can settle down to the satisfying business of bringing out structure, order, and emphasis. The search for structure is an important part of the act of painting. I remember when I was an art student we did not speak merely of painting, but of *picture-building,* a term that

reinforces the concept of *constructing* a composition in terms of planes and volumes within pictorial space.

Although random actions may start the painting, they do not finish it. What was begun in a mood of playful accident should end in a mood of contemplation and cool calculation. The final painting should be carefully orchestrated so that the viewer's first impression of the picture is not *here is a mixed-media painting,* but rather, *here is a painting—which just happens to have been executed in mixed media.* In other words, do not make the viewer too aware of your materials; they are the means to an end but should not be unduly apparent or distracting.

HOW DO YOU KNOW WHEN TO STOP?

I suppose the question most often asked about improvisational painting is: How do you know when you are finished? This is probably a very real problem to many people for two reasons: (1) There is no subject matter toward which the picture can be directed from the beginning, and (2) a generous amount of accident plays a part in the development of the picture. There is a risk that the accidental effects, appealing as they might be, can go on happening almost interminably while the artist stands around waiting for something marvelous to appear.

This could be a frustrating situation, so it is therefore doubly important that you keep yourself attuned to what is happening on the painting surface. You must always be ready to act in answer to what arises there, to recognize and grasp those elements that suggest the route to order and structure in the painting. Once the control image has been found, the act of painting becomes more purposeful. Finally, a point is reached when you find yourself fussing with unimportant little things, when you have said all you wanted to say, when nothing can be added or subtracted without upsetting the picture's overall organization. At that point, your painting is finished.

FRAMING MIXED-MEDIA PAINTINGS

All exhibition prospectuses specify that acrylic paintings will be judged as oils if they are framed as oils, without glass, and as watercolors if they are framed with glass. This rule also applies to acrylic collages and mixed-media work.

Since it has been left up to the artist to decide just how he prefers to submit his painting, he should consider the general look and scale of the painting in question. In my own work, my only rule is that if the picture is on illustration board I frame it as a watercolor, and if it is on a large Masonite panel I have it framed as an oil.

Mendocino, Stage 1. The panel was first coated with Yellow ochre acrylic, then broad strokes and spatters of diluted gloss medium, over which sand was sifted while it was still wet. After drying, all excess sand was brushed away and acrylic colors (opaque red acrylic and transparent green watercolor) were added to the composition—such as it is.

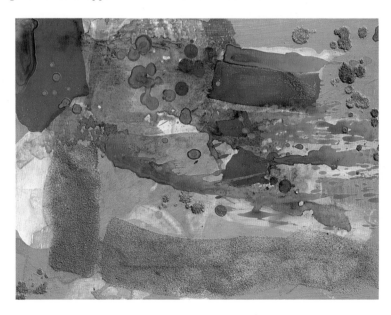

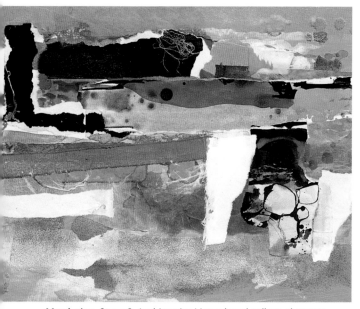

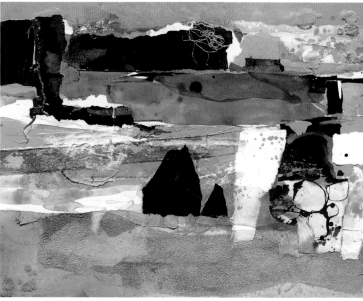

Mendocino, Stage 2. At this point I introduced collage elements: parts of wash drawings, a strip of muslin, some loose threads, shapes torn from rice papers and prepainted watercolor papers. Next came some more colors—orange, pink, red, blue—some opaquely, others as transparent washes in ink, watercolor, and acrylic. Nothing was considered precious or sacred; all areas were subject to possible change and revision. Although there was the hint of a subject emerging, it was not yet recognizable.

Mendocino, Stage 3. The black shapes began to suggest rocks or headlands, the blue-greens took on watery associations, and then even a specific geographical area came to mind—the rugged coast of Mendocino, California. Once these decisions had been made and a "control" image had begun to appear, all subsequent additions to the picture related to that central idea as to where and what the picture was all about. Unifying the surface—making it readable— was the main objective from here on.

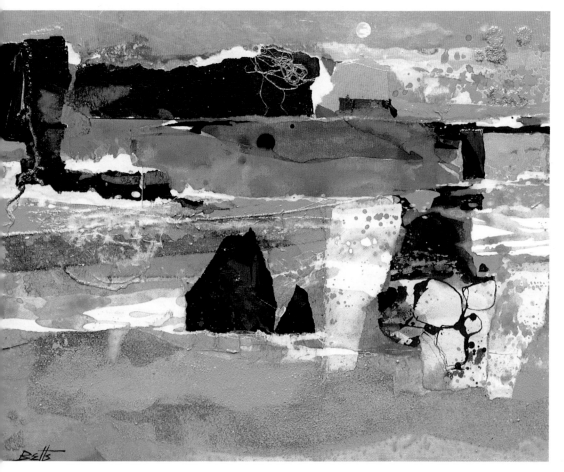

MENDOCINO, 1992, MIXED MEDIA ON ILLUSTRATION BOARD, 13 × 17".

The picture in its final form remains a sensuous experience in mixed media surfaces, but it should be noted that in the earliest phases the mixed-media techniques were utilized in the search for the basic character of the forms that would ultimately prevail in the finished painting. Once those forms had been determined, mixed-media methods were then used again to control the design and provide a range of textural variation. The orchestration of all the elements used is of the utmost importance; the composition must read as a whole, without any undue awareness of the wide variety of methods and materials involved in its creation.

SPRINGTIME, 1990, ACRYLIC ON MASONITE, 15 × 21". PRIVATE COLLECTION.

This did not start out as a spatter painting, but as the picture evolved the dappled color took over, and I followed enthusiastically. The drippings may look casual and random, as indeed they sometimes are, but they still must be fitted consciously into the patterning of colors and values that give structure to the picture. If the dripped paint is too jumpy or spotty and disrupts the surface, it should be removed and the process repeated until it relates properly. One of the most interesting effects of dripped paint is the vibrating color produced by dripping colors of equal intensity into each other, such as pink into orange, red into green, or pale green into deep yellow. Variations of emphasis as parts of the surface come forward or recede, are assertive or diffident, are controlled through color choices and the relative scale of the color spots.

PAINTING WITHOUT A BRUSH

Centuries ago some of the great Asian painters were fond of flung-ink techniques. In more recent times, Jackson Pollock—and before him, Hans Hofmann—demonstrated dramatically that paintings could be made without the direct touch of brush to canvas. They poured, dribbled, and flung their paint, not with the intention of shocking their audiences but to achieve what they hoped was a greater immediacy of contact between artist and viewer, and also to rid themselves of the tyranny of traditional, conventional methods of applying paint only with a brush. Other major contemporary painters have hit on the same idea and used it according to their own needs and artistic styles: Morris Louis, James Brooks, Helen Frankenthaler, Robert Motherwell, and Paul Jenkins are only a few.

To be sure, the brush is still an indispensable tool for the painter. I am not advocating an elimination of all use of the brush, which I believe will always remain the principal means not only for getting paint onto the picture surface but also for conveying—through the expressiveness of the brushstroke—the character of the artist.

Nevertheless, we painters tend to repeat the same strokes, the same gestures, just as naturally as we sign our names. A certain amount of repetition begins to set in, and although this might be interpreted as a recognizable mark or style, there is always the danger that it can become monotonous and boring (for example, when paintings are seen as a group in a one-person show) or, at worst, the strokes can become meaningless in their relation to the subject matter.

It seems to me that if we are to be truly creative in our thinking, the same spirit of creativeness and discovery should extend to the technical means used to put the color on paper. Experimentation with methods and materials must necessarily accompany experimentation with pictorial concepts, an expansion of means as well as of mind.

The brush can produce many effects, but it does have its limitations, and to press beyond them requires using it with other tools or materials and trying out unorthodox methods that will extend the range of surface effects and textures. Experimentation means getting away from old, shopworn routines and taking chances, acting on impulses, responding to effects that might not be possible with the brush. It means thinking inventively and looking for new solutions. Such experimentation is stimulating for the artist and for the viewer.

The various ways of painting without a brush are not a substitute for brush painting but are means to supplement brushwork and enrich the look of the various paint surfaces. So, how about taking a vacation from the brush? See what can be done through other methods that require a different way of thinking—that are less easily controlled perhaps, but which are just as applicable to painterly expression.

NOTES

Paints

Either watercolor or acrylic paints can be used, or both can be combined in the same painting. Begin the picture with the thinner transparent paints and add the opaque colors as the picture develops.

If transparent watercolor alone is used, care must be taken to preserve some white paper, at least in the early stages, by masking off areas with liquid frisket (such as Maskoid), newspapers, or masking tape. Start painting with light, high-keyed washes and work toward the middle values and the darks later. This procedure is not necessary if only opaque paints are being used, since it is possible to alternate light and dark applications continually, retrieving lights that might have been lost using transparent techniques.

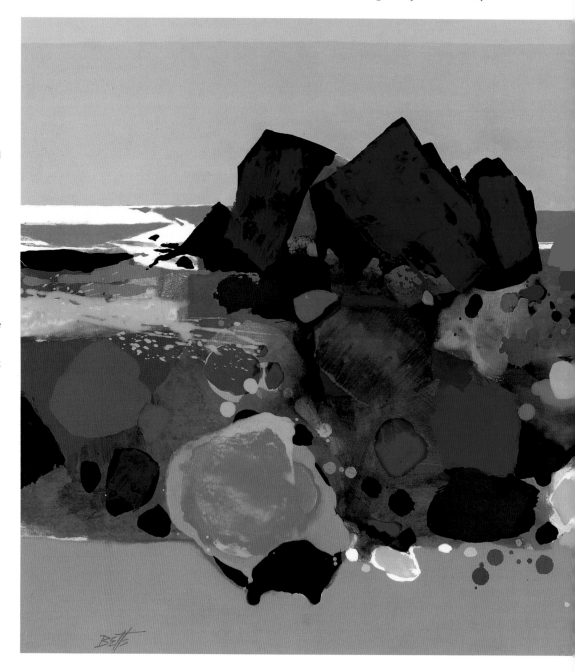

MAINE SHORESCAPE, 1979, ACRYLIC ON ILLUSTRATION BOARD, 22 × 30". PRIVATE COLLECTION.

This is essentially the same subject as *Oarweed Cove* (see Chapter 3, page 41). Some of the shapes might appear to be collage but are not; all the rock forms were created with the transfer method. The attitude toward the use of color is quite different than that in the earlier version, where the color was more tonal. Here it is not so much value against value as it is color against color. Also, this color is more vivid and daring, but more assured. A painting should reflect the joy that was felt during its creation; every picture has its dark moments but they should not show.

Brushes

True, brushes will not touch this picture, but they are required for flinging or dribbling paint, or for spatter. Of course, a toothbrush is always convenient for stippling. Some experimentation will suggest which brushes are best for specific purposes: Paint flung from a watercolor brush, for instance, produces a splash quite different in character from that flung from a 2-inch bristle brush.

Ruler

This is used somewhat as though it were a brush: A pool of paint can be

poured onto the paper or panel and then spread across the surface by laying the ruler in the midst of it and sweeping the paint around in arcs or bands or whatever shape seems appropriate to what is happening in the painting. (I suppose this is a little akin to playing the piano with the entire forearm rather than the fingers, as the vanguard composer Henry Cowell sometimes did.) At any rate, the ruler pushes the paint around, thinning it out and distributing it in broad masses and shapes, sometimes dragging it over previous layers to create intriguing textures or broken color.

Although I use a 12-inch plastic ruler, any ruler at all will serve, or even strips of cardboard, providing they are stiff enough and have edges straight enough to move the flow of paint as a wide mass rather than in streaks, as sometimes happens.

Plastic Containers

When paints are to be poured, dribbled, or flowed onto the picture, larger amounts of paint are needed than are normally mixed on the palette. Plastic containers or large paper cups are required to hold such quantities of paint.

Before beginning a series of paintings in acrylic, I premix about twenty-five colors, some of them pure colors straight from the jar and others that are mixtures, all of them in varying degrees of opacity and transparency, and then store them in a set of covered plastic jars. I place them to the left of my painting panel, somewhat as though they were pigments on a palette, to dip into or pour from when I'm working. It's important to keep the paints covered when not in actual use.

Sometimes an entire container is emptied to create a large area of color, but generally enough paint is left so that other areas can be painted with the same color, and retouching, if necessary, can be done very easily without having to remix and match the previously painted colors. Or these containers can be used to hold color mixtures that will be sprayed or poured in a one-shot operation and will not be needed over a prolonged

period of time. (I find that my work is done either very rapidly, in a single session, or at the other extreme, over a period of six to ten months.)

Fixative Blower or Spray Bottle

There are two methods of applying a spray mist of color over the picture. One is to mix color in a container and use a fixative blower—the kind used for charcoal fixative or oil retouch varnish—to spray it. The other method is to mix color in a spray or atomizer bottle, such as a Windex bottle, and spray the color directly from it.

I tend to prefer the former method because not as much paint has to be mixed when I need only small or moderate amounts. With a spray bottle, however, a certain level of paint, often considerably more paint than is really needed for the picture, must be in the bottle before the spray mechanism will lift it up and expel it. Also, acrylic paint used in a spray bottle is likely to clog the mechanism unless special care is taken to clean it thoroughly with very hot water after each use.

Newspapers

I keep a small stack of old newspapers not far from my painting table. They are used for lifting color and blotting, or they can be painted and used to transfer color to the picture, usually with unpredictable but fascinating textural effects.

Ink Roller, or Brayer

The ink roller can be used to apply paint throughout, although I am apt to use it more frequently in the earlier stages of the painting and not at all as the picture nears completion. For certain geometrical designs, the roller, or a series of rollers of different widths, might conceivably be used to paint the entire picture.

Paint Rags

Paint rags are not just for cleaning brushes and wiping off palettes but also for painting. Crumpled in the hand and dipped into paint, the rag is a good tool for spreading on large washes of color. Obviously, it would not be very effective for work requiring detail or exactness.

METHODS OF APPLYING PAINT

As you might already suspect, painting without a brush is not as limiting as it might at first seem, and in fact it is even something of a challenge to see just how much can be done without recourse to more familiar methods of applying paint. Let us now examine what some of those alternative methods are (remember, all these methods are equally applicable to watercolor or acrylic, although it is the latter medium in which I use nonbrush methods the most).

Pouring

For pouring paint it is essential that the paper or panel be lying flat on an absolutely level surface. To assure that my surface is level, I check it very carefully with a carpenter's spirit level, placing the level in several positions on my painting table to make sure that not even the slightest tilt could affect the flow of paint once it has been poured. If there is to be any tilting of the panel, I want to control it myself and not have the paint accidentally flow off in a direction I had not intended. The idea is for the pool of color to stay where it was poured so that it can be left as is or guided slightly and possibly allowed to spread out to some extent. I do not want it wandering off on its own!

If acrylic paints are to be poured, mix the paint from jars in fairly large amounts, stir thoroughly to make sure the colors have been completely blended together, and store in covered containers. Pouring the paint from the container is something that can be done with sweeping gestures from a foot or more above the picture, or it can be done cautiously and slowly from only a few inches above the painting.

The paint can be poured on a dry surface, where it will more or less retain its shape with a minimum of spreading out and leveling. Or the surface can be moistened first—with a wet cloth, sprayed with water, or brushed with diluted acrylic medium—and the paint poured into the wet areas to spread naturally and form unusual patterns.

To control the spreading and flowing, the paint that is poured on should be thicker or heavier than the damp surface or wet paint that is to receive it. If the paints are too thick, however, they may dry into an ugly, encrusted surface, and since this is an effect I am not fond of, I mix my paints anywhere from a very thin, transparent

Diluted white over dry dark paint, with brief drifting

Glazes allowed to drift

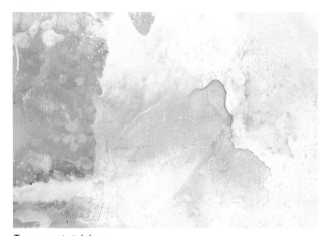

Transparent staining

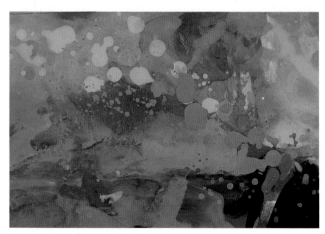

Dripped paint, light into dark

wash containing a good amount of acrylic medium and some water to an opaque mixture about the consistency of heavy cream. I seldom use paint much thicker than that.

Once the paint has been poured, it must be allowed to dry and set. It is a good idea to check it every now and then to see that it is drying more or less according to plan. The drying process itself, because the paints are so very fluid, may take anywhere from a couple of hours to overnight. After the paint has dried, other colors can be poured on. Try not to be in a hurry; to pour on too much wet-in-wet at one time is to end up with a mess in which everything flows into everything else, losing all shape and pattern.

I recommend leaving the panel in place while it is drying rather than moving it to dry elsewhere in a spot that might not be as perfectly level as the painting table.

One technique I especially enjoy is underpainting large areas with dark colors and after the paint has dried flowing on a very thin, semiopaque wash of light color, sometimes tilting the board to let it drift even more thinly. When the latter wash dries, it usually produces a delicate, granular effect that can either be left as is or glazed over to excellent advantage.

Pouring color is a highly effective way of beginning a painting, of setting up shapes and color relationships. Pour freely and spontaneously at first; as the picture proceeds, the pouring should be done with greater care and precision.

Dripping

This is a variation of pouring, but with less paint, and is generally done when there is only a little paint left in the container or when only small spots of color are needed for small-scale areas. Here again, if the drips or droplets are of heavier paint consistency than the paint into which they fall, the spreading of the color is minimized and paint does not drift aimlessly. It retains more of the original shape it had when it first reached the picture surface. When I drip paint, I like to use color oppositions that have color vibration or bounce—for example, a pale, intense blue against a golden yellow, a pink against bright orange, or a brilliant orange-red against a blue-purple.

Some painters favor a plastic mustard or catsup dispenser with a pointed spout from which the paint can either be dripped or squirted. They feel this gives them greater control over the quantity and size of the color blobs.

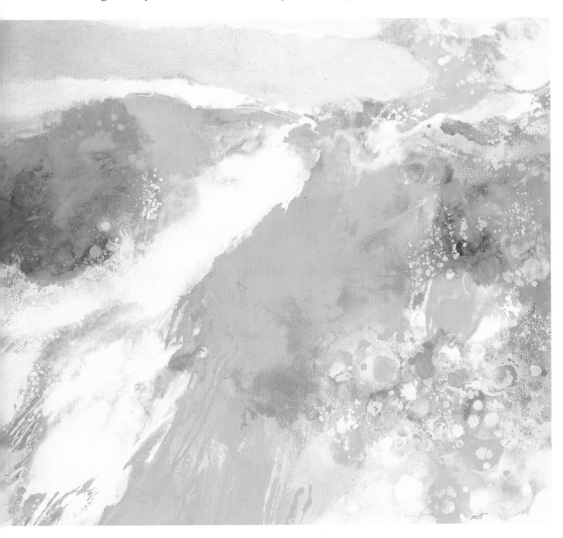

SUMMERSCAPE II, 1975, ACRYLIC ON MASONITE, 42 × 50". COLLECTION WILLIAM A. FARNSWORTH LIBRARY AND ART MUSEUM, ROCKLAND, MAINE.

Several areas in this picture were done by pouring generous amounts of paint on the panel, then tilting the panel on edge or on one corner to let the color drift and run, either as a mass or in dribbles and rivulets. In other areas, paint was dropped and spattered, and since the subject had declared itself to be a hillside scattered with flowers and grasses, I kept the colors high-keyed so as to project the feeling of light and warmth, choosing colors that were naturally bright and intense. Cadmium orange was the darkest color, and all the other colors were of equal or near-equal intensity, thus emphasizing color vibration rather than tonal contrast.

Flinging

Flung ink or paint was used by Chinese artists several hundred years ago and was a technique very much in fashion at the height of American abstract expressionism during the 1950s. There is no doubt that tossing off paint with a sharp flick of the wrist gives the picture a sense of freedom and abandon, a sense of the paint acting on its own as a combined result of the force of the stroke, the fluidity of the paint, and the distance or angle at which it was tossed at the picture. (As a fringe benefit, it is also probably splendid therapy for the artist!)

In watercolor, the flung paint must be right the first time. If the splash looks ugly or formless or does not fulfill its function in enlivening an area, it can ruin the entire picture—unless it can be successfully wiped off without a trace.

In acrylic, since previous color layers are waterproof, flung paint that is not satisfactory can be completely cleaned off and the operation repeated until the artist is satisfied with the look of the "happy accident." Quite often I have flung acrylic paint at a picture ten, fifteen, or even twenty times before achieving a splash that felt right to me, that functioned properly as color and shape or line, and that gave the impression of having happened naturally and casually, without a hint of the effort required to achieve it.

In other words, just *any* splash or blot that is flung onto the picture will not do. It must be a fully integrated part of the painting; it must be expressive, provide some kind of accent or change of pace, or activate an otherwise unremarkable passage. Most of all, it should have an inevitability and an aesthetically satisfying look to it. To achieve all this in one stroke is not as easy as it might appear, and a very considerable amount of practice goes into getting a feel for how much paint should be used, how fluid it should be, which brush should be used, and what gesture of arm or wrist would best accomplish the desired effect.

Flowing

The methods of flowing paint are very similar to the wet-in-wet technique in transparent watercolor. One method is to pour or drop paint onto a surface already moistened with water or with acrylic medium diluted with water. If only water is used, the paint may spread and flow very freely with little control possible; if diluted medium is

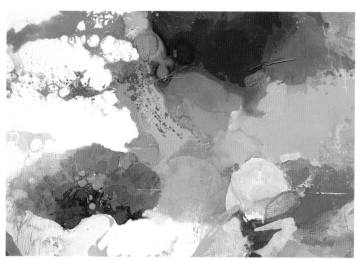

Paint dropped onto both wet and dry surfaces

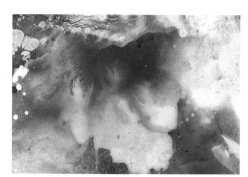

Thin washes poured, then sprayed with water

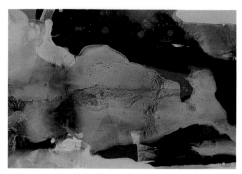

Thin paint flowed over thick dry paint

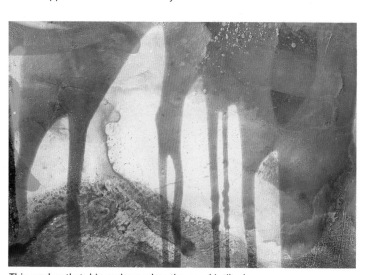

Thin washes that drip and run when the panel is tilted

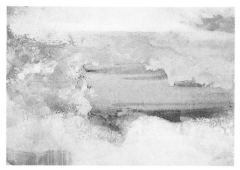

Wet-in-wet allowed to drift very briefly

used, the paint does not flow quite as readily or freely. Instead of wetting a whole area in preparation for flowing paint, it is a simple matter to moisten only those areas where the flow is needed—in strips, circles, any shape at all—so that the flow effect is restricted within very clearly defined boundaries. Once the paint has dried, the same area can be wet again and glazed with repeated application of flow paint.

The other method of achieving flow effects is to pour, drop, or fling paint onto a dry surface and while the paint is still wet spray it with water from an atomizer bottle. Greater control is possible in this case since the amount of water sprayed is entirely up to the artist. With a little spraying the paint will not flow far, perhaps merely blurring an edge, but if a great deal of water is sprayed on, the paint can spread farther, over a broader surface. If the paint is very fluid, the water spreads it easily and permits freer flow. Conversely, the thicker the paint, the less the water affects it, and its flow is relatively confined.

This pour-and-spray method offers a greater latitude of choice as to hard and soft edges, since the spray can be applied selectively to only one edge or one part of a shape, leaving the rest of that area with a hard edge.

The flow process should be used on a level surface so that whatever flow takes place can be monitored by the artist. Intentionally tilting the paper or panel is always possible in order to assist the flow, but an unintentional tilt could ruin the whole picture. The artist has to remain watchful and blot or wipe up the color when it wanders into territory where it is not wanted.

Even though the flow method is essentially and profoundly accidental, it is still left up to the artist to impart some quality of order and color orchestration to the picture. Accident combined with aesthetic intuition and a sense of selection and design can result in a meaningful work of art. To leave everything totally to chance is to remove the personal element and to relinquish all responsibility for creating a world of forms that is, if possible, both intellectually and emotionally satisfying.

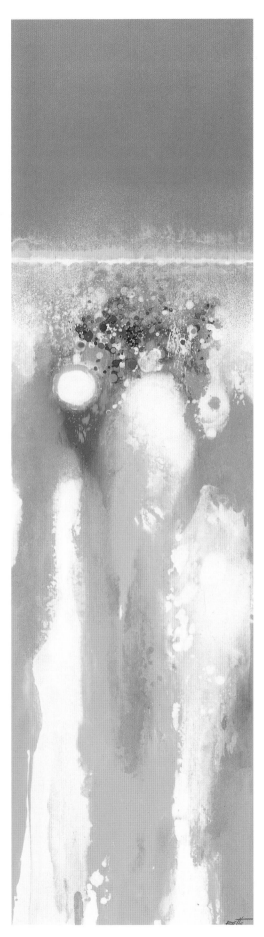

PASSAGE INTO SPRING, 1978, ACRYLIC ON MASONITE, 48 × 14".

This was the first time I used drifting, flowing color as a major pictorial element occupying the greater part of the design. It was applied both as wet-in-wet and over dry areas. The sky is built up of multilayered stippling, with a great deal of attention given to the blended transitions and soft edges just above and below the horizon. Multiple spattered layers suggested the flowers. With so much paint being spattered about, it was essential to occasionally mask off large parts of the picture with newspaper in order to protect them from unwanted flying paint. By barring any use of the brush on the surface I avoided ingrained habits of applying color, and gave myself something to struggle against.

Spatter

A technique used by even the most conventional watercolorists is spatter, in which the paint-filled brush is tapped sharply on the forefinger or some rigid object, causing the paint to fly in spatters upon the picture. Using generous amounts of fluid paint on the brush will result in large blots scattered over a wide expanse, whereas somewhat thicker paint will result in a finer-textured spatter that is confined to a more restricted area. In either case it would be wise to mask off with paint rags or newspapers any parts of the picture where spatter is not desired.

Although spatter is usually employed in rather moderate amounts, either as descriptive texture or simply as a paint texture, I have on occasion used spattered paint to create very large areas of pointillistic broken color, areas perhaps 2 by 5 feet in size. To build up such areas solely by the spatter method is a long and laborious method, to be sure, but there is no other way I know of to achieve that special effect. (I have seen Chinese ink paintings in which an entire landscape composition was formed exclusively through the spatter technique, the spatter ranging in scale from massive blots to a fine spray.)

Spattered passages can be applied in large areas, or liquid or paper friskets can be used to limit the area to be covered and to mask edges so as to form specific, designed shapes. Spatter, like spraying, can also be used effectively to create transitions between areas without having to blend paint—gradations from one color to another or from light to dark and dark to light.

Spray

Spraying paint is a refinement of the spatter method, a reduction of the small dots of paint to the finest spray mist imaginable. Spray is applied either with a mouth fixative blower or a spray bottle. Very subtle optical effects of superimposed colors are possible with sprayed paint, but ones quite different in appearance from those obtained by glazing. In addition to spraying large areas, edges and shapes can be created by masking off sections of the picture with pieces of torn newspaper randomly placed. This will produce an interplay of soft, blurry edges with sharper, crisp edges and gentle color transitions as the shapes fade from one to another.

A stencil technique can also be used. Here, a single cut-out or torn-out shape is placed on the picture, sprayed,

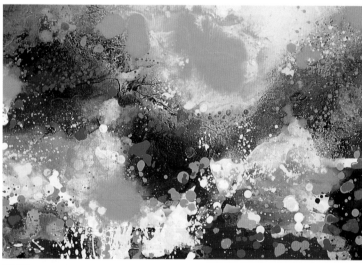

Spatter

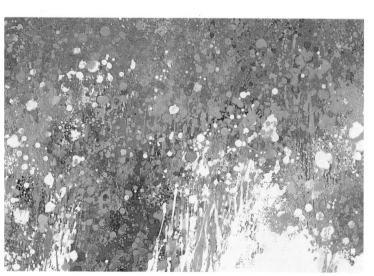

Stipple

Spatter forms in nature. Spatter, the clusters of many large and small dots of paint, has its counterpart in nature. Shown here are spatter patterns from underwater in a tidepool and shallow water washing in on the shore. Of course, other spatter forms are to be found elsewhere: lichen on a rock, water drops on the windshield of a car, bubbles in foaming seas, flowers in a field, or periwinkles clinging to submerged rocks. If we liken the process of developing a painting to nature's own processes of growth and change, then spatter can be regarded as being one of the principal visual elements. It is one of the universals, so to speak. (Also, it's fun to do, as any child can tell you.)

then moved slightly and sprayed again. Various placements of the shape and the overlappings of the sprayed paint produce interesting repetitions and combinations of shapes, all related to each other through the original cut-out shape.

My sole reservation concerning spray techniques is that if they are overused they can create a look that is too slickly mechanical and posterlike, too smooth and anonymous to relate well to the more painterly, freely handled areas. Spray must be used with some discretion so as not to dominate the picture surface. It should remain in its place as one of many methods in the painter's repertory.

Stipple
Applying paint by scraping a knife blade along a toothbrush dipped in paint produces a pattern that is more delicate than spatter but not quite as fine, and not distributed as evenly, as spray. I use this method mainly for small areas, with or without a frisket, to break up color, provide a textured surface, or create transitions between areas.

Here again, it goes without saying that areas not meant to receive the stippling should be carefully masked off. Sometimes when I am not careful enough about that, I may be shocked to find that three or four maverick drops of paint have landed somewhere distant and spotted an area in which they obviously do not belong. Usually, if caught in time, these spots can easily be wiped off with water. When dry acrylic paint is stubborn about being removed, denatured alcohol will probably do the trick.

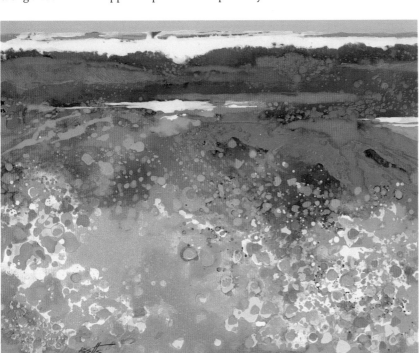

SEA AND MEADOW, 1979, ACRYLIC ON ILLUSTRATION BOARD, 14 × 18". PRIVATE COLLECTION.

In this case, spatter has been used as a foil for more conventional paint application elsewhere in the picture. The sky was the only area painted with a brush; all the rest was flung, poured, softened with waterspray, blotted, transferred, wiped, glazed—and of course, spattered. Quite a variety of methods of getting paint onto the surface can be used, but they must be integrated and orchestrated into a readable whole, not a random mingling that is confusing to the eye.

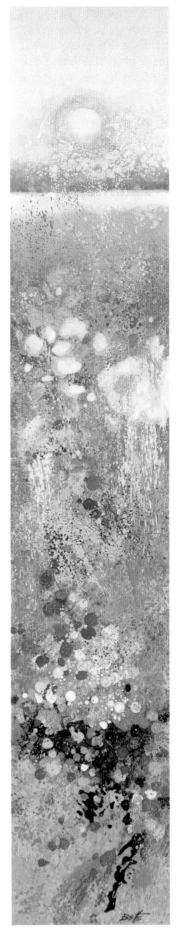

SUMMER SUN, 1972, ACRYLIC ON MASONITE, 39 × 7". PRIVATE COLLECTION.

Once the major color areas had been established, the remainder of the picture was done wholly with spatter and stipple, where the brush, only lightly loaded with color, is tapped forcibly against an extended forefinger, resulting in a very fine spray of paint. The entire surface was composed of dots and droplets—almost an impressionist use of tiny units of color. Instead of deep, saturated colors, I preferred here a more delicate range of color notes that was consistent with the handling of paint. The hanging scroll format betrays my devotion to Asian art.

Transfer

The transfer method involves applying paint fairly generously to newspaper, cardboard, or matboard, then quickly placing it paint-side down on the picture. The paint will spread and form accidental shapes that can be turned to good account by the artist. Hand pressure on the newspaper or cardboard will cause the color to spread farther, influenced by the direction of the pressure.

I like to place a long, torn strip of painted newspaper on the panel, then lift it up and replace it in a slightly different position. Since the greatest part of the paint is deposited on the picture the first time, each succeeding time it is placed down there is less paint transferred to the picture. It remains a solid color no longer, but a beautifully mottled color-texture.

Lift and Blot

The reverse of painting newspaper and applying it *to* the picture is to use flat strips of newspaper to lift wet paint *from* the picture. The idea here is to get paint onto the surface by any means at all, then immediately tear some newspaper or a clean paint rag, lay it on the fresh paint, press or rub it with the hand, lightly or heavily, then lift it. This action accomplishes two things: It slightly alters the shape of the painted area, and it lifts or blots up part of the paint, thinning it out and leaving a textured effect that is often quite handsome. Fresh paper can be used to lift off even more color if the first application did not lift a sufficient amount.

Or the newspaper originally used for lifting, with the wet paint still on it, can be used to deposit that paint elsewhere in the picture. Lay it right back down on the surface once or twice more, but shift

Use of brayer followed by glazing

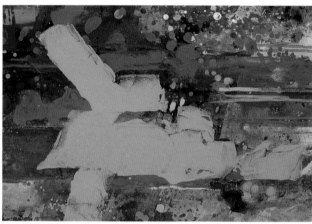

Painted newspaper applied several times in different positions

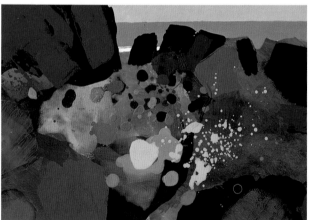

Color transferred with newspaper and spattered after drying

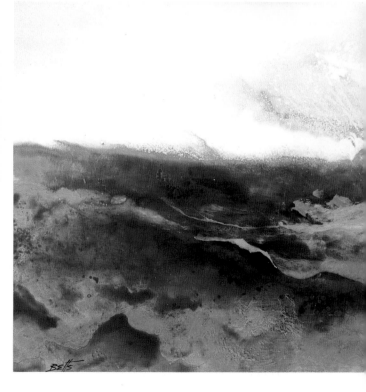

SEA-MIST, 1972, ACRYLIC ON MASONITE, 15 × 48". PRIVATE COLLECTION.
Whereas the sky in this painting was done with flow paint combined with spatter and stipple, the water was begun first with flow techniques and then developed in more detail with blot-and-lift and transfer methods followed by glazing. Some spatter, followed by glazing with Phthalocyanine blue and green, further unified the area and controlled the flow of lights and darks across the composition.

the angle at which it is placed. In other words, use a single piece of paper for two immediately successive operations: to lift color here and to transfer it there.

A variation would be to crumple the newspaper tightly, then open it up and press it briefly against the wet paint, creating strange shapes and textures within the color area. Such shapes often seem to have reference to geological formations and surfaces. Then, too, rags can be pressed into paint to lift color, leaving the woven texture of the fabric showing in the paint remaining on the picture.

Rolling

Applying paint with an ink roller, or brayer, is relatively simple and is commonly done. As I mentioned before, it is most useful in getting a picture started, but the method is limited when it comes to the refinements that are usually necessary in the later stages. The paint should be fairly fluid so as to roll on easily; if it is too thick or stiff it goes on too dryly and produces more of a ragged, spotty texture than a solid band of color. Some roughness or irregularity of texture could, of course, be very

welcome, but too much of a broken-up color surface could destroy the feeling of solidity or mass.

Sponge

Synthetic (cellulose) kitchen sponges, which are standard equipment for most watercolorists, can be used not only to lift or wash off paint, but also to apply it. The sponge is saturated with paint and then wiped across the picture for broad strokes and general washes of color, or it is dipped into paint and dabbed on the picture to produce textural markings.

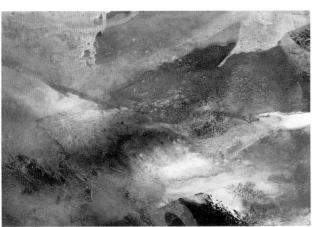

Wet paint blotted with newspaper

Lifting diluted white paint

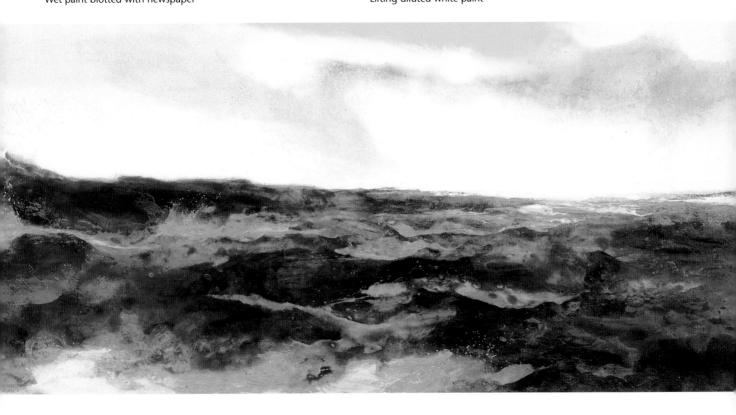

Whatever methods are used in painting without a brush, the main thing to keep in mind is that they should not be allowed to descend to the level of gimmicks or novelty devices, mannerisms that display the skill of the painter without expressing anything pictorially meaningful. As Gustave Moreau told his pupil Matisse, "The mannerisms of a style can turn against it after a while, and then the picture's qualities must be strong enough to prevent failure."

Since a picture as a totality is far more important than the methods or materials used in it, the painter must take care not to get carried away by an infatuation with sheer process. The methods suggested in this chapter are a means to an end, a supplement to and extension of the paintbrush, but they should be used only when the need for them is sincerely felt by the artist. Otherwise, the end product is not a work of art but little more than a decorative trifle—with no more substance than cotton candy.

Many of the painting techniques mentioned in this chapter lead to some gorgeous color and texture effects. It takes stern discipline on the painter's part not to fall in love with some appealing passage that has absolutely nothing to do with the rest of the picture; it takes courage to paint it out or repaint it so that it becomes fully integrated with all the other parts of the picture. The other problem can be to fall in love with an area but not know what to do with it or how to give it meaning. No matter how intriguing some small area may be, it may have to be sacrificed for the good of the whole picture—the whole picture, in the long run, is what counts most. It should function as a totality, not an assemblage of several isolated sections lacking coherent formal structure.

Using techniques in which accident plays such a prominent role requires that same stern discipline in still another respect: It is all too easy to be seduced; to relax and sit back and let the paint have its way; to accept the accident as the final statement. Admittedly, some areas might appear to be complete in themselves, apparently not needing the artist's touch, but this, I think, is the exception rather than the rule. The artist's job is to scrutinize, deliberate, and then make tough decisions, remembering that technical methods are always subordinate to what is being expressed, that it is the artist who controls the paint, not the other way around.

THE SEA BEYOND, 1973, ACRYLIC ON ILLUSTRATION BOARD, 22 × 22". PRIVATE COLLECTION.

My working idea here was a field of flowers set against a distant background of mist and ocean. The painting is a compendium of just about all the nonbrush techniques mentioned in this chapter. The spots of color, both pastel and brilliant; the color vibrations between strong colors; the range in scale from tiny stippled dots to large pools and blobs of color; the varied edges and blendings—all were made possible by the use of paint applications that avoided the standard uses of brush or painting knife. This is not really a painting of flowers, of course; it's about units of color coming together, and about atmospheric effects at the seashore. Flowers are merely an excuse for playing with paint, not to be rendered as a horticultural record. It isn't that most flower paintings are terrible, it's that most painters have not adequately dealt with that subject in terms of formal and coloristic relationships.

Edge of Winter, Stage 1. The very general divisions of the picture surface were faintly apparent even in the earliest stages, but I like to keep the painting open and not let an image appear too soon. Spontaneous improvisation is a most enjoyable phase, after all, and the fun might as well be sustained a while until the point is reached when nitty-gritty decisions have to be made.

Edge of Winter, Stage 2. The overall structure seemed so loose and formless that I decided to place a blue strip at the upper edge of the panel to provide a straight, hard-edged geometric element that would act as a foil for all the softness elsewhere in the composition. That thin strip was a start, but too thin and small to be effective. Nevertheless, it was that firm horizontal that suggested the possibility of an almost subliminal grid of horizontals and verticals functioning just beneath (or behind) the forms nearest the picture plane.

EDGE OF WINTER, 1987, ACRYLIC ON MASONITE, 42 × 46".

Finishing the picture was a matter of developing greater nuance and delicacy over the entire surface: subtle shifts of warm and cool whites and grays, oppositions of hard and soft edges to bring out the atmospheric qualities, and an interplay of simplicity and complexity. The geometric understructure was sensed rather than overt. Landscape here was not described or specific; a quality of weather was the principal subject: the chill dampness of snow and wet mists as winter ends and edges toward spring.

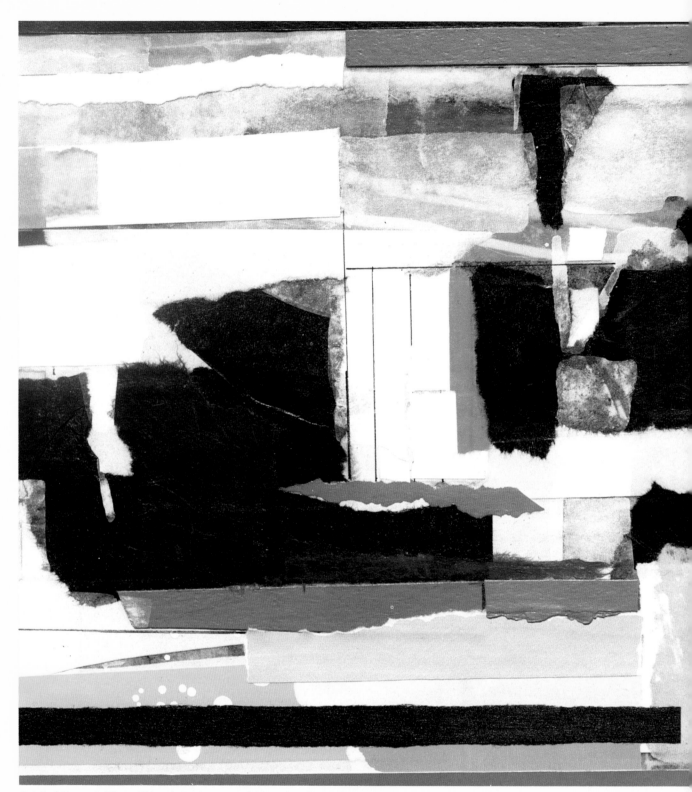

Detail of *Quarry in Winter.* This painting is a successful interplay of irregular organic shapes versus geometric hard-edged shapes, flat and textured, transparent and opaque; of paint working both with and against collage materials made up of rice paper, typing paper, prepainted watercolor papers, and black tissue paper (which seems to retain its color better than the other colored tissues). (See page 125 for the complete painting.)

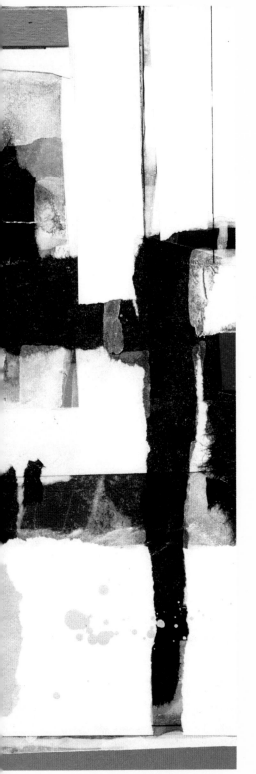

PAINTING FROM NATURE TOWARD ABSTRACTION

There are two general ways to deal with subject matter in abstract painting. One is to begin with an observed motif and take it by stages—either mentally or through preliminary studies—from realism toward abstraction, which is the process that concerns us in this chapter. In the next chapter we will discuss the alternative procedure of beginning without a subject and discovering it through the act of painting.

In a sense, painting from nature toward abstraction can be considered as making variations on a theme, since the artist responds to a specific subject and then develops it, logically and intellectually, on several levels and through several phases: realism, simplification and analysis, semiabstraction, and nonobjective design; in short, from descriptive realism at one extreme to pure design at the other.

Abstraction is not the sort of thing you leap into without acquiring a thorough understanding of the subject beforehand. The artist must understand what the subject looks like, analyze its forms and spaces, and identify the emotional response to be expressed. This chapter is a problem in several parts, an outward enactment of the mental processes a painter might go through in painting an abstraction based on a theme taken from nature. The first phase in the development of the motif is *research,* drawing and/or painting from nature. The second phase is *analysis,* in which shape, value, and pattern are explored. The final phase is *synthesis,* a bringing together and integration of the previous phases into a painting that is a combination of formal structure and expressiveness.

This systematic reorganization of the subject in abstract terms is not altogether coldly analytical, since it allows plenty of leeway for personal response and for experimentation with color and design. The principal advantage of such a process is that the painter knows what he is doing at all stages during the evolution of his picture and is therefore in complete control of the situation at all times. His control enables him to treat the final version very freely and loosely, if he chooses to, because of the knowledge and confidence that he has gained from thoughtful preparation. In music, such an approach was used by orchestra conductor Herbert von Karajan, who was said to rehearse his players with exactitude and precision to reach complete perfection of detail and then let them play freely during actual performances.

The other advantages to this approach are that by the time the artist has explored his motif from several viewpoints and gotten to know it well, he has clarified in his own mind exactly what he wants to say. Now he can project his vision of that subject as forcefully and directly as possible, with no fumbling or ambiguity; moreover, he has considerable latitude as to just how far toward abstraction he cares to carry the motif—whether he wishes it to be stylized, semiabstract, symbolic, or even totally nonobjective.

PHASE 1: REALISTIC

I use representational drawing and painting as a means of familiarizing myself with the subject. Long before I attempt to paint an abstract version, I have already observed and either sketched or painted the subject from

several viewpoints, trying to find the most dramatic effects of light and shadow and seeing which angles suggest the best compositional arrangement of the forms. Sometimes these viewpoints are combined in a single painting that portrays the subject from more than one angle simultaneously, as in one of the later phases of this exercise.

I visit the subject at different times of day. As every painter and photographer knows, early morning and late afternoon usually provide the strongest shadows, which are of special importance to me. It is the shadows, or darks, that give a watercolor its drama and its compositional structure, so I try to make the most of them. Because I have always regarded watercolors as a tonal use of that medium, depending for their success on the design and patterning of the light and dark washes, I invariably am conscious of the lighting of the

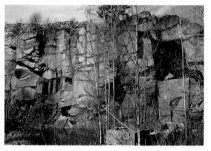 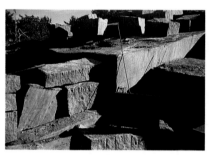 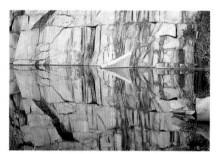

Quarries—like barns, cliffs, surf, skyscrapers, clouds, subway stations, bookshelves, flowers, or mountains—are already abstract to begin with. These photographs of quarry motifs give an idea of the forms that first appealed to me, forms that are best seen in strong, dramatic lighting that heightens the sense of shape and pattern. The blocky forms and diagonally cast shadows have a cubistic look to them that is irresistibly attractive to many abstract painters.

The pencil drawing was done on the spot as a research drawing, indicating the scale and character of the forms. I wanted the sketch to supply me with information, but not in so much detail that I would be a slave to visual facts when it came time to paint.

The ink-and-wash drawing was done later from memory in the studio, executed entirely in Neutral Tint India ink and a sumi brush. This is a painterly kind of drawing, visualizing the scene as a winter composition and reducing the forms to dark gray against the white of the paper.

Research drawings of this sort are the first visual contact with the motif, and since such impressions are important, these sketches must catch and hold whatever the response was to that subject. From this point on, no matter what transformations may take place later, that first vision must be retained.

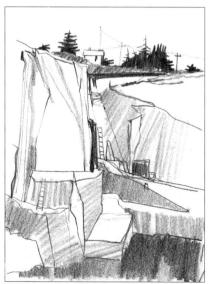

MAINE GRANITE QUARRY, PENCIL ON PAPER, 14 X 11".

MAINE GRANITE QUARRY, INK AND INK WASH ON PAPER, 14 X 11".

subject: how it reveals the basic form and how it can be utilized to give the picture a maximum of light and dark contrast.

Although my representational watercolors are meant to record the subject only in the most immediate visual terms—what it *looks* like—I also may do two or three other versions, trying for variations of mood or perhaps composition. Here I try out different vertical or horizontal formats to see how much of the subject might be included or omitted.

Seeing the subject at different seasons of the year is a vast help in developing other ideas and getting to know the subject intimately. The angle of the sun will change the lighting; snow may create new patterns and designs; the colors of fall or of rainy skies may suggest other schemes. All this should be recorded for later use in drawings or watercolors, or stored away in the memory.

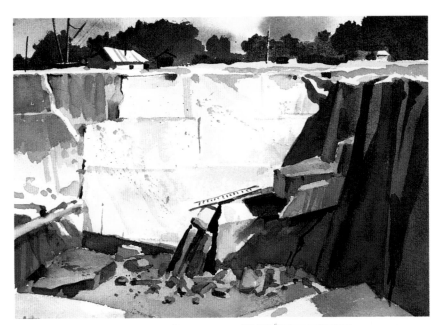

QUARRY STUDY, 1974, WATERCOLOR ON WHATMAN ROUGH, 7 × 10". PRIVATE COLLECTION.

This on-location study is so tiny that there is no room for detail or refinement of textures, but it does stress the strong light-and-dark pattern upon which the final version was based.

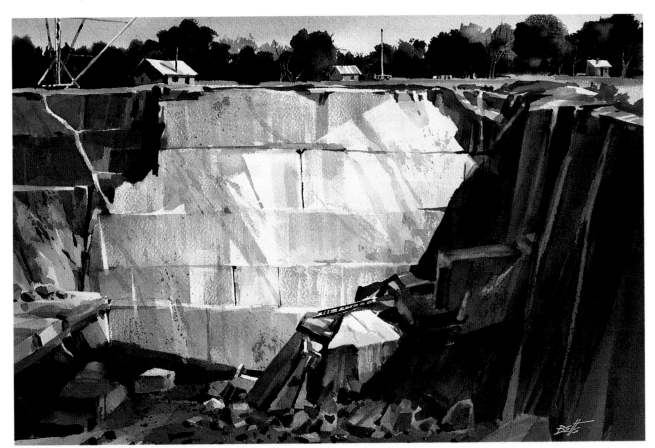

SWENSON'S QUARRY, 1974, WATERCOLOR ON 300-LB. ARCHES ROUGH, 14 × 21". PRIVATE COLLECTION.

The culmination of the realistic research phase is often a fully developed watercolor or gouache. By that time there is a thorough understanding of the quarry, its form relationships, and the way it is affected by lighting. Several different quarries were the source of the work reproduced in this chapter so there was no temptation to paint a particular quarry in all its specifics, but rather the final picture would be the "essence of quarry," going beyond the local to something more universal. Note that there is already a hint of abstract design beneath the realism. I strongly suspect that the study above is, as usual, better than the painting that resulted from it.

PHASE 2: SIMPLIFICATION AND PATTERN ANALYSIS

Once the subject has been assimilated on a purely visual level, the time has come to examine it more schematically in two different respects: severe *simplification* of the essential forms and analysis of the light and dark *pattern,* as a means of searching out the structure that exists in nature.

To simplify the forms is to get rid of extraneous detail—unimportant incidents and accidental effects—and to concentrate on bringing out only the basic, elemental planes and shapes. You will discover some of their design potential, though still on a fundamentally realistic level. However, there is no need to push toward abstract reorganization too early; merely emphasize whatever relationships seem to express the subject in its very simplest terms.

At just this point, I change my attitude toward light and shadow. No longer is it a matter of light striking a sculptural volume; in my mind light and shadow have been transformed into an overall arrangement of pattern in a scale of five values. I use lights, darks, and middle tones to design the rectangle within which I am working, whether it be a page in my sketchbook or a sheet of watercolor paper or illustration board.

Most paintings need a clearly worked-out pattern, not only to give the picture its strength, but to keep the surface from looking flat and monotonous. Very often it is the manipulation of pattern that first opens the door to abstract design, and it is in the planning of this pattern that purely pictorial considerations take precedence over description of the subject as the eye sees it. These are the first departures from reality, where top priority is given to those decisions that relate to the total organization of the painting as a painting. The subject has dropped in importance; designing the surface has taken over.

I should point out that studies in simplification and pattern should be done monochromatically, in three or four values of a single color, so that there is no chance for a rainbow of colors to distract from the prevailing purpose of this phase.

QUARRY STUDY (LINE ANALYSIS), 8 1/2 X 18". MARKING PEN ON PAPER.

An analysis of the linear elements of the watercolor on the previous page would produce a diagrammatic analysis something like this, though each artist's analysis is entirely personal and invariably quite different from one done by someone else. Here the lines of varying weights and thicknesses were drawn with a marking pen and ruler without a preliminary blocking-in. It developed without plan, and the only guide for what lines did and where they were placed was constant reference to the watercolor that preceded this exercise.

The main idea behind the line analysis is the emphasis on the major lines and shapes, simplified and stylized so that they activate the surface of the paper in a way that is close to abstract design but that never loses sight of the original subject. Planes are reduced to bare linear forms that intersect and overlap; the subject is flattened out so that volumes are treated in as two-dimensional a way as possible, denying their volume and insisting above all on the flatness of the paper surface on which the lines are drawn.

The analytical line design is the first time where purely pictorial considerations take precedence over the appearance of things in nature, and when finished, this line drawing should be interesting mostly as a manipulation of interacting line elements; the subject itself is of only secondary interest. It has become a vehicle for design conceptions, but is no longer the primary object of interest.

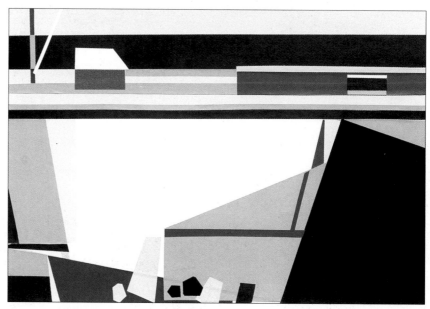

QUARRY STUDY (VALUE ANALYSIS), COLLAGE ON CARDBOARD, 12 X 18".

In addition to line analysis, and equally if not more important, is the analysis of value and shapes. Here the cardboard was given a coat of light middle gray, and then construction paper in white, black, and two grays was laid out on the drawing table. There was no preliminary drawing as a basis for placement of shapes; many of the values being used referred directly to the realistic watercolor version of the quarry. (Watercolor, gouache, or acrylic can be used just as effectively as collage.) Every effort was made to keep the shapes strong and simple, to maintain contrasts of values so that no two adjacent values were the same, and to arrive at a dramatic, readable design in which there was a varied range from very small shapes to very large masses. For me, the pattern of light and dark can often make or break a painting, so this value study is one on which I place the utmost importance.

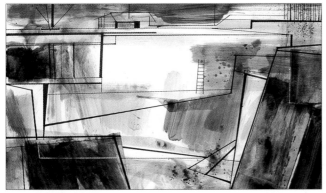

QUARRY STUDY (COMBINED LINE AND VALUE ANALYSIS), MARKING PEN AND WASH, 14 × 24 1/2".

In this study I combined free washes with superimposed line analysis, an approach to the subject that comes nearer to a painterly treatment. The splashy washes were done without any drawing beforehand, and it is the straight ink lines that serve to give the composition a more disciplined sense of order; each acts as a foil for the other, setting up a tension between the loose patterning of the wash values and the control of the linear structure. (It is like superimposing two quite different slides to form a more complex arrangement and interaction of parts than either one of them has alone.)

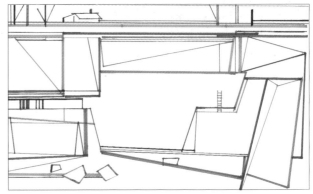

QUARRY STUDY (COLOR-LINE ANALYSIS), DESIGN MARKERS, 11 1/4 × 18".

This cannot really be called a color study since only lines, not shapes, are handled in color. This is simply an exercise in beginning to bring color into play as a pictorial ingredient, but without a commitment to any specific colors as they might function in the finished painting.

Once line and value have been thoroughly explored, and decisions made as to the best way to construct the picture, solutions to the color problems, in terms of volumes and space, can be dealt with later as a separate phase. Analyzing color simultaneously with line and value can be accomplished, but only with the passage of much time and with considerable experience.

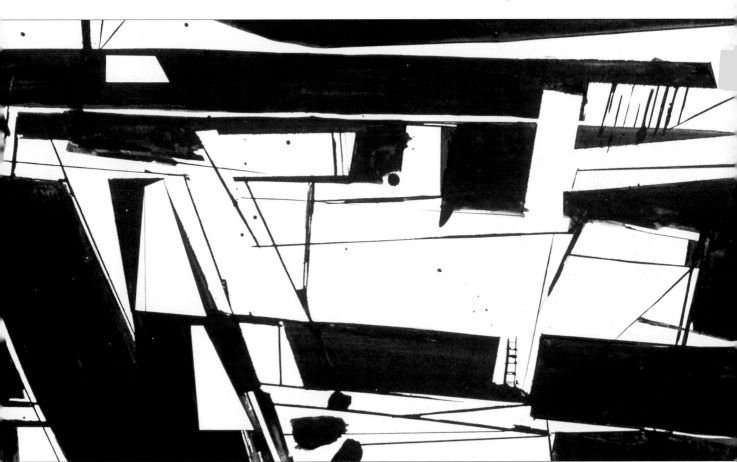

MAINE QUARRY, 1976, BLACK ACRYLIC PAINT ON ILLUSTRATION BOARD, 11 3/4 × 20 1/2".

With the research and analysis phases behind me, it was now time to bring together what had gone before in the way of all that was seen, known, and felt about the subject, and to explore avenues that would lead to a more fully realized treatment of the theme. This rapid gestural drawing is a spontaneous interpretation that emphasizes the quarry's dramatic contrasts of light and dark—its jumble of sharp forms—that are characteristic of almost any quarry. Some areas were applied with a brayer or a wide bristle brush, while linear accents were struck in with a painting knife. The forms in this drawing were extracted from the forms in the quarry, and then intensified to the point where expressiveness was far more important than description. If its sources are known, this drawing can be seen as a meaningful abstraction rather than the nonobjective design it might at first glance seem to be.

PHASE 3: SEMIABSTRACTION

Semiabstraction is a matter of carrying the design further in terms of pattern, paint texture, and especially color, though not so far as to make the original subject unrecognizable. Hence my use of "semiabstract," by which I mean halfway between descriptive realism and pure design.

In traditional watercolor painting, values and patterns are more important than color organization; in abstraction, color constructs the picture, creates its mood, and establishes its spatial relationships. Even though the completed abstraction may have very muted or limited color, the relationships among brilliant color shapes initially get the picture under way.

Colors here are nevertheless firmly anchored to the values in the preceding pattern study. If, however, color is to be the major concern, and if the color relationships are in themselves beautiful enough, pattern then becomes less important. Black-and-white reproductions of paintings by Bonnard look like so many mudpies, since it is color alone that carries his pictures—color so shimmering and radiant that we are happily willing to overlook the fact that pattern, structure, or academically correct drawing are often missing.

When a painter is not an accomplished colorist, though, an understructure of pattern as a base for the color will give the picture visual drama, an abstract arrangement of values that will compensate for possible color deficiencies.

I know of no one book on the subject of color that answers all an artist's color problems. Most of the color books seem to lean too strongly toward the theoretical, and as fine as they are, they somehow have very little application to the actual problems faced in the studio from day to day. Many things that look so orderly and systematic on the printed page are almost impossible to carry over into a painting in progress.

The only way to learn about color is to deal with it intimately year in and year out and to discover its limitless potentialities, emotional and intellectual as well as optical. The number of apparently natural-born colorists is depressingly small; most of us have to learn our use of color the hard way through years of trial and error; of thinking, looking, and painting; of solving new color problems as they arise in each picture. A strict and undeviating set of rules for color use is the kiss of death to creative painting. Color knowledge does not result from a scientific system but from each

artist's personal struggle. I wish there were an easier way, but there isn't.

In this semiabstract study, color can be explored more freely than ever before because color can be divorced from subject matter if the artist's ideas so demand. Color does not have to be true to nature; it can be selected with consideration only for the requirements of the picture itself. This freedom to use color for its own sake is one of the liberating qualities of abstract painting, and it seems to me that if we are working with various colored paints then we should enjoy the use of color to the utmost—not simply tonal or descriptive color but *creative* color—using it as a reference to the visible world, of course, but mainly as a sensuous experience and for ordering of space.

If I give the impression that I like raw or crude color, that is a mistake. I do like rich, brilliant, opulent color, strong and vibrant, but if color becomes gaudy and cheap, then that means that the colors have not been successfully related to each other in terms of intensity and of proportion. I can tell a student that such and such a group of colors is handsome or exciting, and yet it turns out that the student's use of these very colors produces something less than handsome or exciting. He used the suggested colors, so what went wrong? Perhaps he used the colors in incorrect proportion to each other; he missed the fact that one of the major color considerations is *how much* pink, *how much* orange, *how much* green or brown or gray. As I have said, there are no color rules that guarantee success. It is mostly a matter of developing color sensitivity, learning to sense how much of a particular color should be used in relation to the others.

Aside from this, color has to be used intellectually to create spatial situations—a logical progression and recession of forms within the established pictorial space of the painting. Cézanne used his color touches in such a way that each dab of color took a very specific position in space, while denoting a facet of volume, or form, as well.

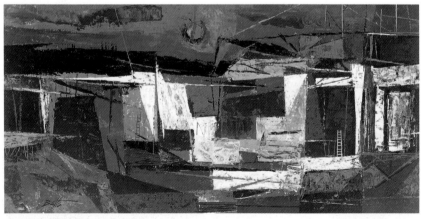

QUARRY, 1952, CASEIN ON ILLUSTRATION BOARD, 13 × 26 1/2". PRIVATE COLLECTION.

This painting, winner of four awards in national exhibitions, was purchased before I had a chance to photograph it in color. The casein was applied with a painting knife, which was a help in bringing out clear-cut, faceted forms and suggesting stone textures. The picture grew out of improvisational color-shape relationships, but with the knowledge beforehand that it would be a quarry subject. It is a freely reorganized version of the original motif, partly because the forms had to be related to the accidents out of which the composition developed, and partly because the idea to be projected was more that of quarries in general than of any particular one. *Quarry* is a semiabstract painting: Instead of leaning toward either realism or pure design, it lies somewhere midway between nature and geometry.

According to the tenets of tonal painting, color becomes lighter and grayer as it recedes into space. In abstract color painting the situation can often be reversed, so that planes we know in our minds to be at the rear of the picture space are painted with intense color and planes near the front of the picture are painted in more subdued or neutral colors. The purpose is to keep those rear planes from receding too far back and the front planes from coming too far forward. This unexpected manipulation of space, this reversal of normal relationships, not only helps to maintain a limited depth in strictly pictorial terms, but is also another way of frankly departing from the look of things. It reorganizes nature into a series of relationships that are complete in themselves, based on reality but dealt with from the viewpoint of creating a *painting,* not a report of what the eye has already seen.

The semiabstract phase, then, is where reality becomes secondary to imagination, invention, and an integration of visual reality with color and design.

PHASE 4: NONOBJECTIVE

In its purest form, nonobjective painting has no subject matter at all. A painting of this sort refers to nothing outside itself. It is totally self-sufficient: The relationship between the pictorial elements in their barest form is what constitutes the basis for enjoyment of the picture. For this reason there are many artists and critics who regard nonobjective art as the most elevated form of aesthetic experience.

There are two basic categories of nonobjective painting: *geometric* (hard-edged) and *painterly* (freely brushed). The geometric is static, formal, decorative, and decidedly intellectual in its appeal. All elements in the painting are precisely and tightly organized, adjusted with highly refined taste. The painted surface is clean, mechanical, and anonymous. The purity of the conception and the color-shape relationships are of the utmost importance.

In contrast to that, painterly nonobjectivism is very loose, informal,

and highly emotional. Instead of developing in an orderly manner, the picture is a triumph of intuition and spontaneity over discipline and rational analysis. Freedom and excitement replace precision and calculation, and every effort is made to avoid the look of conscious organization. The paint surfaces are casual and vigorously brushed, with no attempt at nuance or refinement. There may even exist an intentional brutality that keeps the work from looking too polished or "artistic."

Although nonobjective art is supposed to have no sources in nature,

some of the finest abstract expressionists do indeed draw their ideas from observation of the everyday world. Nevertheless, by the time they have finished dealing with it, the subject is no longer even faintly discernible. One of the greatest of our contemporary hard-edged painters, Ellsworth Kelly, readily admits that he constantly uses reality as the source for his severely geometric compositions: a shadow, a fragment of architecture, the spaces between objects, a scarf forming a triangle on a woman's shoulders, or the piping on a tennis sneaker.

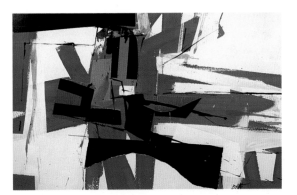

COLLAGE SKETCH (QUARRY), 1968, ACRYLIC AND COLLAGE ON ILLUSTRATION BOARD, 12 × 17". PRIVATE COLLECTION.

This is a nonobjective treatment in which gesture and shape take precedence over the look of the original motif. Collage was used in conjunction with painted brushwork in order to stress geometric qualities, but the subject matter was no longer of any importance.

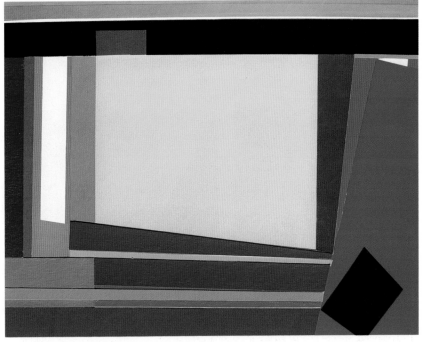

QUARRY PATTERN, 1992, COLLAGE ON ILLUSTRATION BOARD, 11 × 14".

If the quarry forms are condensed, distilled, and purified to the point where they are reduced to wholly abstract symbols, then we are dealing with painting in which the subject has been completely submerged in the interests of working exclusively with the most formal, intellectual relationships. This is a hard-edged nonobjective painting, yet it is still possible to identify the sources of several of the shapes and planes. This is an example of using nature to derive suggestions for a nonobjective composition that is to be experienced as pure form, complete in itself. I could have pushed this even further toward a minimal number of horizontal-vertical relationships, à la Mondrian, in which the quarry would disappear altogether.

It is then quite possible and legitimate to take the subject that has just been dealt with as a semiabstraction and push it all the way to total abstraction, where design is everything. Reality has now been banished from the picture, except insofar as it provided the initial idea. This can be accomplished either by a process of extreme simplification and distillation, or by closing in so near to the subject that enlarged detail eliminates any trace of recognizability. All that remains now is a concentration on the design relationships, and the fewer the elements the more perfect the adjustment of the relationships between those elements must be.

In the more painterly approach it is possible, after having carried the subject through the three preliminary phases, to start a picture with a few random marks derived only generally from the original motif and then proceed to develop a nonobjective composition. One color stroke leads naturally to another. A red area here demands a blue touch there. A picture evolves spontaneously, to be enjoyed as pure paint, color, and shape. But nonetheless its beginnings are in reality, and if the subject is too apparent it must be painted out until the final picture stands on its own as pure design.

I am convinced that in order to keep the forms in nonobjective painting vital and varied, to prevent repetitious, sterile design, it is essential that the artist stay in constant contact with all things visual, that he keep his eye eternally alert for forms and combinations of forms that he can eventually put to use in his paintings. The wells of invention can go dry unless they are continually fed by intense observation.

GENERAL REMARKS

Now that we have taken a motif through several progressive stages from realism to abstraction, it is time to assemble the paintings that have been done and assess the results:

Phase 1, done representationally, is probably the least interesting of the group, since it was done simply as a record of direct observation.

Phase 2 is more of a diagrammatic study than it is a painting, but the information it contains is crucial to what happens in the two final paintings.

Phases 3 and 4 do not necessarily have to be done in that order. Sometimes I do one first, sometimes the other, depending on the subject or on my mood at the moment. When Phase 3 precedes phase 4, the nonobjective

composition becomes the climax of the problem, where the subject is pushed to its ultimate limits as a distillation of its very essence in purely formal terms.

When the nonobjective phase is done prior to the semiabstraction, however, it serves to clarify the design and reduce it to its simplest elements. The semiabstraction then becomes the culmination, bringing together the fundamental forms through a painterly treatment in which subject, design, and painterly textures are all inextricably combined.

Either phase can be considered the logical conclusion of the entire problem, depending on your viewpoint and philosophy. For my own part, I regard the semiabstraction as the most demanding and by far the most difficult to achieve. Realism is simple if you have good training and are willing to take the time to paint things exactly as you see them; nonobjective design is also relatively easy if you have had good training and have an eye that is extremely sensitive to purely formal relationships of line, shape, and color.

But the average realistic painting can be boring because it depicts nothing more than what the eye sees. And the average nonobjective painting can be equally boring, because no

Rocks at Schoodic, Maine.

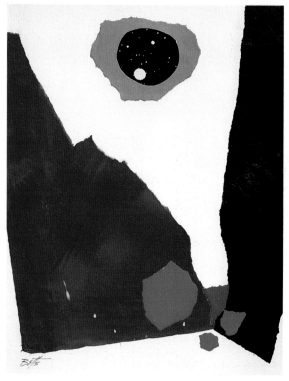

COASTAL FRAGMENT #8, 1969, COLLAGE ON ILLUSTRATION BOARD, 16 × 12". PRIVATE COLLECTION.

The sole concern here was the reduction of the subject to its simplest terms, of seeing how much could be said with how few shapes. Toward that end the final image was arrived at by means of rigorous simplification, elimination, brevity, intensification, and compression.

matter how intricately and beautifully it has been worked out, it is lacking in subject matter or substance and soon exhausts itself. One is short on form and the other is short on content.

The semiabstraction, however, is a complex balance of nature and geometry, and to effect a balance of that sort seems to me to be the highest achievement possible. It has been the struggle toward that goal—never reached—that has kept me painting all these years.

Quarry in Winter, Stage 1. The panel was covered with Yellow ochre acrylic, then Terra vert acrylic was painted on at random. When dry, rice paper shapes were applied in overlapping layers, and white lines were used to accent the surface and create movement. There was no subject in mind, just playing with ideas and materials, watching for whatever might emerge in the way of a subject.

Quarry in Winter, Stage 2. Further development in terms of both white and colored collage shapes, and still highly improvisational. There was still no haste to determine subject matter, though the strip of green at the top suggested a sky. The horizontal-vertical relationships began to stabilize the design so that it was no longer quite so jumbled.

Quarry in Winter, Stage 3. Semitransparent whites were painted in various areas, beginning to suggest depth, and only partially allowing color beneath to be visible on the surface. Ink lines drawn with a pen set up further visual activity and variety. By this time a quarry theme had been decided on, so that was the direction the composition would now pursue. A "control" image had been found, and the preliminary analyses were referred to when needed.

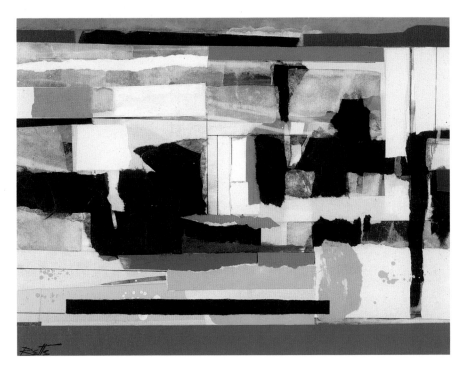

QUARRY IN WINTER, 1992, ACRYLIC AND COLLAGE ON ILLUSTRATION BOARD, 11 × 14". COLLECTION OF THE ARTIST.

The composition badly needed a support along the base, something to prevent its dropping out the lower edge of the picture; the blue band accomplished that and in addition supplied the idea of a quarry pool there. The ochre undercoat not only shows through in the finished work, but also affected some of its color selections. I should point out, too, that while the technical procedures in this picture were improvisational, development of the subject in terms of abstract design was based on the knowledge acquired earlier, in the research and analysis phases.

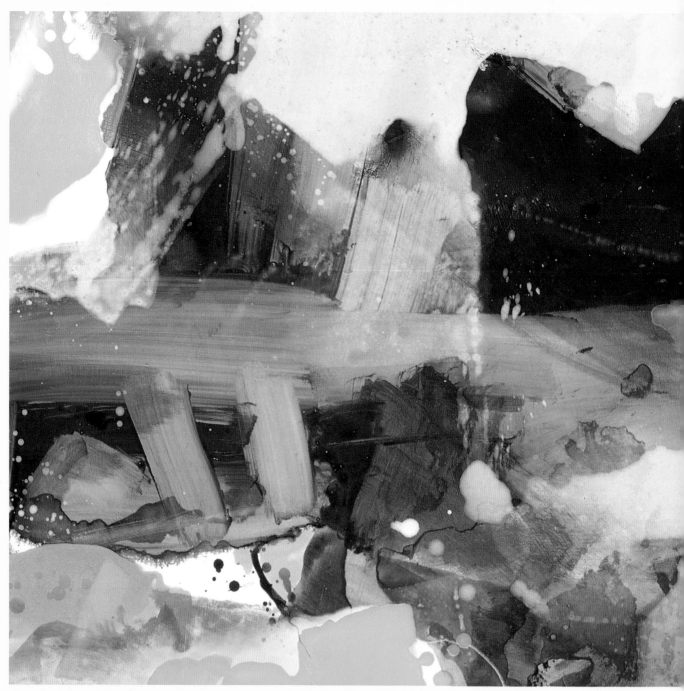

The colors I choose to work with in the first five minutes do not necessarily set the color key for the final painting, but the first colors, selected purely at random, certainly affect the choice of colors that follow immediately. (See page 128 for other beginnings of paintings.)

PAINTING FROM ABSTRACTION TOWARD NATURE

If the sequence of events is reversed so that instead of starting with nature, the painting begins with abstract forms that are gradually developed toward naturalistic references, a correspondingly different attitude and state of mind are necessary. In the preceding chapter, nature was observed and then carried toward pure design through a predominantly intellectual process. In contrast, painting from abstraction toward nature is, as we have noted before, largely intuitive and spontaneous, involving a considerable amount of chance.

It seems to me that most painters tend generally toward one approach or the other. Their tastes and personalities are inclined to be either classic, rational, and objective, or at the other extreme, romantic, intuitive, and subjective. Obviously, these opposing characteristics overlap in some individuals, but we usually find ourselves, in varying degrees, more on one side than the other.

Painting from abstraction toward nature means that the artist must dispense with the essentially Renaissance notion that a picture is prepared through a series of exploratory sketches followed by compositional drawings, pattern and color sketches, detail studies, and a final cartoon. While all this has a certain orderly quality to it, there are some painters who find it impossible to sustain genuine enthusiasm in such a long, drawn-out procedure. Their final paintings are likely to be rather contrived, or worse, stale and lifeless. For such painters, who cherish spontaneity, freshness, and directness of approach, and a response to materials, it would seem that eliminating drawing as a basis for beginning a picture and discovering the subject matter through the creative act itself would be a viable alternative.

Admittedly, this manner of plunging into haphazard color areas at the very start and emerging triumphantly with a satisfying work of art is not for everyone. For those who depend upon the security of knowing precisely what they are doing at all times and who require a logical plan of action, improvisational techniques can often produce only impatience, frayed nerves, and general confusion, with the added likelihood that these individuals may deceive themselves into thinking the picture is unified and resolved before it actually is. For such persons, improvisation might better be postponed for a while until they can muster their courage.

The painters who have the most success with intuitive methods are those who have extensive experience in, and knowledge of, painting from nature and who therefore have a deep reservoir from which to draw inspiration. These painters are sure enough of their professionalism to take certain risks, to venture into unknown areas without fear of the consequences; in fact, they are much less concerned with painting successful pictures than they are with discovering more about themselves and about possibilities in painting.

In addition, they resist easy solutions and the temptation to stop before the picture is fully organized. They demand more of themselves and of their paintings—they won't tolerate loose ends or unresolved parts—and it is this insistence on quality, on full realization of all that is involved in the picture-building process, that separates superior from mediocre work.

BACKGROUND FOR IMPROVISATION

Because I have accepted and learned to live with my split personality, I paint my watercolors and gouaches knowing exactly what I am after, with everything planned in advance and with a clear idea of what the finished painting will look like. In my abstract acrylics, on the other hand, I feel my way with no idea at all as to what the final result will be. As long as I keep the two approaches distinctly separate, no confusion of purpose or technique results within the individual paintings.

In any event, for some forty years the greater part of my painting output has been done improvisationally or intuitively. I cannot remember now exactly how I fell into it, and certainly no one suggested it to me, but I have the feeling I became aware of the possibilities quite fortuitously.

Probably I was preparing a panel with an underpainting of bright casein colors and suddenly saw the suggestion of a painting appearing there, but one different than the one I had in mind. Probably, too, I followed my impulses and decided to develop the new idea instead. It must have turned out rather well, because from that time on the pictures that evolved out of random underpainting pleased me far more than the conventional ones I had been doing up to that time. There was for me greater excitement in the process of painting because of the challenge of dealing with the unexpected things that occurred. From then on it was only a

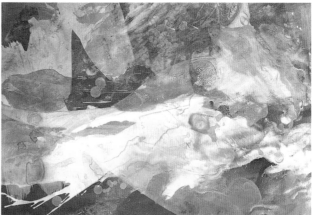

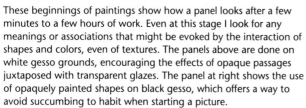

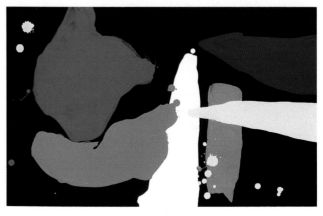

These beginnings of paintings show how a panel looks after a few minutes to a few hours of work. Even at this stage I look for any meanings or associations that might be evoked by the interaction of shapes and colors, even of textures. The panels above are done on white gesso grounds, encouraging the effects of opaque passages juxtaposed with transparent glazes. The panel at right shows the use of opaquely painted shapes on black gesso, which offers a way to avoid succumbing to habit when starting a picture.

If no subject appears, painting randomly is continued until either a design begins to form or a subject comes into being. It is important to stay intensely alert for whatever ideas might fleetingly occur to me on how best to capitalize on whatever accidents might happen. The completed picture is secondary to the search that led up to it.

matter of exploring that approach in greater depth and perfecting it as a "method without a method"—one consciously kept so open and flexible that it could never become routine.

In particular, two trips to Monhegan Island off the coast of Maine, in 1948 and 1950, had a tremendous impact on me and on my art. My memory and experience of that island, with its harbor, pines, cliffs, and crashing surf, kept cropping up in all my paintings with insistent regularity, almost obsessionally, for more than thirty years afterward. But the interesting thing

to me was that my representational paintings of that rugged island were academic and ordinary, pleasant but predictable, whereas the improvisational, semiabstract paintings were, I felt, more expressive of the rocks and cliffs and forest of Monhegan, more true to the spirit of the place.

This served to confirm my suspicions that the pictures that emerged from my subconscious paint manipulations— guided and controlled by memory and emotional response and a knowledge of nature—were the best I had yet done. They were not great by any means,

but they indicated a path to follow, a working method that might lead to better things. It was, in short, a highly gratifying coming together of an artist, a subject, and a way of painting.

So, in order to experience a fresh way of developing a painting, that of starting to paint without a specific subject in mind, put your sketchbooks and photographs away, clear your mind of any preconceived notions as to what you are going to paint, select a panel, squeeze out your colors, take brush in hand—and then begin to paint. It's as simple as that.

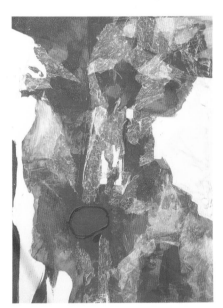

Snow Gorge, Stage 1.

This painting was begun in sand, paint, tissue paper, and rice papers on a gessoed panel. At about the point shown above, it began to read better as a vertical than a horizontal. My improvisational painting is an ongoing dialogue between me and the accidents that occur on the picture surface. I respond to the developing shapes, textures, and colors, thinking above all of creating a design that works as design, of course, but that also offers hints as to where I might guide it next, and as to what it might mean. Maintaining a state of flux, a ready willingness to follow any and all impulses, and feeling that everything is subject continually to possible revision, gives full play to my creative imagination. At a certain stage I decided that the reds exited the composition too equally at both top and bottom, so I cut them off near the top edge; simultaneously that upper area implied mist and sky, the white gesso suggested snow, and the reds seemed to refer to rocky forms, possibly a cliff. With the subject clarified to that extent, the whole picture acquired a sense of direction, and bringing it to completion was no problem at all.

SNOW GORGE, 1970, ACRYLIC AND MIXED MEDIA ON MASONITE, 48 × 35". PRIVATE COLLECTION.

For freewheeling improvisational painting, there is a free choice of materials: transparent watercolors, gouache, acrylic, or mixed media can be used. I have personal reservations, however, about the appropriateness of transparent watercolor for such work. I know it can be used—and some artists do—it is just that I have seldom had much luck with it. I prefer opaque or mixed media, where I can revise and repaint indefinitely, and I would recommend those media over transparent watercolor, especially for those painters who may be trying this approach for the first time.

It has always been my conviction that watercolor is principally for those who plan ahead and know what they are doing. If the improvisational approach is undertaken in this medium, there is a fair chance that the painting will get out of control. So rather than strive for its customary directness and freshness, the artist using watercolor might do better to try to work accidents to his advantage or depend on the various corrective measures available to a watercolorist in redoing areas that are not coming along successfully.

To those who insist on trying watercolor, I suggest that they use only the heaviest high-quality rough paper, which will withstand punishment in the way of wiping, bleaching, sanding, scraping, and sponging.

If the surface of the painting does not reveal any fumbling, it is quite possible to produce an improvisational watercolor that is not in the least tired or overworked-looking but instead is characterized by lovely nuances of subtle color and texture. Look, for example, at the marvelous series of sea paintings done in watercolor by Emil Nolde. They are accidents raised to the highest form of art, where perception, idea, image, color, and medium are all indissolubly entwined.

An alternative attitude in doing improvisational watercolors is what might be called the "picture magazine syndrome," whereby as many as a hundred watercolors are painted, but only five are kept by the artist as successful examples, all the others being destroyed. Considering the high cost of a sheet of watercolor paper these days, I doubt this is an approach that will have a strong appeal for many painters; nevertheless, it does remain a possibility for those so inclined.

It might be strongly advisable, then, to use gouache, acrylic, or mixed media for first efforts at improvisation and try watercolor later, when a background of experience and confidence has been established and you have more of a fighting chance to outwit the medium.

BEGINNING THE PAINTING

A State of Mind

In painting from abstraction back toward nature, the artist's state of mind is of prime importance. For one thing, the mind must be absolutely free of any idea as to what is to be painted. To have even a vague plan of action or a motif in mind could inhibit a free, organic growth of forms within the painting, and the artist could very well find himself reverting to predictable images or repeating, even without intending to, elements from his own previous work or the work of other painters. So, a mind that is swept clean of all plans and preconceptions is the first requisite.

Second, the painter must have deep faith in his own intuitions and responses. If there is anything that modern psychology has taught us, it is that the human subconscious has laws of its own and that we should feel free

Winter Seascape, early stage. The color and design that characterize the earliest phase do not necessarily dictate color and design in the finished painting; they are things to be accepted or rejected—to respond to in some way—but a painting creates its own laws as it develops and is not a slave to its formative procedures.

WINTER SEASCAPE, 1972, ACRYLIC ON ILLUSTRATION BOARD, 23 × 35". PRIVATE COLLECTION. Most of this painting was done in spatter, stipple, and spray once it was free of its beginnings. Once the wave image appeared, I found that spatter and stipple best achieved the feeling of mist and ocean spray. The spatter was done directly from a small housepainting brush flicked sharply against a forefinger; all the stipple was done with an old toothbrush dipped into paint and scraped with a blade. The less paint there is on the brush, the finer the stipple and the greater control there is. Any areas not meant to receive paint are masked off with paint rags or newspaper so that paint application is as localized as possible. Paint that is sprayed on with a spray bottle or fixative blower is best for large areas where a fairly uniform paint film is desired.

to discover what they are and use them for creative purposes. Even in the most rational, rigidly controlled paintings we often find a passage of pure inspiration without apparent reason or precedent. There it is, and it works! The artist may wonder what it was that possessed him to do that unexpected but remarkable thing; it was probably intuition, one of the creative person's most powerful resources.

Finally, the artist must be ready to thoroughly involve himself in the act of painting with the fullest concentration and enjoyment and to act as though he knows what he is doing (even if he doesn't). It does take a certain amount of nerve to attack a painting without a plan, without a preconceived image toward which to aim, but the picture should still be begun in a spirit of joy and relaxation, with no inhibitions whatsoever. After all, painting should be a celebration. Remember Robert Henri's advice: "Paint as though you are going over the top of a hill singing."

The beginning of an improvisational painting is perhaps the most exhilarating experience of all, because at that point the possibilities are infinite. If the artist has set his mind properly, he is in a position to make the most out of those possibilities.

The red rocks of Sedona, Arizona, are impressive formations, but it is their vivid redness itself that is their major attraction for many painters, whether they are inclined toward realism or abstraction.

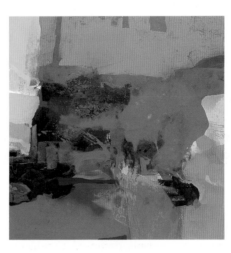

Sedona, Stage 1. In the early phases of improvisation I am most interested in activating the surface of the panel by arranging shapes that divide up the picture and relate to the four edges of the composition. In this instance I was working within a square format, which reputedly is a difficult one to design since it is so liable to fall into equal or symmetrical divisions of the surface. Nevertheless I am very fond of it *because* it is more challenging, and forces me to design with special care.

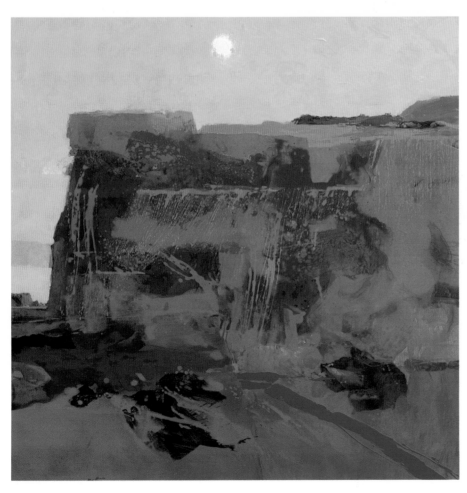

SEDONA, 1986, ACRYLIC ON MASONITE, 48 × 48". PRIVATE COLLECTION.

The stark drama of the red rocks against the sky lent itself naturally to an abstract treatment. Color was intensified to heighten the visual impact of the immense rock against a bright sky. I made no attempt to copy actual formations, but to catch their spirit in purely painterly terms; the details of geological masses were not rendered but suggested by means of flung and splattered color. This picture uses Sedona only as a point of departure for creating an experience in color, paint, and gesture.

Accident and Chance

How often have we seen an artist whose paintings are all so alike that we feel when we have seen one we have in essence seen them all? To deliberately provoke accidental effects in a painting is one way to ensure that you will not repeat yourself. Avoiding habit, formula, and standardized solutions should be a guiding principle for any truly creative painter, and one way to accomplish that goal is to set up totally new or unexpected situations and then try to deal with them freshly and adventurously.

I once asked a distinguished West Coast abstract expressionist if he were not depending a little too much on the accidents that occurred in his painting, and he answered with some irritation that there *were* no accidents. At first, I thought he was implying that his "accidents" were determined by heavenly powers, and since they had holy sanction they were therefore not to be thought of as accidents.

In the years since then, however, I have come to believe that an accident does not remain an accident after it has been contemplated aesthetically and

ultimately either accepted or rejected. Once it has been accepted and retained in the picture, if only for a short time, to me it then ceases to be an accident—a choice, a commitment, has been made.

I am thinking of accident as a means of stimulating the artist's intellectual and emotional powers, of probing the subconscious for suggestions unknown and unrealized until they are sparked into action by unplanned occurrences in the painting. Chance effects that are unproductive or unsuccessful— that do not release creative ideas or satisfactorily relate to other parts of

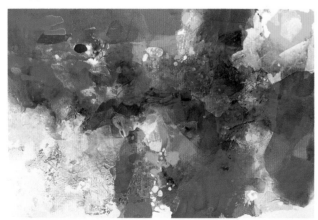

Sea-Meadow, Stage 1. I began working on a prepared surface, mostly of white tissue paper brushed on haphazardly with diluted acrylic gloss medium, and also some areas of sand. This provided a textured surface that was ideal for color glazes, some wiped or rubbed, with others left as is.

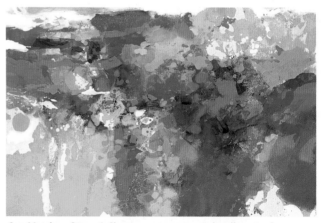

Sea-Meadow, Stage 2. Many of the areas seemed heavy-handed and clumsy, and I felt the surface needed to be lightened in order to receive fresh color. I used thin whites applied by the transfer method to get rid of much of what I had already painted, so as to open up the picture to new shapes and new ideas. It was largely a process of simplifying the many shapes and colors in Stage 1 so that the picture would be less confusing and jumpy.

Sea-Meadow, Stage 3. More color was flowed and poured on; obviously I was in my Red Period at that time, but in any case I was gradually limiting the color masses to red (dominant), orange and yellow (subordinate), with small accents of blue, purple, and pale green. The distribution of masses across the surface was more to my liking than anything that had yet appeared, but on the other hand nothing "spoke" to me in terms of what the subject matter might be. I concentrated on developing an abstract design with which a subject might merge at some later point.

Sea-Meadow, Stage 4. Shapes were rearranged, yellows took over more of the surface, and some hot pinks and yellow-greens were introduced. I felt encouraged by both the design and the way the small color touches played off the large color masses. By this time I sensed the presence of clusters of flowers, and the upper edge of the composition suggested either sky or water, or both.

the picture—must be painted out and replaced by others which either "speak" to the painter or fulfill a specific function in the picture. My first impulse when faced with an accident of questionable value is to try to find a way to use it, to make it work, to integrate it with areas already established. Failing that, I eliminate it immediately.

The point to painting improvisationally is that instead of imposing his will like a cookie cutter upon natural forms, the artist is conceiving his picture in terms of the medium itself. He is enlisting accident to help bring about an interweaving of his paints with possibilities and probabilities, and with a personal vision, both conscious and unconscious. Improvisational painting is a way of taking an accident beyond the accidental, of giving it not only form but meaning as well.

Applying Paint

The whole spirit or mood of this sort of painting is identical to mixed-media technique. I have no one standard method of beginning to paint, but usually I start off by pouring paint onto the panel. The panel's surface may be dry, but often I spray it first with water or flow diluted acrylic medium on and then pour on the color and let it do what it will. This operation may take no more than three or four minutes. However, I am in no hurry to cover the entire surface all at once, nor do I want to have too many different areas flowing into each other so that they lose their quality of shape and edge. Therefore it is my habit to begin a painting at the very end of a painting day, so that it can dry overnight.

The following day more paint is poured—or flung—on. Some areas might be glazed with a wide brush or paint rag, other areas spattered or stippled or sprayed. At this stage, it is usually necessary to stop and let the paint dry. After it has thoroughly dried, I apply a coat of diluted acrylic medium over the entire surface.

Because of the amount of drying time inevitable with this method, I work on seven or eight paintings at a time, so that while one is drying I have several others to keep me occupied. At some point, when all the paintings are well on their way, one might begin to interest me especially and I may single it out to press on to a conclusion before any of the others. With a pour-and-flow method, of course, the drying periods can be frustratingly prolonged, but if the improvisational method is carried out along more ordinary lines—painting and glazing with a brush, or in mixed media—the picture comes along much more rapidly and if all goes well can very easily be completed in a single day.

Uppermost in my mind right from the start is a deep concern with color relationships; in fact, as I begin to paint I compose with color—not just line and tone—because I want color to carry the major burden of putting the picture across to its audience.

Since there are really no rules for handling color, an intuitive approach is as good as any; with extended trial-and-error comes experience, knowledge, and taste, which I much prefer to rigidly formulaic systems. I've always urged my students to make color a primary consideration in their art, to make color their special and personal contribution—the quality that sets their work apart from everyone else's. I know from my own participation on national art juries that when all things are more or less equal—craftsmanship, design, expressivity—it is the superior use of color that tips the scales in favor of some artists over others.

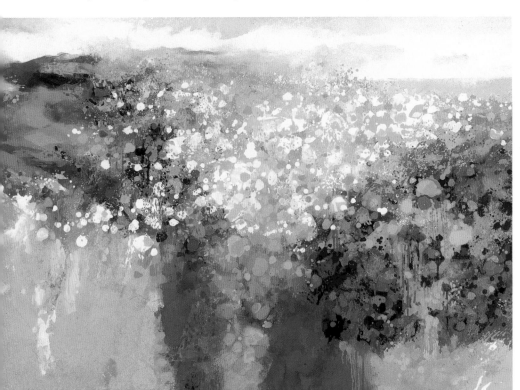

SEA-MEADOW, 1988, ACRYLIC ON MASONITE, 40 × 60". PRIVATE COLLECTION.

The upper edge of the painting was clarified by establishing a firm horizon along with ocean and soft clouds, the color being put on with all the nonbrush methods. Allowing paint to drip downward freely is a calculated effect I use fairly often, but only when it is appropriate to design needs or to the subject matter; in this case it referred to grasses, stems, and stalks. The hillside mass dotted with scattered groups of flowers, all set against the distant sea, required organization as a readable, unified surface, executed in terms that were wholly painterly in spirit, not descriptive.

DEVELOPING THE PAINTING

Discovering the Subject

Whereas accident and chance play a large part in beginning the painting, they become less pertinent as the picture goes along. If the picture is to have meaning or communicative qualities, the paint must refer to something other than itself.

After a while the haphazard areas of the painting have to assume some sort of direction, and the first thing I look for is a *design* in the largest possible sense, an overall arrangement of big relationships in shape and pattern. Then, as memory and associations are brought into play, I can begin to see suggestions of *subject matter,* which must be coordinated with the design. At this stage, it might be said that the painting is something like a glorified Rorschach test, in which I search the picture for clues to its eventual meaning.

It is the chance effects of paint, combined with a recollection of my own experiences and imaginings, that cause the image to emerge. Then the role of accident is immediately minimized, and further development of the picture becomes a far more conscious act. Even though technically I may still be using methods of paint application that are largely accidental, now they are being used with purpose, to evoke and clarify the image or idea that is central to the entire painting. Every stroke, every mark, every blot, everything added to or subtracted from my painting from this time on relates to the control image I have decided upon, and there is now a specific reason for everything I do to the painting. Accident has served its purpose as a catalyst and can be put aside; the main thrust of all subsequent painting is to work in terms of the governing idea and to achieve a structured, expressive organization of color, plane, shape, pattern, and texture.

FINISHING THE PAINTING

As I mentioned previously, finishing the painting can be a problem for some people, perhaps because they are not sure whether they want to leave the picture looking free and brushy and nonobjective or to carry it further toward a more tightly controlled semiabstraction. In my own case, I may decide to keep the forms suggestive and ambiguous, or I may push the picture almost to the point of realism. Some paintings look almost nonobjective, with only the most obscure references to nature, and others seem closer to straightforward descriptive realism. My decision on this varies from painting to painting, depending on what has happened within the picture and what my feelings are in regard to what it should look like.

In any case, I have no rigid preconceptions as to what sort of appearance my work should have, either stylistically or regarding the degree of abstraction. I am determined that each painting should be a separate exploration, that it live its own life (with my guidance), and that its final look be peculiarly its own.

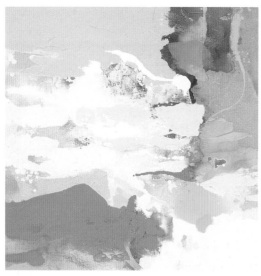

Riverscape (early stage)
The work-in-progress photo shows the painting at about midpoint in its development. I was working only with the major masses, concerned mostly with the disposition of the shapes across the panel. At that stage the general format had emerged, but precise color decisions had yet to be made. From there I concentrated on spatial relationships, the interplay of references to earth and water, of warm and cool color, and flat versus textured areas. The principal forces at work were both the intuitive and the rational. Incidentally, too few artists trust their intuitive decisions, which I regard as being direct shortcuts to logical conclusions. (Logic takes longer, of course, but the outcome is usually the same.)

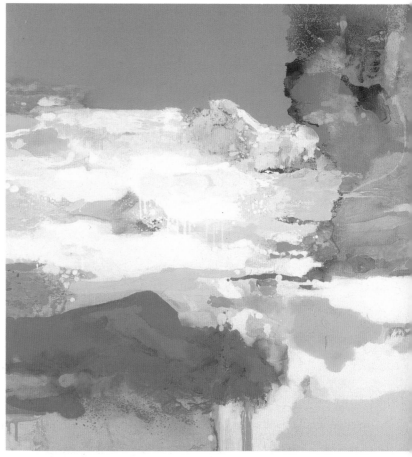

RIVERSCAPE, 1988, ACRYLIC ON MASONITE, 48 × 48".

The degree of finish is, of course, a very personal choice, but it should be consistent with the attitude behind the painting of the picture. A freely painted, splashy picture would not have to be brought to the same finish as a tightly painted one where every square inch has been solved and meticulously dealt with. Sometimes, in fact, paintings can be too finished, with everything neat, pat, orderly, drained of all signs of the human element. Perhaps it might be better occasionally to leave in a slight awkwardness here and there, not solve everything too thoroughly, leave a passage blurred instead of sharp-edged. In short, keep it fresh, natural, and relaxed.

CONTROLLING THE IMAGE

One of the biggest problems in finishing the painting is the matter of the artist's control over the spectator's interpretation of his imagery. This is of no concern to a nonobjective painter, whose forms refer to nothing other than their own interrelationships so that no misinterpretation is possible. But a painter who is attempting to deal with a definite subject has to exert some control so that people see in his work what he wants them to see. It can be infuriating for an artist to paint a rocky landscape and then have someone mention to him that they see in it a little tugboat in a harbor or three pussycats perched on a hill.

I suppose there is no real answer to this. Where people insist on reading their own subject matter and their own associations into a work of art, the artist has already lost control and may as well sit back and let them play their games. The best he can do is try to eliminate confusing or unintentional ambiguities and see to it that all the forms apply as directly as possible to what he is trying to express.

Titles are sometimes a great help to the spectator because they usually furnish a hint to the subject underlying the painting; but there is no avoiding the fact that a person usually sees the picture before he looks at its title, so the picture should stand on its own merits as much as possible and not require explanatory labels. Actually, most of us

develop thick skins and are not hurt by minor misapprehensions of what our work is all about, but it is also up to us to do all we can to express our visual ideas as clearly as we can without being obvious—which just might be a greater sin than being obscure.

Painting intuitively back toward nature is, as we have seen, an alternative

creative process to the more analytical treatment of natural forms. Once you embark upon improvisational techniques, it is well to keep in mind the old saying, "A good watercolor is a happy accident," and especially the second part of that saying, "and the better the artist, the oftener the accident happens."

High Rim, Stage 1.

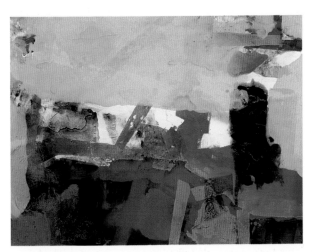

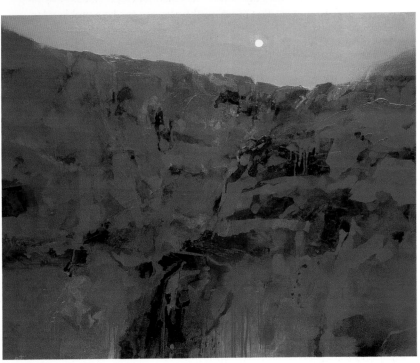

HIGH RIM, 1989, ACRYLIC ON MASONITE, 48 × 60".

In Stage 1 this painting could have gone either toward the yellows or toward the reds, since both colors occupy about equal space. Since the yellow area was rather uneventful compared to the complex shapes and color changes in the red zone, I opted to develop the red. Ultimately the picture turned out to be another version of the cliffs at Sedona. Because the cliff was made up of such a multiplicity of small shapes—fissures, crevices, and ledges—the sky was kept absolutely flat and simple so that there was no chance for it to compete with—or add to—the complexity of color and shapes in the lower section. Accents of blue or green were kept minimal in size, just enough to serve as a touch of color contrast to the overwhelming amount of red. The composition is simplicity itself—only two areas—but the visual interest is sustained by the manipulation of intricate shapes, planes, and textures within the picture's largest mass.

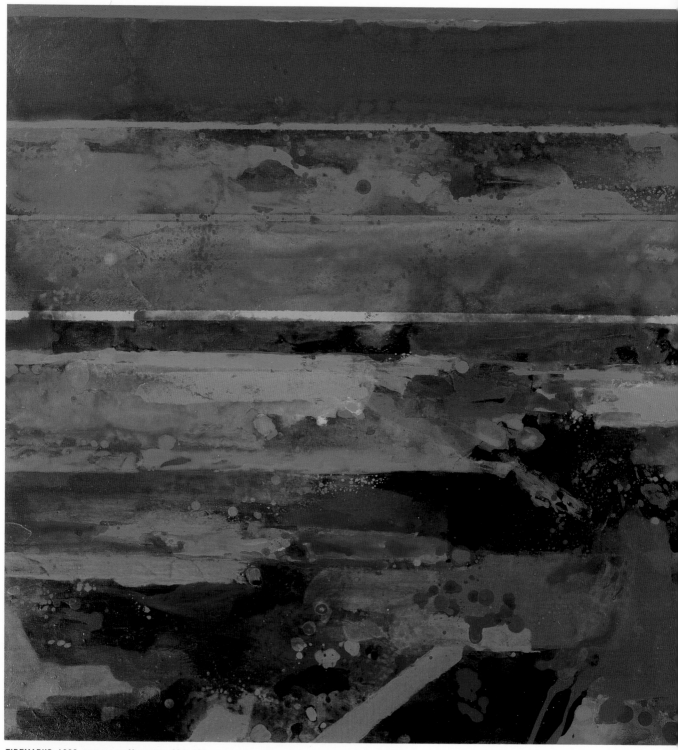

TIDEMARKS, 1990, ACRYLIC ON MASONITE, 30 × 40".

Joan Miró, the great Spanish modernist painter, once said that "A painting rises from the brushstroke as a poem rises from the words. The meaning comes later." This painting is essentially about relationships of rich, resonant color very loosely applied but given a sense of structure by the use of clearly defined horizontals. The composition took form through extended intuitive manipulations of color patterns; the meaning came later when I sensed an emerging image of the various strata of the shore at low tide.

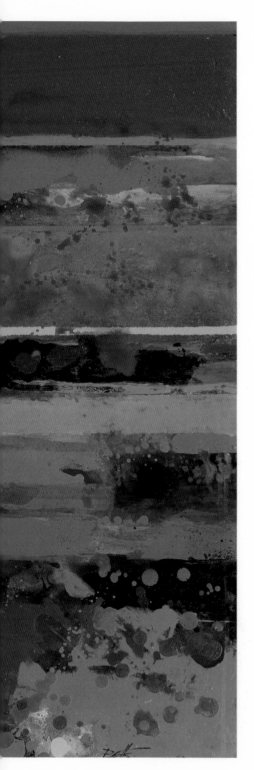

BRINGING IT ALL TOGETHER

Take all the paintings you've done and set them up around you in a room where you can sit and contemplate them. I am a great believer in paintings revealing to you who and what you are as an artist. Sometimes painters think (or hope) they are a certain kind of artist and their work typifies a specific style, whereas the work itself may indicate something altogether different.

Look at the drawings and paintings: Varied and sometimes conflicting attitudes seem to lie behind all this work. Yet despite that, what thread seems to you to run through all the pictures? What pops up with some degree of regularity in almost everything you have painted? Do you find you are primarily an intellectual, impersonal painter with an urge for order and organization? Or are you an incurable romantic swinging a wild brush? Is color your strong point, or is it decorative line, dramatic pattern, or expression of mood and atmosphere? Which paintings did you enjoy most as you did them, and which did you find not so congenial to your tastes? Although you have always considered yourself a formal kind of painter, why is it that those casual, offbeat sketches seem so much better than your usual work? Do they indicate a new direction? Can their qualities possibly be incorporated into the work you plan to do next?

Answers to these questions and others like them are the first step in sorting out who you are as an artist. From your work itself you get clues to the general direction your style is taking (and it does have a direction of its own, so that you sometimes may feel you are only a vehicle) and the specific qualities that for better or worse seem to be your personal strengths or obsessions.

CULTIVATE YOUR STRONG POINTS

The second step is to cultivate those strengths, to push the work even farther in its natural direction toward whatever end it seems to be headed. It means that you drive toward that goal with intensity and passion, allowing no distractions or deflections from your course. I may shock some by saying this, but I strongly feel that an artist should improve and enrich his strong points and not waste time trying to improve his weak points along a broad front. If you do not draw cows very well, there is little to be gained in taking great pains to become a painter of cows. Put them in deep grass or forget them, leaving them to other painters who can paint them with conviction. You should aspire to improve your own strengths to the point that what you already do well, you will do better than anyone else in the world. You might not reach that goal, of course, but it is certainly worth the struggle to see if you can.

I further recommend that every five years or so you should go through all your artwork currently stored in your studio, and be brutal about destroying the really weak items. The mistake artists often make is that they hang on to everything they ever did just on the remote chance that there *might* be a buyer for it somewhere, someday. Any drawings, sketches, or paintings that are obviously poor in quality are certainly not worth keeping; anything casual or trivial, anything that is in any way unworthy of you or your professional reputation should be disposed of, if only to make room for the new work as it comes along. Set very high standards for yourself and then be absolutely uncompromising about getting rid of anything that does not conform to those standards.

ON BEING INFLUENCED BY OTHER ARTISTS

Every painter has influences when he starts out on an art career. You have to build on something; do not be ashamed of it. (My own idols as a very young art student were John Singer Sargent, Frank Brangwyn, Winslow Homer, Robert Henri, and the illustrator Dean Cornwell. Slightly later heroes included Cézanne, Braque, Soutine, Bonnard, John Marin, Ben Nicholson, and Ben Shahn.) But do not copy your heroes. To make an outright copy of a work by your favorite painter may teach you a smattering of what you need to learn, but you are still dealing with something that has already been observed, selected, organized, and executed by someone else. It is far more to the point to determine your own subject and then try to imagine it through the eyes of the one you are emulating: How would so-and-so have painted it; how would he have dealt with its color and composition? In other words, go after the principles underlying the work, not just the outer manifestations of style. Even if you are heavily influenced at the start of your career, the longer you paint the more the influences drop away, one by one. Eventually, you are left with your own art, your own viewpoint, and the courage of your own convictions. Naturally, you will still enjoy looking at paintings by artists you admire, but they will no longer have a direct effect on your work. They will have become something completely separate and outside your own painting.

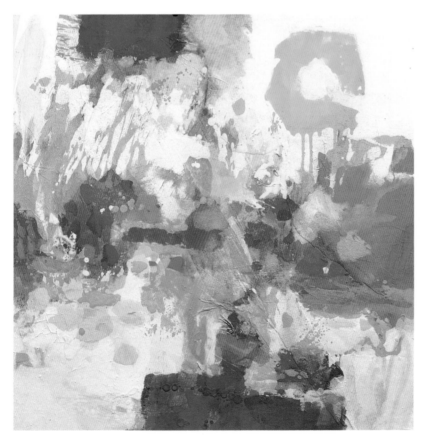

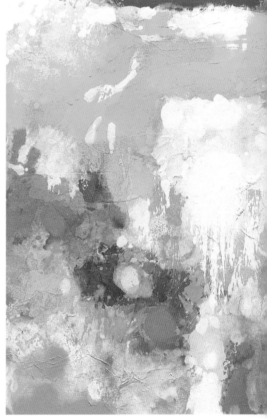

FINDING A PAINTING STYLE

What about painters who paint with equal fluency in several styles? Well, it means they are still shopping around for the style that suits them best and have not yet felt a genuine pull toward one in particular. If you want to look at it positively, you might say that painting in a variety of styles is evidence of versatility and that the painter has kept an open mind instead of becoming locked into one style for a whole lifetime. Open-mindedness is an important thing—it means you are constantly receptive to fresh ideas and different ways of seeing things, that you are unwilling to settle on a style from which you feel you can never deviate. However, style changes over the years, gradually, imperceptibly, and the true artist flows with it. You seldom make arbitrary decisions about the direction of your work, because then you would be imposing your conscious will on something that should be left to develop and change naturally.

This is true even in the formative stages of a style. You do not go out and select a style as you would a jacket in a clothing store. Style evolves very slowly—without your really being aware of it—out of your own seeing, your own honest reactions to what you see, and especially your involvement with your subject matter. Surprisingly, style is not so much a matter of technique as it is the result of an attitude. If you paint directly, naturally, and without thinking so much about style, the style will appear by itself. You should try not to be conscious of it; let it happen and don't direct it intentionally. The main thing is to be relaxed about it and not grow anxious or impatient. In the creative arts patience is everything: Time does not count, but art does.

A style should be an inevitable outgrowth of both the artist's technique and his philosophy. It should in no way be forced or artificial. Above all, the style should be flexible enough to express a variety of subjects and ideas. A style that imprisons you or limits your selection of subject is worse than none at all. If the style is forced or contrived in any way, it will add little or nothing to your painting. Judges in national exhibitions usually do not want a style thrust in their face. They are looking not for personal idiosyncrasy but for an overall balance of form and content and a mastery of technique.

You cannot paint with an eye to salability and you cannot paint just for competitions. If sales are your foremost concern, you will find yourself severely restricted as to what you paint and how you paint it. For one thing, you may be limited to noncontroversial subjects, feeling impelled to include a boy and his dog in every work in order to increase its sales appeal. Similarly, you may find yourself in the position of wanting to use a bright red splash but not daring to because it will offend buyers who want only the standard decorator greens and tans.

And as for competitions, how can you guess how the judges will react? How can you know what they are really looking for? An abstractionist may just possibly have broad enough tastes to enjoy many forms of realism, and a superrealist painter may not be favorably inclined toward work that imitates a genre which he feels is exclusively his own territory and that is without need of any more imitators, good or bad.

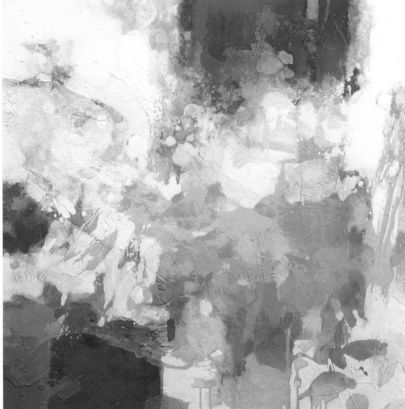

IN THE SUMMERTIME (TRIPTYCH), 1987, ACRYLIC ON MASONITE, EACH PANEL 36 × 36".

This is landscape by implication or inference, an avoidance of recognizable subject matter in favor of evoking a sense of season. My work in recent years has tended toward highly abstract compositions in which the paint serves as a visual equivalent of the various forces and phenomena of nature: mist, snowfall, sunlight, winds, skies, or seasons. It could be said that ideally paint and subject should be virtually inseparable.

I recall that a number of years ago the only jurors at the Pennsylvania Academy Watercolor and Drawing Exhibition were Stuart Davis and Andrew Wyeth. What do you submit to a jury that includes two such opposite stylists? Well, you forget personalities, you forget the artistic schools represented by the jurors, and you send in your very best work and take your chances. Jurors' tastes are not always as narrow as might be supposed, so all you can do is submit what you know to be your best recent work and not try to predict what the jury will go for. Being represented at your best should be your main concern, not guessing games.

The best painting I know of comes out of compulsions and obsessions, out of deep love or hate, out of intellectual or emotional involvement with something that lies outside the painting itself. These are the things that ultimately form a painter's style.

A MATTER OF BALANCES

Out of my experience in the field of painting over a good period of time, I have come to the conclusion that the best art seems to be what the poet W. B. Yeats once referred to as "a mingling of opposites," the establishment of some sort of equilibrium between contrasting elements, such as intellect and intuition, formality and informality, the calculated and the accidental. I have already mentioned the idea of the inseparability of form and content. In addition to that, there are those who believe that art's greatness may lie in combinations of predictability and surprise, or in the collaboration between the creative conscious and the subconscious. These extremes have to be resolved somehow, and the effort to achieve that successful resolution is what gives the work of art a certain implicit tension and excitement. It is my belief, shared by others, I am sure, that the degree

to which these opposites are reconciled is to a great extent the yardstick of excellence in any work of art.

Sometimes it seems that it does require two sides of a person's nature to paint a picture: A part of the artist is the inspired, imaginative visionary—the creative person; the other part is the craftsman-critic, the professional who puts it all together with a combination of technical skill and calm objectivity.

WATERCOLOR: THEN AND NOW

For a long time the aqueous media lacked the prestige of oils. Watercolors and gouaches were considered too fragile and too intimate in scale to compete on the same level with oils. Nor could they command equal prices. Now, however, this is no longer true, and watercolor has really come into its own.

The fragility of watercolor is true only to the extent that paintings on paper must be kept under glass. Outside

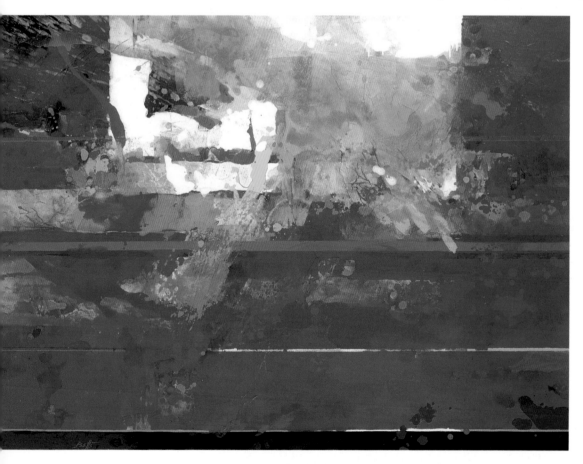

COASTAL HORIZONS, 1991, ACRYLIC ON MASONITE, 31 × 44".

This picture was painted, on and off, over a period of three years. One of the advantages of acrylic paint is that it allows this sort of continual revision until an acceptable image is found. Literal meaning or recognizability were of little consequence to me here; indeed, some degree of ambiguity can enhance a painting by imparting to it a touch of mystery, of things not completely revealed, of subjects or moods that are felt rather than defined. At worst, such ambiguity can be meaningless, so it is up to the artist to strike a balance between clarity and obscurity, avoiding the obvious on one hand and unintelligibility on the other. In the long run it is not important to me that the viewer identify my own associations within the painting; it has to stand on its own as color and design.

of that, a watercolor done in 1750 with nonfugitive colors is probably in prime condition today compared with an oil painting done the same year. The oil will have undoubtedly darkened and cracked, betraying its age more than it should; the watercolor looks as though it was painted yesterday afternoon.

Whereas watercolors used to be tiny, intimate works (the British still call them "watercolor drawings"), contemporary watercolors are often done on paper that is five feet wide, and of course acrylic paintings on Masonite or canvas can be much larger than that. In terms of scale, too, the aqueous media are most certainly on an equal footing with oils.

It is intriguing to me that some of the highest points reached in contemporary art have been in the works of the "color field" painters, who work with vast washes of glowing acrylic color on gigantic canvases. In the final analysis, this is a logical extension of an attitude toward and use of a medium that is above all else a *watercolor* conception.

In terms of prices, the old double standard is again something that seems to be equalizing. It is not at all unusual to see full-sheet watercolors by some of our finest living painters selling for $20,000 or more, with large acrylics bringing even higher prices.

Finally, it is by now quite evident that the watercolor sections of some of our national painting exhibitions are frequently far superior to the sections devoted to oil paintings. Very often, the watercolor rooms contain work that is genuinely fresh, daring, exciting, and innovative, in which the artists are involved in experimenting in a spirit of commitment, breeziness, and buoyancy, as well as technical control. Certainly, it is difficult not to respond wholeheartedly to such a frank love of the medium for its own sake.

Watercolor is no longer a "minor" medium; in fact, it is my conviction that in the past fifteen years we have been experiencing what might be called a watercolor renaissance. If all of us paint with total dedication and insist on being uncompromisingly creative, I believe we can carry the watercolor medium to even greater heights than it has already attained.

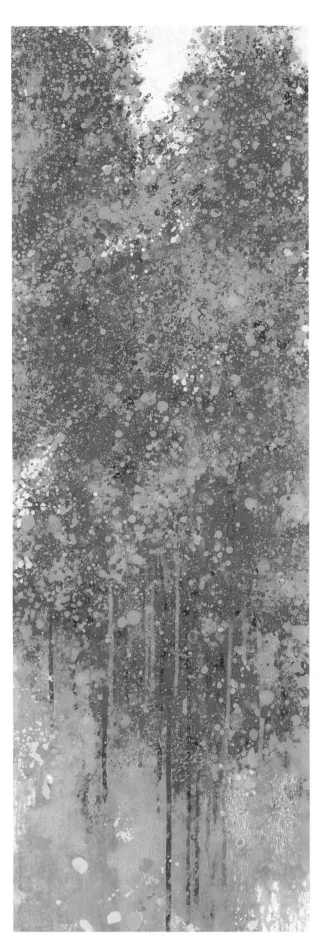

FOREST LIGHT, 1989, ACRYLIC ON MASONITE, 40 × 14". PRIVATE COLLECTION.

The subject of this painting appeared fairly early in the painting process, principally because greens dominated the surface and because a few random drips suggested tree trunks. The simple areas of sky and foreground contrasted with the complex spatter throughout the rest of the composition. Within the spattered and stippled areas I took pains to vary the size of the dots so as to avoid any monotony of treatment; also, I varied the concentrations of spatter so that some patches came forward and others receded somewhat in the shallow picture space.

SUGGESTED READINGS

Baur, John I. H. *Nature in Abstraction.* New York: The Macmillan Co., 1958.

Betts, Edward. *Creative Landscape Painting.* New York: Watson-Guptill Publications, 1978.

————. *Creative Seascape Painting.* New York: Watson-Guptill Publications, 1981.

Blake, Wendon. *Acrylic Watercolor Painting.* New York: Watson-Guptill Publications, 1970.

————. *Complete Guide to Acrylic Painting.* New York: Watson-Guptill Publications, 1971.

Blanch, Arnold. *Methods and Techniques for Gouache Painting.* New York: American Artists Group, 1946.

Brandt, Rex. *The Artist's Sketchbook and Its Uses.* New York: Reinhold Publishing Co., n.d.

Brooks, Leonard. *Painting and Understanding Abstract Art.* New York: Reinhold Publishing Co., 1964.

Brommer, Gerald. *Landscapes.* From the Insights Into Art series. Worcester, Massachusetts: Davis Publications, 1977.

————. *Watercolor and Collage Workshop.* New York: Watson-Guptill Publications, 1986.

Carpenter, James. *Color in Art.* Cambridge, Massachusetts: Fogg Art Museum, Harvard University, 1974.

Cathcart, Linda L. *The Americans: The Collage.* Houston, Texas: Contemporary Arts Museum, 1982.

Cobb, Virginia. *Discovering the Inner Eye.* New York: Watson-Guptill Publications, 1988.

Hale, Nathan Cabot. *Abstraction in Art and Nature.* New York: Watson-Guptill Publications, 1972.

Kepes, Gyorgy. *The New Landscape.* Chicago, Illinois: Paul Theobald and Co., 1956.

Le Clair, Charles. *Color in Contemporary Painting.* New York: Watson-Guptill Publications, 1991.

Loran, Erle. *Cézanne's Composition.* Berkeley and Los Angeles, California: University of California Press, 1943.

Malraux, André. *The Voices of Silence.* Book III, "The Creative Process." Translated by Stuart Gilbert. Garden City, New York: Doubleday and Co., Inc., 1953.

Newhall, Beaumont. *Airborne Camera.* New York: Hastings House, 1969.

O'Brien, James F. *Design by Accident.* New York: Dover Publications, 1968.

Phillis, Marilyn Hughey. *Water Media Techniques for Releasing the Creative Spirit.* New York: Watson-Guptill Publications, 1992.

Quiller, Stephen, and Barbara Whipple. *Water Media: Processes and Possibilities.* New York: Watson-Guptill Publications, 1986.

Reep, Edward. *The Content of Watercolor.* New York: Van Nostrand Reinhold Co., 1983.

Roukes, Nicholas. *Acrylics Bold and New.* New York: Watson-Guptill Publications, 1986.

Terenzio, Stephanie, ed. *The Collected Writings of Robert Motherwell.* New York: Oxford University Press, 1992.

Weng, Wan-Go. *Chinese Painting and Calligraphy.* New York: Dover Publications, 1978.

Wolberg, Lewis. *Micro-Art: Art Images in a Hidden World.* New York: Harry N. Abrams, n.d.